## MORRISTOWN
## CENTENNIAL LIBRARY
## REGULATIONS
### (802) 888-3853

Books and audio cassettes may be kept four weeks unless a shorter time is indicated and may be renewed once for the same period.

A fine of five cents a day every day open will be charged on all overdue library books and audio cassettes. A fine of one dollar a day every day open will be charged for overdue library videos.

No book is to be lent out of the household of the borrower.

All damage to library materials beyond reasonable wear and all losses shall be made good by the borrower.

### LIBRARY HOURS

| | |
|---|---|
| Sunday & Monday | Closed |
| Tuesday | 9:30am – 7 pm |
| Wednesday | 9:30am – 7pm |
| Thursday | 10am – 5:30pm |
| Friday | 10am – 5:30pm |
| Saturday | 9am – 2pm |

still *working*

edited by stuart shedletsky
photographs by larry fink
essays by ann gibson, selma holo,
erika d. passantino, harry rand,
and jeffrey wechsler

# still *working*

## underknown artists of age in america

Parsons School of Design, New York, in association with
University of Washington Press, Seattle and London

Since the inception of this project, in 1991, five of the artists included in the exhibition have died. Their works remain, in memorium, as part of *Still Working*. The exhibition and its accompanying catalogue are dedicated to their diligence and to their faith in art's primacy as well as to the magical spirit that provide its existence against all odds.

**hans burkhardt 1904–1994**

**felrath hines 1913–1993**

**carl morris 1911–1993**

**jon serl 1894–1993**

**oli sihvonen 1921–1991**

**itinerary**
Corcoran Gallery of Art, Washington, D.C.
June 18–August 21, 1994
Chicago Cultural Center, Chicago, Illinois
October 22–December 23, 1994
The New School for Social Reasearch and Parsons School of Design, New York
January 24–March 10, 1995
Virginia Beach Center for the Arts, Virginia Beach, Virginia
March 26,–May 7, 1995
Fisher Gallery, University of Southern California, Los Angeles
September 6–November 8, 1995
Portland Art Museum, Portland, Oregon
January 24, 1996–27, 1996

*Still Working* was organized by Parsons School of Design, a division of the New School for Social Research, New York. Its presentation has been underwritten by a grant from Julien J. Studley Incorporated, with the generous support of the Richard A. Florsheim Art Fund.  ⧫⧫  ◆ STUDLEY

Cover: Oli Sihvonen, *Mobius Mode*, 1989, oil and acrylic on canvas, 96 x 68 inches (243.8 x 172.7 cm). Estate of Oli Sihvonen.

Back cover: Studio of Miriam Beerman, Montclair, New Jersey, December 1993.

Editor: Virginia Wageman
Design: Uretsky & Co.
Printer: Studley Press

"A Scale in May," by W. S. Merwin, from *The Lice*
(New York: Atheneum, 1969), © 1967 W. S. Merwin. Reprinted by permission.

Statement by Frederick Hammersley from Donald Bartlett Doe, *Paintings of Frederick Hammersley*
(Topeka, Kansas: Mulvane Art Museum, Washburn University, 1993).

Statement by Jon Serl from Susan C. Larsen, *Jon Serl* (Portland: Jamison/Thomas Gallery, 1988).

Copyright © 1994 Parsons School of Design

ISBN 0-295-97385-4

# contents

# forewords

We think of art making as a youthful enterprise. Young artists capture our notice, challenge norms, conger up new expressive ideas, attend visual art schools, push against frontiers, and otherwise demand, and get, our attention. But why must this be so?

The old were once young—and we should be confident that the old who have sustained art begun in youth, whose earlier experience persevered and matured—who are still working—are especially worthy of our attention. This is the idea behind the exhibition *Still Working*.

This excellent art has much to teach those who wish to learn. At a bare minimum, it sends the clear message to young and old alike that mature artists can stay fresh, creative, and vital. Parsons School of Design, an institution devoted mainly to the education of youth, is proud to sponsor the exhibition.

Like any great exhibition, this one began with an idea, and was sustained by commitment. The curator, Stuart Shedletsky, is a faculty member in fine arts at Parsons, and the idea was his. The commitment came partly from him, in the form of years of sustained hard work, and partly from Julien J. Studley, whose generous patronage provided the lion's share of the financial underpinning, without which the idea could never have been realized. On behalf of Parsons School of Design and the thousands of people who will enjoy this exhibition, I extend profound thanks to both Stuart and Julien.
**Charles S. Olton**
**Dean, Parsons School of Design**

In the late 1970s, about halfway through my nineteen-year tenure at the helm of Parsons School of Design, the painter/philanthropist Ruth Abrams offered to support an exhibition that would identify and document the work of under-recognized artists in their middle-age or beyond–particularly those who had built up a substantial oeuvre but who remained in relative obscurity.

The idea was most appealing. Serious students of art history cannot but be struck by the historical discontinuity between the critical fashions of an artist's lifetime and the potential of his or her work for long-term aesthetic success or recognition.

To my considerable surprise, the idea paralleled one held by Stuart Shedletsky, a young painter in his mid thirties who chaired the Exhibition Committee at Parsons during those years. Shedletsky was so enthusiastic, however, that he confirmed my strong intuition about the importance of this concept, suggesting through his own commitment that the exhibition would be recognized well beyond the generation of artistswhose work it addressed. And so we began to plan a show.

Unfortunately, Ruth Abrams's sudden death pulled the financial rug from under our plans, and Shedletsky's rotation off the Exhibition Committee a year or so later ended, for the moment, any remaining impetus we might have had. It was not until a decade had gone by, when Julien Studley, a member of the Parsons/New School Board

of Trustees, told me he wanted to find an innovative exhibition vehicle for funding by Julien J. Studley Inc., that the idea came back to life.

We were just beginning to plan the project when I decided to leave Parsons and New School for Washington, and so it came as a particular pleasure to learn, a year or so later, that the exhibition was again underway. It was especially gratifying to discover that Stuart Shedletsky, now an established artist and a very senior member of the Parsons faculty, had heard of these plans, that his original enthusiasm had never waned, and that he had volunteered to devote his forthcoming sabbatical leave to the massive curatorial research, organization, and selection of this exhibition.

It is fitting, therefore, that *Still Working* should have the Corcoran Gallery of Art as its first venue. Although, in the event I was unable to participate in the details of the exhibition's development, I remain deeply committed to its fundamental idea–that the determinants of success or obscurity in an artist's lifetime can be as ephemeral as a talent for good cocktail conversation or, more likely yet, a roll of the dice. It is therefore the obligation of responsible institutions always to go beyond current fashions, defining substance in terms that draw upon informed intellectual judgement and the most serious belief in the importance of art. In an art world that often appears to have lost its footing if not its maturity, I hope this notion becomes a fashion in its own right; but in any event, it gives me great pleasure, after these many years, to host *Still Working*.

**David C. Levy**
**President and Director**
**Corcoran Gallery of Art**
**Washington, D.C.**

Stuart Shedletsky's lucid and poignant introduction to this exhibition. as well as the distinguished accompanying essays, describe the intent and relevance of *Still Working*.

The educational scope of *Still Working* is particularly interesting to me as an exhibitions director and artist-teacher. I watched this project grow, provided technical advice when required, and offered a sympathetic ear to my colleague as Stuart pursued venues and support for his curatorial odyssey. When it became evident that Stuart's curatorial passion had transcended our physical capabilities at the Parsons Exhibition Center, we decided to support an additional documentary exhibition that would focus on the still working in order to insure the integrity of the exhibition as a complete entity. When *Still Working* is greeted by the New York audience, this educational adjunct to the still working project will be hosted by the Parsons Exhibition Center.

We look forward to the realization of this most important exhibition and salute all of the artists and patrons who have made it possible.

**Clinton Kuopus**
**Director of Exhibitions**
**Parsons School of Design**

Our role as sponsor of the *Still Working* exhibition, like the creative paths of the artists it features, evolved over an extended period of time. It began for us five years ago, in Mendocino, California, at a meeting of Studley's Board of Directors. Perched on a picturesque mountainside overlooking the Pacific coast, we explored the notion of sponsoring, as a corporate project, an exhibition of under-recognized artists. I turned to the New School for Social Research, with which I have had a long and rewarding relationship, and its president suggested I talk with David Levy, then executive dean of Parsons School of Design, a division of the New School. David referred me to Stuart Shedletsky, a full-time faculty member at Parsons, who had been contemplating a similar but more defined concept–orchestrating an exhibition honoring exceptional painters and sculptors who are sixty years of age or older and who had not achieved national recognition. Upon talking with Stuart, we were immediately interested in forming a partnership with Parsons.

Initially, the show was to be presented on the East Coast only. However, after some discussion, we were able to expand the exhibition, and currently six cultural institutions, across the country, are committed to the project.

We are very pleased to be sponsoring this effort, and believe the exhibition and its accompanying catalogue capture the spirit and creativity of the selected artists and their works. We hope when you view *Still Working* your experience is as thrilling as ours has been in making it possible.

**Julien J. Studley**
**President and Chairman**
**Julien J. Studley, Inc.**

# acknowledgments

Ideas are contagious. They evoke in concerned individuals a collaborative spirit. The spirit of collaboration in turn calls upon selflessness and dedicated attention and generosity. A number of people who gave freely of their time and enormous expertise also have essays included in this book. I feel, however, that in spite of the contribution their writing evidences I must additionally thank them for the invaluable guidance they provided; they got me facing the right direction and asking the right questions of the right people.

Ann Eden Gibson has been an amazing ally and resource; she answered what, in the beginning, had to be very naive questions and gave me insights into the process I was initiating. She spent many night hours on the telephone with me letting me pick her fertile mind and she told me, in no uncertain terms, to do my homework.

Clinton Kuopus, Director of Exhibitions at Parsons School of Design, was a critical aid in the laying of groundwork for the exhibition that this book accompanies. His intimate guidance, navigational intuition, and support gave me balance and perspective when doubt reigned supreme and the small show we originally planned took on leviathan scale.

Erika Passantino guided me through the goings on in the art world in Washington, D.C. She made available her carefully researched records on the artists connected to the circle of Duncan Phillips and the Phillips Collection and she cheerfully brought to her piece of the project a sense of order and attention to detail that, if I possess, I keep hidden, even from myself. Erika initiated the goals of the photo essay, and she was an affable and enthusiastic traveling companion whose great eye for architecture and good-humored tolerance for a lot of silliness and sushi balanced our mission.

Harry Rand helped beyond his incisive and able writing. He confirmed for me the necessity of the project. He supported its goals with high intelligence. He gave opinions and generous direction. He gave his friendship.

Jeffrey Wechsler, a genuine maverick in his devotion to underknown American artists, gave me the nod that helped me trust my instincts. I return the nod with a wink and my thanks.

Others whose concern and attention were invaluable and who eased the course or cleared it are:
My lovely, wise, and patient wife, Judith, and my very good-humored children, Lauren Ari and Emily Marin. My old friend, colleague, confidant, and source of sensible guidance Martica Sawin provided advice and direction at critical points throughout the project's gestation; her support was invaluable. Robin Schreiner Kroll, my administrative assistant, really did all the work. Bernice Steinbaum gave me so much of her captivating and gentle hysteria that at times, more than she will know, I used it to fuel me. She also advised me and led me to dozens of artists

I could not have proceeded with *Still Working* without the dedicated help of many individuals connected with art facilities and organizations around the country. To the best of my memory and notes their names follow:

In the New York area: Alajandro Anreus, Curator of Contemporary Art, Jersey City Museum; GregoryAmenoff; Larry Campbell, Archivist, Art Students League; Honoria Coral; Milton Esterow, publisher of *Art News;* Leon Golub; Cathy Goncherov, Curator of Collections, New School for Social Research; Barbara Hollister; Corrine Jennings, Director, Kenkeleba Gallery; Jane Karlin; Dan McIntyre; Christine Kempner; Kennan Rapp; Janet Levy; Grace Lichtenstein; George McNeill;

Lucy O'Brien, Office of Public Education, Museum of Modern Art; Joe Porrino, Executive Vice President, New School for Social Research; Charles Selliger; Gary Snyder; Joan Snyder; Judd Tully; AlisonWeld, Curator of Contemporary Art, New Jersey State Museum; Ingrid Wells; and James Yohe.

People in the Chicago area gave generously to the project. I gained ready access to Chicago's rich artistic community due to the generosity of the folllowing: Denis Adrian; Don Baum; Roy and Ann Boyd; Jan Cicero; Greg Knight, Department of Cultural Affairs, City of Chicago; Martin Prekop, School of the Art Institute of Chicago; Betsy Rosenfield; Maureen Sherlock; William Struve; Susan Weininger; and Beryl Wright, Museum of Contemporary Art.

My work in California was aided by the help of Susan Landauer who gave me a great deal of telephone time and very useful leads in the Bay Area. Ann Ayers of the Otis Art Institute in Los Angeles and Merle Schipper gave kind and enthusiastic direction. They guided me to many artists and workers in the L.A. art world. Others who helped me to get a handle on a very complex scene are: Paula Anglim; Adrian Fish; D. P. Fong; Selma Holo; Fred Martin, San Francisco Art Institute; Jess; Martin Muller; Peter Frank; Phillip Linhares, Director, Oakland Museum; Jack Rutberg; Manny Silverman; Dina Sorenson; June Wayne; and Steven and Connie Wirtz.

Gloria and Allan "Skip" Graham fed me, led me, and sped me all over New Mexico. I can't thank them enough or love them more. Others in New Mexico who helped are James Moore and Ellen Landis of the Albuquerque Museum of Art, Science, and History and Jennifer Sihvonen.

John Weber, formerly Curator of the Portland Museum, was enormously helpful in getting me to know the artists in the Portland and Seattle areas, as were William Jamison; Elizabeth Leach; David Morris; Prudence Roberts, Curator of Painting and Sculpture at the Portland Museum; Laura Russo; Francine Sedars; and Daryl Walls.

In Detroit, the guidance and hospitality of Joy and Ray Colby made the city open up to me. I could not have done without them. Sarah Colby must be thanked for remembering to make the introduction. Roy Slade of the Cranbrook Acadamy and Jan Vandermarck, Curator of Contemporary Art at the Detroit Institute of Art, must also be thanked.

Thanks too to my good friends in Maryland, Duncan and Elizabeth Tebow; to Carl Hecker for getting me started in Buffalo, New York; and also to Linda Priest of Bedford, Massachusetts, for her insights into the work of Morton C. Bradley, Jr. Tory Larsen, Exhibitions Coordinator at the Corcoran Gallery of Art, has been enormously helpful in providing documents and showing me the ropes.

I extend special thanks to Charles Olton, Dean of the Parsons School of Design, whose support and direction have been extremely helpful in bringing all this about. David C. Levy, President and Director of the Corcoran Gallery of Art, is to be thanked for his early vision toward and enthusiasm for *Still Working*. And of course my deep gratitude goes to Julien J. Studley for his courageous backing of a renegade idea and his decisive guidance in seeing it through.

**Stuart Shedletsky**

# introduction

STILL WORKING BRINGS TO NATIONAL ATTENTION THIRTY-TWO professional lifetime artists whose ages range from sixty to ninety-eight and who are currently—or have been, prior to their very recent deaths—engaged in the strongest work of their careers. They have each found the means to reinvent themselves creatively in a cultural milieu antagonistic to late self-discovery.

*Still Working* began as a conversation in New York in 1981. The late painter Oli Sihvonen, then sixty years old, and I talked about art in his Chinatown loft among hundreds of paintings, his color-filled and silent monologue on perception's shift into sensation. Oli received little attention for his jazzy, visually witty works, despite the soulful certainty of them. No stranger to the New York art world, he understood its capricious, political, and mercurial nature and within it found himself an island of relative obscurity. Too experienced and self-aware to re-enter at the bottom and too proud to undersell himself, he cushioned his disappointment in a mix of self-righteous anger, ironic humor, and wisdom, but mostly he put it aside to begin a new series of paintings that were burning to become.

I was then thirty-seven years old and had recently left a respected gallery in New York that had supported my work with shows and sales for several years but within which I seemed to have become invisible. Seeking representation in some of the newer galleries, I discovered that although I believed myself to be a young artist, I was seen to be too old for a youth-driven art world. My track record had become a deficit in a community more interested in newsy firsts than developed vision. In my state of concern for the attention my career was missing, I was touched by Oli's tenacity and refusal to stay embittered by his own profound invisibility; moreover, I was moved by the sense I had in front of his bold new work that his maturity had linked with his very obscurity to create a force of determined invention that allowed him deeper access to his concerns. He was still working to resolve the two most basic concerns facing a contemporary painter: What to paint, and how to paint it. He was engaged in a debate upon issues of significance and quality.

I resolved, if the opportunity arose, to seek out for exhibition other mature artists for whom continuous self-invention served to keep their minds and spirits rising to a level of ever higher curiosity and rising as well above despair. I was interested in artists who were still working to not settle, still working not to look over their shoulders at missed opportunities, working not to repeat or copy themselves or mark time as their advanced age would, in the eyes of a generally pitying but effectively absen-

tee audience, so surely allow; simply still working to not give up working at the highest level of achievement,

Popular artists grow old in glory more or less deserved, while the unrecognized, if they are to ascend to their own demands, work very hard indeed. For an underappreciated artist, still working is a testimony to the power and primacy of art itself and a necessary hedge against deflation. Good artists, known or unknown, can't retire, they mustn't, for they remain professional, which means, among the artists in the exhibition this book accompanies, total dedication to substantiating quality and total personal investment for its own sake. The thirty-two artists in *Still Working* have earned their living from art; they have earned their keep wherever they could.

In 1990, nearly a decade after the concept for *Still Working* had been rooted in my mind, the opportunity to realize this exhibition arose in the form of the support and vision of two individuals: David C. Levy, then an enthusiastic and experimental administrator at Parsons School of Design in New York, where I have taught for the past twenty-six years, and Julien J. Studley, a courageous patron and active member of the board of trustees at the New School for Social Research, of which Parsons School of Design is a division.

David Levy and I first discussed my idea for *Still Working* in 1984. Mr. Studley, some time later, expressed interest in underwriting an exhibition similar in nature to the one I had described to David but without the age component. Introductions soon were made. Over months of discussion Mr. Studley came to share my conviction that artists throughout the country were quietly challenging beliefs about the effects of aging on creativity as well as overthrowing the misguided and bogus trust that provincialism had not been technologically dismantled. Mr. Studley was from the start eager to see the exhibition take a national form, and he became more and more interested in its potential as a tour rather than a single event. We agreed that such a show would fly in the face of the popularly held notion that little of artistic merit occurs west of the Hudson River or east of the San Andreas fault; we also agreed to collaborate on what we saw as a timely and necessary, albeit renegade, project. By 1991 the funds were in place to begin a wide-ranging search for artists who were for the most part unknown to me but who my every instinct told me could be found: artists over the age of sixty whose work would help provide a truer impression of the range and quality of American art at the end of this century.

Beginning in the fall of 1991 I traveled to cities throughout the country seeking little-known mature professional artists. It was a search made on recommendation only. I viewed no slides prior to studio visits as they serve only to distort. I also wanted to ensure, as much as possible, a spontaneous and unprejudiced live viewing of each artist's work. Artists were selected through a careful search of state arts councils and educational art facilities in the communities where hosting venues were sought, as well as through consultations with other artists, art historians, museum directors and curators, and commercial gallery personnel. Referrals by at least two art professionals independent of each other resulted in a studio visit. The work of hundreds of individuals was seen. Armed with lists and notes made in advance, I arrived in the cities

I had targeted, checked into a local hotel, and began to call on people. The resulting visits were candid and engaging; sometimes they were thrilling.

As the search developed, it became evident that there are questions that this project can make inroads into advancing, if not resolving: Does the condensation of means dictated by physical stress also provide urgency and declarative freshness that enriches the worker's enterprise? Do the strategies for materialization that characterize the work of older artists illuminate the creative process itself? Do the concessions and modifications of praxis yielding to physical deterioration simultaneously renew power and vision to the content in late work? How do an artist's late approaches provide systematic technical, narrative, and material freedom to the quality of expression that only time-informed practitioners can bring to their concerns? Questions also are raised about regionalism: the evolution of styles informed by local concerns and loyalties to developments that emerged in contraindication to received models and the media-driven obstinacy that makes them appear dominant.

Harry Rand, in his provocative essay in this volume, titled "The Uses of Obscurity," raises important issues concerning the very existence of provincialism in a society driven by electronic instant recall. The long held certainty sustained by high-stakes mythologizers of an outlying nether world with legions of misinformed and misguided practitioners whose very instincts are derailed by their cultural impoverishment has become, as this exhibition reveals, merely self-serving. Nonmainstream developments can no longer be dismissed as having no importance for the art viewing public. It is not true that artists not in the mainstream simply failed to get in the mainstream. In fact, regional developments, isolated lineage's, reconsidered positions, and late self-realization are authentic aspects of American art. Refusal to acknowledge careers developed and nourished outside of media-approved developments or politically correct associations is to refuse American art its integrity.

Much of the painting and sculpture made available to the public for delectation and study has been provided through art commerce, persuasions of fashion, or scholarly examinations of the past. In the first two instances, attention has been focused on young emerging artists; in the third, dead artists or those associated with critically defined epochs have been identified and acknowledged. Because of contemporary art trends, maturing artists find it difficult, if not impossible, to enter or re-enter public view in spite of their originality and present achievement. This skewed predicament provides America's public art institutions a unique opportunity to claim again the role of introducing artistic vision rather than serving as inheritors of a myopic and repetitious received view.

Ageism is probably the deepest rooted and most collectively practiced bias in America. Like racism and sexism, it denies humanity its humanness. To become old is anathema to Americans who will jeopardize both physical and mental wholeness and shatter the serenity that is earned in human maturation to protect the desperate pretense that it isn't really happening. We face maturity with dread. As a society we despise the old. Our misplaced pity erases the potential of the fastest growing and most experienced human force in the country.

Thus, the overarching linkage, the theme as it were, of *Still Working* is the very fiber of humanity's process. Aging is a process that, as it appears in art, brings to completely divergent principles and aspirations, constant factors of ease and poetry that serve each separate vision to its own resonance. The collective force represented by American artists of age must be seen as a major cultural energy. The contemporary work by artists who have matured and developed their individuality in different parts of the country, free of media attention, resounds America's greatest gift: the freedom of independence.

In a few cases these artists are virtually unknown. Some have luminous careers that are locally bound and known only to small regional audiences. Still others have had a historical presence but have not been viewed as contemporary practitioners. Collectively they reveal that remarkable bodies of mature, energetic, and challenging painting and sculpture are being realized throughout America by a segment of the population that, if considered at all, has been marginalized as a minority.

The people whose works are included in *Still Working* have lived through one if not two world wars. Most have survived with vivid memories the devastation during, and the fertile creative optimism that followed the great national economic depression. They have been attending to their art free of the pressures and compromises imposed by publicity, notoriety, and market attention and have measured their accomplishments by their work itself. Their art is the fruit of a process charged with urgency and self-realization. These artists did not, however, mature outside of the aesthetic developments of the twentieth century; in some cases, indeed, they were seminal to the configuration of those developments—as were David Slivka, Hans Burkhardt, and Carl Morris to Abstract Expressionism, or Sidney Gordin and Florence Pierce to the American reverberations of European structuralism and abstract transcendentalism. Frederick Hammersley was a pioneer in the development of nonobjective abstraction in California, and Claire Falkenstein is an important but underacknowledged inventor of new forms for sculpture rooted in automatism, Surrealism, and antimaterial experiments at precisely the moment that Jackson Pollock addressed the same issues.

These artists and others like them constitute a historical parallel to the mainstream. They are artists who have evolved not in accordance with fashion and opinion but in an independent lineage. Their accomplishments are of major importance to a full understanding of American art. *Still Working* serves to broaden the means by which the art of this century is viewed by including visions other than those stemming from adherence to doctrine or imposed critical groupings.

Unseen, rarely seen, or regionally bound visions produced by artists in the late phase of their creative lives constitute an important aspect of America's cultural heritage. These works help to provide a clearer scope through which a view of that heritage may be regarded. There is, in the elastic title of this book and exhibition, an admonition to the cultural superstructure to look again because in that look resides the real appearance of American art, rich in sources, inventive and free, wild in the utilization of style and aesthetic paradigms, wise and wide ranging, and above all accessible and profound as a sharing of deep personal vision. The artworks them-

selves, like the artists who produced them, are "still working" as cultural entities, whether watched or unwatched but all the more illuminating when watched. Art students especially must take this opportunity to study the work of serious professional artists the age of their grandparents and great-grandparents who are deeply committed to their creativity, not merely to a hurried effort to enter the limelight, and are accomplishing outstanding work in their studios. Art making must be recognized by the aspiring young artist to be a long and life-affirming undertaking so that perhaps he or she too may cherish a slow career.

*Still Working* begins a process of correcting a narrow view and limiting standard that have been too long applied to the art of this century and brings into light a collective national treasure.

## a scale in may

Now all my teachers are dead except silence
I am trying to read what the five poplars are writing
On the void

Of all the beasts to man alone death brings justice
But I desire
To kneel in a doorway empty except for the song

Who made time provided also its fools
Strapped in watches and with ballots for their choices
Crossing the frontiers of invisible kingdoms

To succeed consider what is as though it were past

Deem yourself inevitable and take credit for it
If you find you no longer believe enlarge the temple

Through the day the nameless stars keep passing the door
That have come all that way out of death
Without questions

The walls of light shudder and an owl wakes in the heart
I cannot call upon words
The sun goes away to set elsewhere

Before nightfall colorless petals blow under the door
And the shadows
Recall their ancestors in the house beyond death

At the end of its procession through the stone
Falling
The water remembers to laugh

**W. S. Merwin**

*ernest acker-gherardino*
**born 1924 kingston, new york**
**lives and works in new york, new york**

*i* CALL MY UNALTERED FOUND JUNK PIECES 'DUMP WORKS.' Dump Works would have no significance whatever were it not for the fact of their existence side-by-side with their opposites: advanced technologies. In the Middle Ages, for example, one would have paid no attention to them at all. Destruction and decay are a condition of our push now to penetrate nature and use it. For every object upon which man has laid his hand to twist it to his own unearthly desires there are countless wasted things that he has used up and abandoned: vastly more beautiful than anything he could create, full of pathos and repose. E.A.-G.

Ernest Acker-Gherardino explores materials discarded by an advancing technology for their sculptural potential. His achievement stems from his acuity for choice and his empathic response to his unaltered finds. Crushed sheet metal, rusted machinery, and splintered boards cook in the weather on his sun deck above the Upper West Side of Manhattan until their elemental patina has given each castaway sufficient character to permit its inclusion in an assemblage, or more miraculously its reclamation, unchanged, as a self-declared finished work of art.

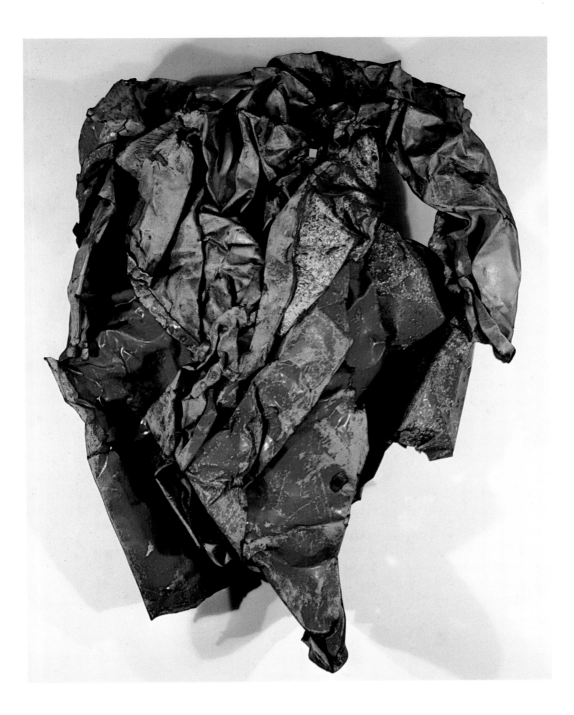

fig. 1. ernest acker-gherardino, *cloak of homelessness,* 1990, found crushed metal,
44 x 29 x 20 inches (111.8 x 73.7 x 59.8 cm). collection of the artist.

**born 1906 edmonds, washington**
**lives and works in la conner, washington**

*i* SENSE PREORDAINED ORDER IN THE UNIVERSE. WITHIN THE preparation over billions of years of the great solar system in which we live and love and disobey, we are reminded by the magic around us of the creation of the sea, the light, the wind, the rain, and the first amoebic stirrings that developed into the myriad rich and profound manifestations we are submerged in. Occasionally we are so much impressed by a hint of the magic that we try to express it in the best and the highest form we can—through song, or works, or painting, drawing, and sculpture; or the making of some exquisite small form of beauty as a gesture. If we remain impressed enough, we desire to do something of a deeper aesthetic nature.

Whether the condition of the world in its light and dark hours changes greatly for the enlightenment of man, he still is a night swimmer among its mysteries. For many years when asked what I most hope to achieve in paintings, my response has not changed: I hope to use the human figure symbolically. G.A.

Guy Anderson has lived in the small fishing village of La Conner, Washington, at the mouth of the Skagit River, since 1960. He chose isolation for the freedom from fashion it provided. Anderson removed himself from the notoriety that followed a 1953 *Life* magazine article in which he was linked to an indigenous northern Pacific style. In the company of Kenneth Callahan, Morris Graves, and Mark Tobey, Anderson has been identified as a "Mystic Painter of the Northwest." These artists shared a deep regard for and knowledge of the spiritual discipline and transcendentalism of Asian philosophies. They found a natural parallel to ancient thought and poetry in the spell of the Pacific Northwest landscape. As a group they turned away from the violent and erratic gestures of Eurocentric New York School abstraction and toward the inherently symbolic vocabulary to be found in the art of the East. Anderson rejected Tobey's "white writing" approach, seeking, instead, a bountiful pictographic synchronicity of image and material that could be arrested from narration.

Steeped in the symbolically familiar, Anderson continues in a broadly calligraphic style to produce timeless images of humankind as mythic dream travelers amid the unfathomable energy and mystery of the universe. Motifs that tug at the unconscious often borrowed from the Kwakiutl, Tlingit, and Haida people identify the authority of a unified cosmos. He shuns both total abstraction and narrative figuration to provide a symbolic view of humanity fused to the calamitous metabolism of the universe—an element materially united with earth, air, fire, and water.

fig. 2. guy anderson, *the seeding,* 1986, oil on reinforced paper, 98 x 74 inches (248.9 x 188.0 cm). galleria dei gratia, la conner, washington.

*robert barnes*

**born 1934 washington, d.c.**
**lives and works in bloomington, indiana**

*I*N HIS REVIEW OF MY FIRST NEW YORK EXHIBITION IN 1958, LARRY Campbell wrote of my work, 'Its strange and interesting incoherence seems to come from an attempt by the painter to combine several irreconcilable attitudes.' At the time I wasn't sure this was a criticism or a backhanded compliment. Now, thirty-six years later, I see that Campbell sensed something that took me many years to realize the depth of a painting is based in oppositions. Some might say 'contrasts,' but I like the harshness implied by opposites. I keep two large magnets in my studio. I like to place them so they snap together in attraction and then reverse the polarity and feel the power of their resistance. This always reassures me and teaches me something about painting. I like resistance, contentiousness, and battle. I miss dragons, crusades, and ordeals; painting takes their place.

"I think of myself as an abstract painter. This is not so surprising since most painters realize that it is through the abstraction that the meaning of a painting is 'telegraphed'. I consider touch, which becomes 'surface,' to be the most intimate and important single element in painting.

"Only time runs in an unbroken line—always forward, and yet even time is subjected to the control of whim. I used to think that process echoed this flow and was the only true metaphor in painting. Well this got me into a lot of trouble because if this conceit were taken seriously I could never conclude a painting. Besides, it isn't the business of art to mimic life or nature. Its business is to be those things. At any rate, I've learned to accept conclusion and along with it the concept of the 'flaw,' which is also imperative to a work of art. Flaws can't be 'put' into a painting but have to occur as a elemental process.

The title of this exhibition, *Still Working*, amuses and annoys me. It implies surprise that we are still working and that at the waning of the terrible hormonal surge that propels the young headlong into all sorts of wonderful absurdities the painter's palsied hand slows, the mind and eyes dull, and resignation takes over. Well I've got news for you; I didn't begin to sense the real power of this thing until I reached fifty. The secret is in the pursuit and that's different from just 'still working.' R.B.

Robert Barnes is the youngest artist in *Still Working*; he turns sixty just after the show opens. He has been an important figure in American painting since his work first appeared in the 1950s. Because of the relatively few works he completes and the complex iconography he employs, his work, prized by a devoted audience of collectors and connoisseurs, receives little of the public attention it deserves. Barnes's paintings are allegorical, autobiographical, and mythic. Freud and Joyce, his rich Scots heritage, and personal experiences provide sources for codification and pictorial strategies. Dense as they become, the works do not demand decoding. Each is brought to a pitch that is answerable only to the best of painting. They embrace complexity without denying entry or complicating the vehicle's discourse. Barnes adores the calling of stories without insisting on their being unraveled.

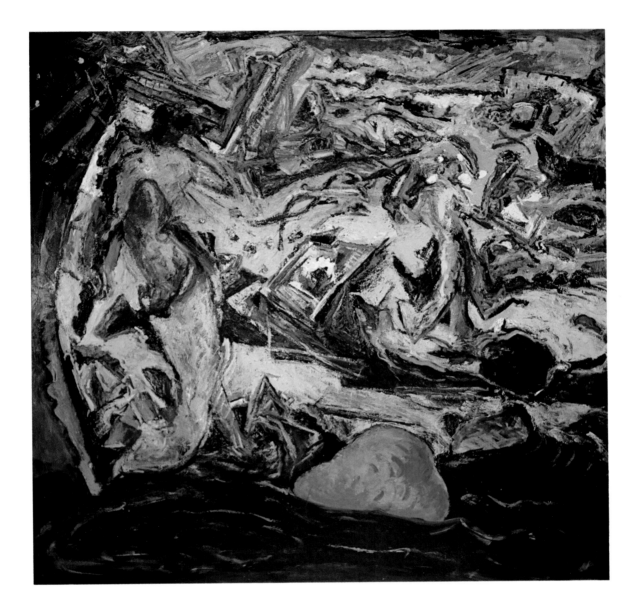

fig. 3. robert barnes, *ludlow silkie,* 1987, oil on canvas,
86 x 86 inches (218.4 x 218.4 cm). struve gallery, chicago.

*don baum*

**born 1922 eescanaba, michigan
lives and works in chicago, illinois**

Y MOST RECENT WORK, A SERIES OF THREE-DIMENSIONAL PORTRAITS, is conceived in much the same way as most of my work. These works depict people I know but are deliberately titled with names of mythological figures in order to exploit the total effect of the legend associated with the name. The materials are found materials that have largely come into my possession from thrift shops and similar sources. It is important to me that my materials have had a previous life in one way or another, i.e., paint-by-numbers paintings, which emerged from an impulse of the producer to express himself visually and to 'make art.' This patina of use and age has been an important one for a very long time. In general, I do not have a preconception but find my solutions in the process. The form the work takes gradually comes about as I construct it, and ultimately they are concluded when they 'feel' right. D.B.

Don Baum has been a ubiquitous figure on the Chicago art scene for decades. He is a highly regarded painter/sculptor/assemblagist as well as a seminal figure in the establishment of the careers of numerous younger artists in Chicago. As a curator, collector, and early champion of Imagist and Outsider art, he helped advance the regional style for which Chicago is best known. The appearance of the wacky tongue-in-cheek humanism with which the art of the crystal city on the lake has become synonymous is to a great degree indebted to the singular efforts of Don Baum.

Baum continues to discreetly sustain his own work at a high level of unpredictability and joy. Seeking significance in a wide range of formulations, he explores playful representation, construction, and figuration. He creates beguiling portrait silhouettes cut from preexisting found paint-by-number paintings that he combines with miniaturized architectural elements and serves up on distressed thrift shop breadboards. He is also the architect and builder of enchanting houses fabricated to his own poetic specifications out of recycled images and discarded memories.

fig. 4. don baum, *odysseus,* 1992, oil on canvasboard and wooden cutting board, 20 x 17 1/2 x 9 inches
(50.8 x 44.5 x 22.9 cm). betsy rosenfield gallery, chicago.

*miriam beerman*

**born 1923 providence, rhode island**
**lives and works in montclair, new jersey**

*t*HE TERM 'BRUTAL FIGURE' REFERS TO BOTH THE PHYSICALLY AND psychically brutalized. Even though visual ideas are outside the realm of words, certain key words continually come to mind as themes: metamorphosis, grotesque, demonic, comic. Ideas of morality, such as good and evil, which have dominated art for centuries, are also part of my concerns. However, much remains purposefully vague and open to interpretation. I hope that my work will be multidimensional in its final assessment.

My paintings and other works reflect larger mythological ideas that go beyond a specific sense of time. Symbolic suggestions in the imagery are both ancient and modern. I am a painter of animals as well as people. From a psychological point of view, animals are symbolic denizens of the collective unconscious. They bring into the field of consciousness a special chthonic (underworld) message. I pursue my kind of intuition while looking for ways to describe desires, dreams, pain, and pleasure; reflections of my own anonymous self; part animal, part transcendent being.

My medium is oil and oil stick on canvas, or oil pastel, chalk, and acrylic on paper, and I am very involved in marrying the medium to the image. The paint is often rough and thick. In recent paintings as well as drawings my love for the heavy layers of meaning has brought me to use the technique of collage. By its use I hope to achieve a greater dimensionality in the physical as well as spiritual sense. M.B.

Miriam Beerman creates an array of visceral imaginings that call to the nightmare demons of personal loss and longing. Her paintings serve to purge memory of its occupants and locales. Beerman is, at her best, an unbridled expressionist. Her powerful oil paintings and collages align with Goya and Francis Bacon to make us painfully aware of how close out of view madness resides.

fig. 5. miriam beerman, *december (in memory)*, 1992, oil, oilstick, and collage on canvas, 74 x 79 inches (188.0 x 200.7 cm). collection of the artist.

*jack boul*

**born 1927 brooklyn, new york
lives and works in bathesda, maryland**

*i* AM INTERESTED IN THE FIRST IMPRESSION, THE LARGE MASSES YOU SEE when your eyes are half open, before the details get in the way. I am interested in the way shapes merge. I am interested in what information you take from life and how you translate it in plastic terms on a flat surface. I am interested in color before it becomes a rendered thing. I am interested in how the canvas is divided, how you enter and move around, how you turn the corners in a painting. I am interested in the gesture of things, how they lean, or stand, or sit. I am interested in painting that which cannot be explained with words. J.B.

Jack Boul works in a seamless tradition with Constable, Corot, Millet, Rousseau, and the artists of the Barbizon School. The metaphysical landscapists Albert Pinkham Ryder and George Inness are inspirations as are the nineteenth-century Macchiaiolli. Boul is an anachronism and a visionary; the direction he faces is subject enough. Asked what makes his work modern he says some of the paintings have telephone poles in them. His interest is in a personal connection to the unchanging. Boul's paintings are small, exquisitely realized, and totally unselfconscious reflections upon his surroundings in rural Maryland where he works to identify with the deepest meaning in their order.

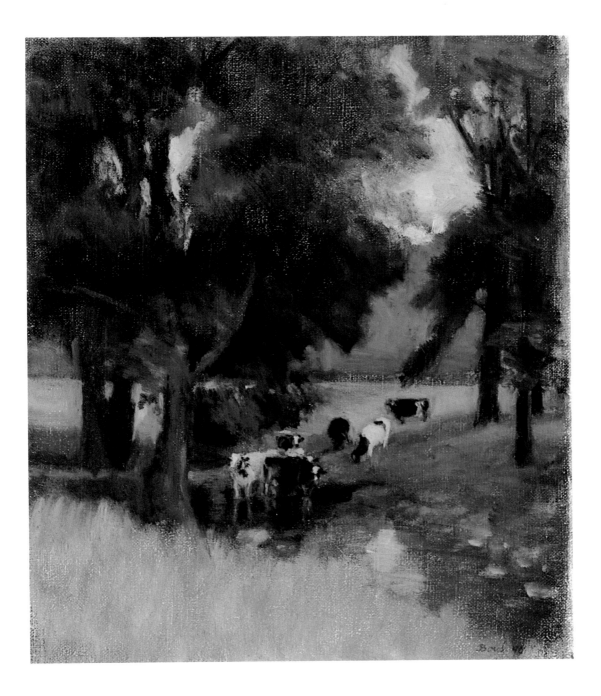

fig. 6. jack boul, *cows in a gulley*, 1992, oil on canvas,
9 x 11 inches (22.9 x 27.9 cm). e. van houten, alexandria, virginia.

*morton c. bradley, jr.*

**born 1912 arlington, massachusetts**
**lives and works in arlington, massachusetts**

Y SCULPTURES ARE BASED ON THE REGULAR POLYHEDRON BECAUSE of the perfection of its form, the complexity and variety with which it can be developed, and the logic with which it can be colored. M.C.B.

Morton Bradley's kinetic constructions are developed from his enormous knowledge of Munsell's theories of color and value combined with an engaging intuition for the fascinating extensions of platonic solids into myriad rotations and complexities. He is seeking the most nearly perfect integration of color and form possible in calculable construction. Bradley employs a number of highly skilled craftspeople to aid in the realization of his wonder-filled geometric fantasies, often begun with a meditation upon a simple pattern in a fold of drapery in a Giotto or a border of Moroccan tile.

Fig. 7. morton c. bradley, jr., *festival,* 1988, steel rod,
diameter: 46 1/2 inches (118.1 cm). collection of the artist.

*mala breuer*

**born 1927 oakland, california**
**lives and works in abiquiu, new mexico**

OUL NEVER REMAINS IN ONE STATE BUT EVERYTHING IS ASCENT AND Descent.—St. John of the Cross

My painting is about being formed from formlessness building form spontaneously intuitively metaphorically within a given structure of linear tension abstracted from everything implicating everything within my vision. M.B.

Mala Breuer creates cool screens of latticed brushstrokes that tangle the surfaces of her refined abstractions. Working in the desert, she strives to replicate the light and spirit of her primordial surroundings. Alert to her own scale and emotional disposition, the calligraphy that is her signature motif veils a vertical registry that guides its path. Color is limited but naturalistic and radiant; even the blacks glow. Reverence for her locale is combined with an intuitive sense of condensed grandeur to give Breuer's work the paradoxical alchemy of the abstract picturesque shared by Agnes Martin, who also chose New Mexico for her late inspiration, and Clyfford Still, who was Breuer's teacher and mentor in San Francisco.

fig. 8. mala breuer, *untitled*, 1992, oil and wax on canvas,
72 x 72 inches (182.9 x 182.9 cm). collection of the artist.

**born 1904 basel, switzerland**
**died 1994 los angeles, california**

 HEN I WAS A CHILD IN BASEL I WOULD GO TO THE MUSEUM WHERE I was most affected by the paintings of Boecklin, Grünewald, and Hodler. These paintings have stayed with me all these years. In the mid-1920s I came to America where I met Arshile Gorky and was introduced to abstract art. I shared his studio for quite a number of years before coming to Los Angeles in 1937. Since then some of my good friends have been artists—Mark Tobey, Irving Block, Raphael Soyer, Lorser Feitelson, among others. They all worked in different styles and somehow never influenced my work.

My ideas for painting come from nature: the figure, landscapes, tortured nails or rusty wires of a city dump, the happy play as well as the sad faces of children, the seeds of a tree falling on the grave of the unknown. And from social and political upheaval. I have to make a painting the moment something happens; I cannot go back to a subject years later with the same power. Look how the world has changed in fifty years. You can't do one painting and make the same thing over and over.

I always prepare my own canvases by hand: stretch, glue, size, and otherwise prepare the surface before I paint. There is a certain honor in making something with quality.

I feel whenever I accomplish something that I have to be satisfied, even if it doesn't please anyone else. I paint the way I live. H.B.

Hans Burkhardt engages his spontaneous response to paint charged with allegiance to personal angst in a marriage to his deep concerns for a world at war with itself and the people who are its casualties. Displaced from the epicenter of the New York School by his choice of Los Angeles as his home, Burkhardt was neglected as an originator. The primary tenets of Action painting exclude conventional narration, while Burkhardt's canvases exploit the power of image as a direct mediator between the conscious mind and the unconscious. Though of the same generation as the artists of the New York School, Burkhardt employs painting as an idiom for social testimony that is passionate and visceral, common and arcane. His inventiveness, immediacy, intensity, extraordinary paint handling, and complex conception put him among the best-known painters of the formative years of abstract painting in America. Hans Burkhardt's uses of painting, his discrete temperament, a refusal to compromise his specialness, and a penchant for solitude have kept him on the outside.

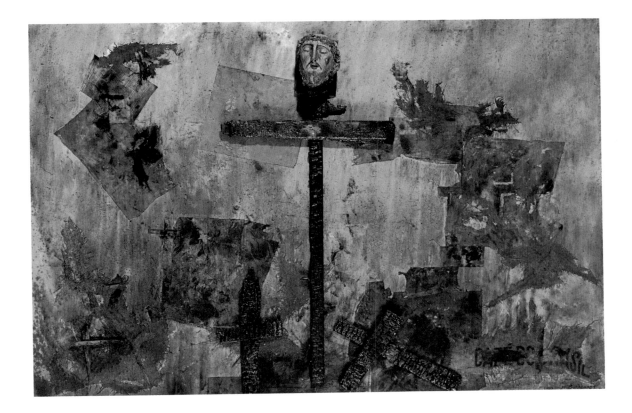

fig. 9. hans burkhardt, *black rain*, 1993, oil and mixed media on canvas,
66 x 96 inches (167.6 x 243.8 cm). jack rutberg fine arts, los angeles.

*martin canin*

**born 1927 brooklyn, new york**
**lives and works in rhinebeck, new york**

*t*O BE CONCISE IN ART IS BOTH NECESSARY AND ELEGANT.—EDOUARD MANET

My work has gone through many changes in the more than forty years that I have been painting, and Manet's statement still resonates for me. Luminosity is still the goal, oil paint on canvas still the preferred medium, shape and color still the plastic means to speak my particular expression. M.C.

Martin Canin paints in a pristine studio that he has converted from a pole barn in upstate New York. The subject of his paintings has always been color. Ethereal phantom of expression, color is painting's fragrance. Fused to shapes measured toward resonant singularity, the ambient force of color kept pure summons memory to engage emotion. Canin, never satisfied in adopting a serial format as did the Color Field painters and the Washington Color School of the 1960s, and suspicious of their leviathan scale, trusts instead his patient sensibility to follow the persuasions of the colors insistence to bring him to the optimum structure for the dramatic terms of each composition. In this regard, Piet Mondrian's tough-minded religiosity serves as his primary model. The measured elegance and deep luminescence of his recent shaped paintings recall the candlelit compositions of Georges de La Tour. Binding form and matter to spirit is Canin's constant goal, and when it is achieved a silent mirror remains.

fig. 10. martin canin, *untitled*, 1993, oil on canvas,
54 1/2 x 93 inches (138.4 x 236.2 cm). collection of the artist.

*constance teander cohen*

**born 1921 des moines, iowa**
**lives and works in evanston, illinois**

*i* AM CONSTANTLY GRATEFUL TO ARTISTS WHOSE WORK HAS LET ME know about other times and places. The works of antiquity and prehistory have always been very moving to me. I do not know quite how this is reflected in my own work. When I make a painting I try to bring into reality what already exists quite clearly in my mind. This is not an idea for a painting but the painting envisioned as it must become. I am evermore aware that painting is a lifelong companion that is always with me. C.T.C.

Constance Cohen's brittle narrations are poems as much as pictures of womanhood. Her paintings each stop short of extras; each is achieved in the spare and fragile voice of a storyteller well acquainted with desire and the serendipitous occasions of circumstance. Cohen's symbolism is domestic to be sure, but it swells from a place full of curiosity, delicacy, and wonder at being alive. With gentle urgency, she speaks of having lived, born children, watched them leave, dreamed, and realized that dreaming itself is realization enough. The material of Cohen's paintings are the occasions, circumstances, desires, and serendipity of her life. She paints when she has a story to tell.

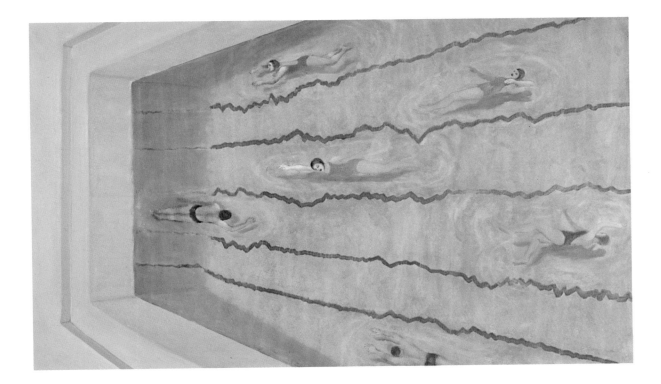

fig. 11. constance teander cohen, *swimmers*, 1982, oil on canvas,
32 x 52 inches (81.3 x 132.1 cm). jan cicero gallery, chicago.

*sherman drexler*

**born 1925 new york, new york
lives and works in newark, new jersey**

SOMETIME IN THE MID-1960S, WHILE MY WIFE AND I WERE PACKING FOR a trip to Europe, we received an unexpected visit from Andy Warhol and entourage, to, as he explained, help us pack 'light' for our trip. Noticing my work, which he was seeing for the first time, he said, 'Oh wow! I didn't know you did these, these paintings of female figures . . . these nudes! Where did you get the idea?' I was unable to answer.

As a kid I drew deep sea divers, dirigibles, fighting planes, sharks, and baseball players. But as I grew older the unadorned human figure caught my attention. I now spend time picking up discarded stones, rocks, and blocks of concrete, looking for pictures that are hidden in their coarse surfaces. My medium includes charcoal, acrylic, and oil. I dream of Lascaux, Pompeii, Egypt, Africa, Rodin, Ryder, Giacometti, and Giotto.

My figures stand, crouch, lunge, dodge, dance, wrestle, rise, and fall. They inhabit their space as if they had always been there. They are elegiac offerings—the latent heroism of the human gesture fuels my work. I don't know where I got the idea. S.D.

Sherman Drexler has puzzled over the significance of the female nude as a metaphor in art throughout his career. His most recent musings achieve a beguiling and mesmerizing level. Fragments of found material—stones, concrete, wood, and metal bits, indeed, any object that strikes his eye as holding or hiding a figure or animal within it—are worked with paint and charcoal until the visions they contain are given presence. Hundreds of objects propel nude figures, some alone, or in groups, some accompanied by tiny horses or birds into a universe of myriad and unexpected predicaments. Drexler brings to a scholar's meditation a mad hatter's compulsiveness and an obsession for discards. The sheer number of his works provokes uncertainty about the identities produced by his salvaged reality as he elevates detritus to the lair of goddesses and his crammed Newark, New Jersey, studio to a place of myth.

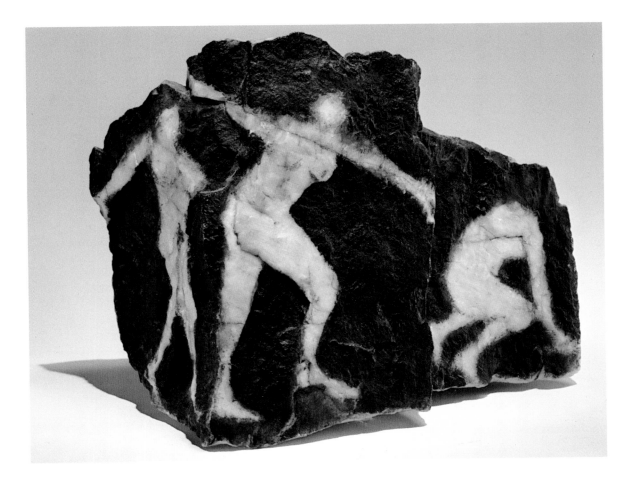

fig. 12. sherman drexler, *three grand figures,* 1994, acrylic on marble,
6 1/2 x 7 1/2 x 3 1/4 inches (16.5 x 19.1 x 8.3 cm). collection of the artist.

*edward dugmore*

**born 1915 hartford, connecticut**
**lives and works in minneapolis, minnesota**

T TIMES WHEN I AM PAINTING I SEEM TO BE MINDLESS AND BODILESS, but everything seems normal to me. Once I am functioning perfectly and the painting is (being) what I want it to be, it seems to become itself by its own volition. There is no struggling anymore, it just becomes. I am astounded as to how it becomes that way. I feel elated and I am lifted out of myself and suddenly realize that I am looking out finally at myself looking in. I know then that it is finished and I am not disembodied, and I am one with myself again. My thoughts are back on another plane, I am released from myself. It is the highest point in my work. All that has taken place is something that I have perceived before and has always been there. I have unlocked that door. I see each canvas as a door and gradually I realize that the door is open and I am allowed inside. I'm elated! Whatever has taken place seems not to (have happened), and I then find myself standing again outside looking in, and it is the same. E.D.

Edward Dugmore was an early student of Clyfford Still. Like Still, he has sought the barest means to maximize the emotionality of his painting. His works address the sublime scale of an internal landscape achieved in scumbled divisions and abbreviated strokes. The surfaces, painted, then washed clean of his hand-ground pigments, are divided then reunified through application of paint in lacy veils, worked over and over again until a resonant sonority is achieved. Dugmore is an existential practitioner whose works, when completed, bear testament to his faith in painting itself.

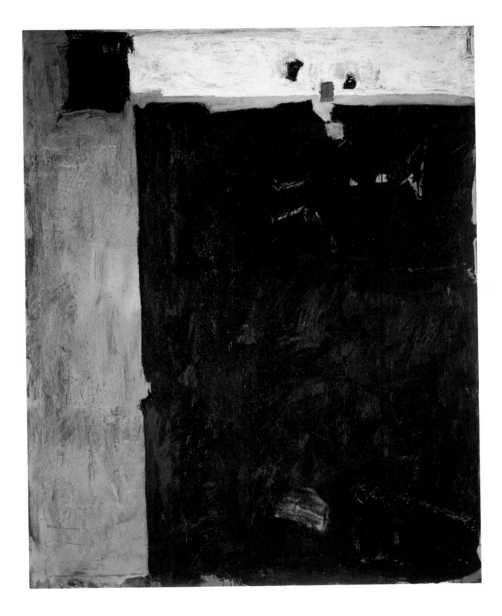

fig. 13. edward dugmore, *guad quartet* 132, 1984, oil on canvas,
84 x 65 inches (213.4 x 165.1 cm). manny silverman gallery, los angeles.

*roberto estopinan*

**born 1921 havana, cuba**
**lives and works in woodside, new york**

RT IS A DIVINE ACCUMULATION OF THE HUMAN SOUL, WHERE MEN OF all ages and races recognize themselves, but there has to be vocation and there has to be devotion to beauty. It is significant that all civilizations have had creative men, men who have produced art. A work of art lives more in the heart of humanity than a great battle.

We have examples of this in America: the Mayas with their marvelous palaces of stone in Peten, Uxmal, Tikal, Copan, and Palenque, with their incredible paintings and notable hieroglyphics; the murals of Bonampak of Uaxactun in the Yucatán; the extraordinary Nazca culture south of the Rio Grande, Tiahuanaco in the Meseta, the Tahuantunsuyo in Chile. We should stop looking constantly to the Parthenon, we should stop studying the art of Greece; place our eyes on our America.

The artist has to create the air of the soul in art, he has to throw to the outside what flourishes in his head and heart. The bones of the artists compost the land that covers them. I expect that in the not too distant future we will find answers to our deep artistic question in our incredible and unknown America.

We will find our roots in the extraordinary ruins of the Maya and Inca cultures. It is unquestionable that these ruins of our peoples express the soul of things, the realization of an encounter yet to be explored. R.E.

Roberto Estopinan came to the United States from Havana, Cuba, in 1961. He was by then a respected sculptor and a well-regarded political voice for the Cuban people. Nourished by the accomplishments of Henry Moore and Constantin Brancusi, he became highly skilled in traditional methods of carving and casting, and has been widely acknowledged as a master of his craft. He has served as cultural attaché to the Cuban Embassy and headed the first cultural mission from the Americas to visit mainland China.

While his reputation was achieved as a sculptor, it is in the rubbed sepia and earth red of Estopinan's recent conté crayon drawings that he has evolved an astonishing language of form. His ingenuity for material application has given etherealized presence to his recurring theme of female torsos and evokes the intangible poetry of femininity. In Estopinan's new drawings, his means dissolve in the realization of an erotically suffused spirit charged with breath and held in metallic grace, at once wind and rock.

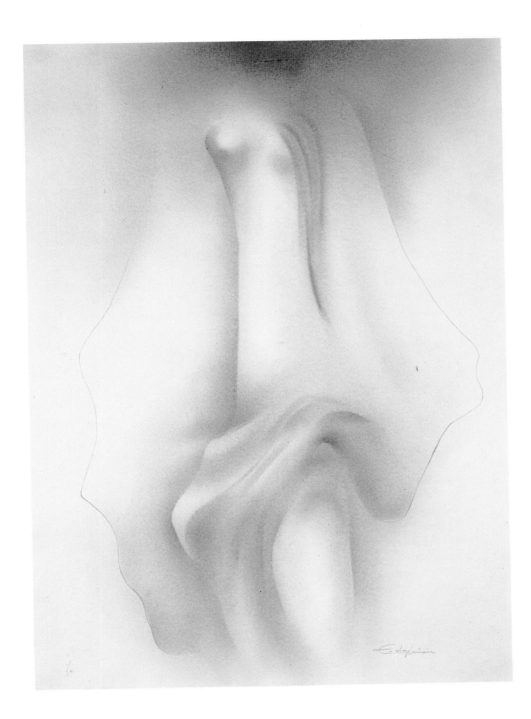

fig. 14. roberto estopinan, *camille claudel series: torso #1,* 1992, pastel and graphite on paper, 28 x 20 inches (71.1 x 50.8 cm). collection of the artist.

*claire falkenstein*

**born 1908 coos bay, oregon**
**lives and works in venice, california**

CATACLYSMIC CHANGES IN ACCELERATION OCCURRING IN LIFE TODAY parallel an ever more penetrating knowledge of our planet Earth within the totality of cosmic forces. The Euclidean world of one visual center on the picture plane in contracting space has become the decentralized space of relativity. Moving focal points without number relate to moving observers in our contemporary world of expansion. C.F.

Claire Falkenstein is painting allegorically now. She has brought to her paintings the light and space of her more familiar latticed glass and steel tangles by allowing blank canvas to permeate the compositions. The opalescence of the glass slags that slowed the course of her twisted lines of metal has relaxed into scumbled maps of earth tones. Occupied by stylized horses, maidens, satyrs, centaurs, gods, and men, they infer fairy tales and morality plays. Figures teeter in shifting imbalance, recalling her earlier sculptural work. It is intriguing that Falkenstein, in her ninth decade, allows so gamesome a narration to carry the themes she suggested but restrained in her abstract sculpture. The new work is winsome and wise. It is free of dialectical responsibility and possesses a youthfulness that delights.

Judged by her originality, creative courage, formal inventiveness, and prophetic accomplishment, Falkenstein stands with Barbara Hepworth, Louise Nevelson, and Louise Bourgeois as a grande dame of modern sculpture. That Jackson Pollock's mature style is not seen to parallel Falkenstein's use of automatic writing and deployment of chance beginning as early as 1944, exposes the silly and self-serving perpetuation of a single-bullet theory of modernism. That she is not recognized as a progenitor of the antiformalism of the 1970s and 1980s attests to convenient and myopic selective amnesia in recent accounts of American art. Falkenstein continues to search. Her art will not keep the defining edges neat. Her new paintings, while leaning heavily on historical and literary references, as well as recent events in Los Angeles, are a radical departure. Playful and outrageous, they are the fruit of an earned acceptance of personal autonomy. She is at the watering hole of her own faith.

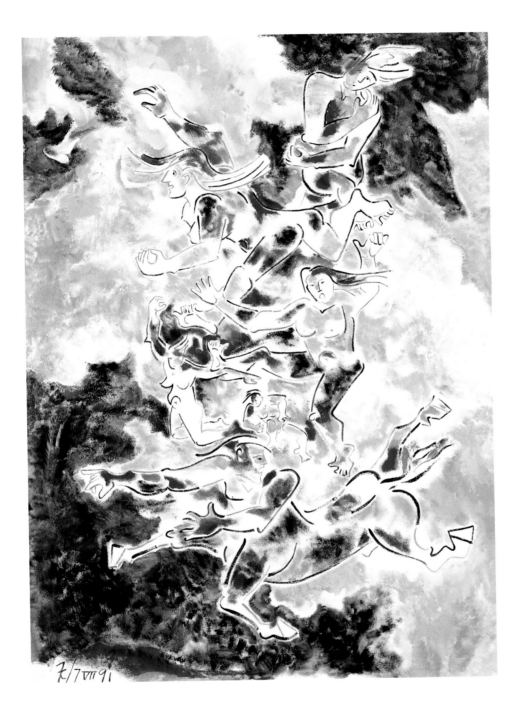

fig. 15. claire falkenstein, *tower of nymphs,* 1991, acrylic on canvas,
78 x 54 inches (198.1 x 137.2 cm). collection of the artist.

*sidney gordin*

**born 1918 cheliabinsk, russia**
**lives and works in berkeley, california**

HEN I FIRST AWAKENED TO ART AS A TEENAGER IN THE 1930S, IT WAS Picasso, Cézanne, and the Cubists who revealed to me the mystery and urgency of aesthetic experience and helped me find myself. Inspired by their beautiful work, form became my subject matter and has remained so ever since. For the past sixty years I have been exploring the infinite aesthetic possibilities of shapes and colors in space. S.G.

Sidney Gordin has dedicated himself to structural abstraction since the early 1940s, when he became involved with the American Abstract Artists group in New York. Gordin began work as a painter but turned to sculpture in the 1950s and built a substantial reputation as an accomplished inventor in the neoplastic tradition of the European De Stijl artists.

In 1988 Gordin returned to painting. He is evolving a body of provocatively clear and sensual abstractions in which line's velocity careens through maps of buoyant color. His brilliant new paintings evidence an artist boldly rejuvenating himself by reinventing his goals and reviving wonder late in a quietly luminous career.

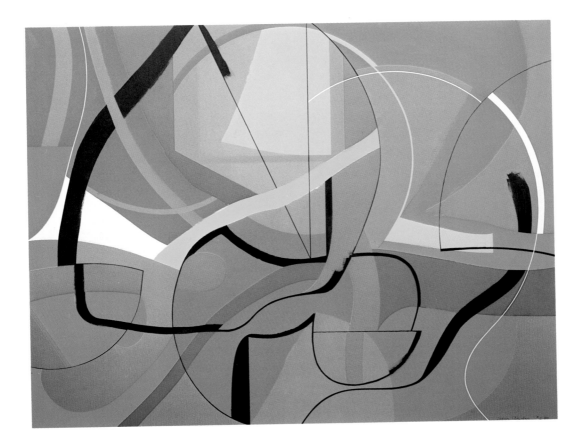

fig. 16. sidney gordin, *#2.89,* 1989, acrylic on birch plywood,
48 x 60 inches (121.9 x 152.4 cm). gallery paule anglim, san francisco.

**born 1919 salt lake city, utah
lives and works in albuquerque, new mexico**

*t*HE LAST TWO YEARS AT JEPSONS [LATE 1940S, JEPSON ART SCHOOL in Los Angeles] I began a series of experiments, first with color, then with black and white. This led me to nonobjective painting, by accident, by hunch. It was a process of painting shapes as they were 'seen.' Paint would be squeezed onto a palette knife and applied to the canvas, no planning, no drawing . . . it was like a dare. Here I discovered the logic of feeling. Nothing was done unless it felt right. There were no corrections—not needed—and, when the last shape went in, it was done. . . . This 'hunch' series was usually composed of many shapes. Then a change occurred—fewer elements. I'd see part of, or the entire painting, in my mind's eye. When that happened, I'd draw it in a book, color it, and wait. When both of us were ready I'd paint it. That system was used for all the hard-edge works. The small nongeometric, organic paintings are done by thinking out loud with a piece of vine charcoal . . . draw, look, erase, draw and erase many times until an image would occur that I'd never seen before but which I 'knew'—a marvelous feeling. I'd wait until color would come, then paint. I think what I've been doing all this while is talking about the center of me, about being alive. When I get there I know it. And, when I get there I like to think it has something in common with the one who looks at it. You see something of yourself. F.H.

Frederick Hammersley is one of four Los Angeles–based painters to surface in the late 1950s under the rubric "Los Angeles Abstract Classicism." Along with Lorser Feitelson, Carl Benjamin, and John McLaughlin, Hammersley developed a spare geometric style filled with light and steeped in a contemplative Eastern tradition. Hammersley has since moved to New Mexico, where he paints spellbinding organic abstractions on a Precisionist's scale. His new works have the double-edged playfulness of Joan Miró and the minor key magnitude of Arthur Dove, but they are resolutely original in their suggestive symbolism and the poetry of their tender relationships.

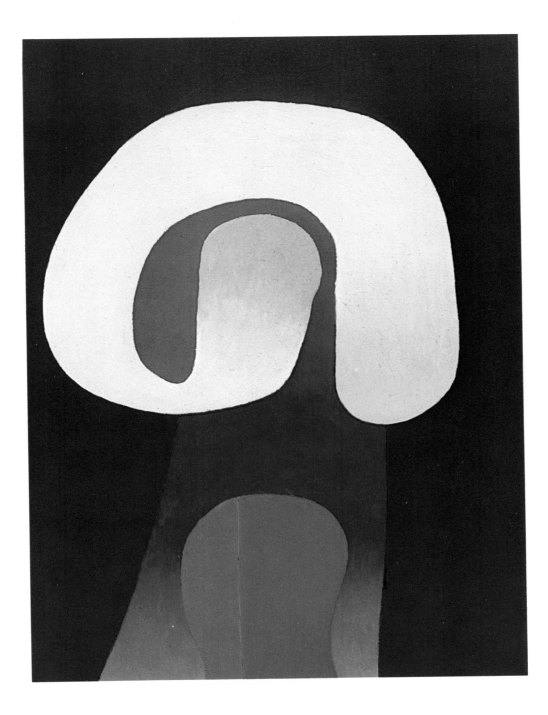

fig. 17. frederick hammersley, *final word*, 1988, oil on linen mounted on masonite,
12 x 9 inches (30.5 x 22.9 cm). collection of the artist.

**born 1922 ellenville, new york**
**lives and works in san francisco, california**

*i*M HAVING A DIFFICULT TIME DEFINING MY ARTISTIC AESTHETIC. EVERY time I write something down, it sounds like bullshit. About my painting—I like to do it. I need to do it. I keep at it. The work has meaning to me and some percentage of it may speak to others. J.H.

Julius Hatofsky's large semiabstract oil paintings are rich and wild. Explosive spaces resonate with clamorous urgency as his personal myths and private legends are told with meanderings of viscous and primary pigment. Forms dash through dangerous spaces figures and twisters fight for the same place. A tale is woven in each it seems, yet the fragmented dream space and interface of sky and fire, land and sea, figures and plants, refuse to be pinned to narration. Hatofsky's imagination will not leave appearances behind; fantasy and formality are juicy handmaidens in his blown-up vision.

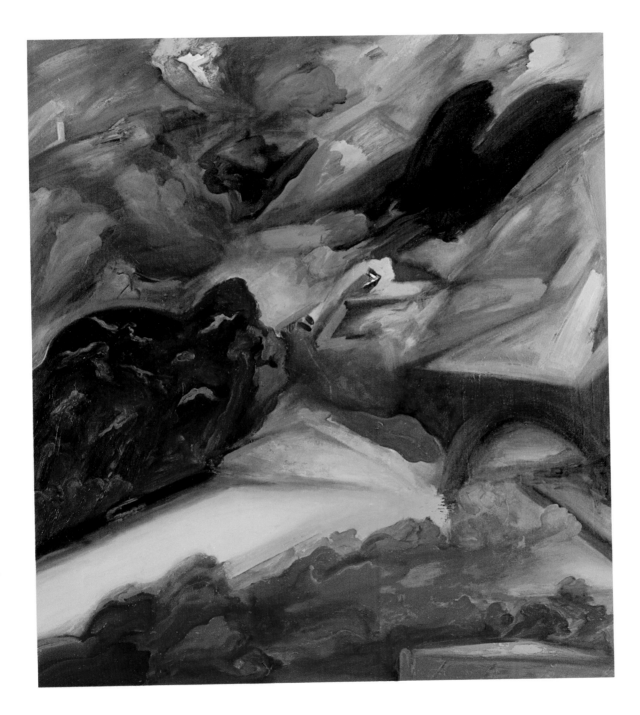

fig. 18. julius hatofsky, *untitled dream fragment*, 1991,
oil on canvas, 80 x 68 inches (203.2 x 172.7 cm). collection of the artist.

*felrath hines*

**born 1913 indianapolis, indiana**
**died 1993 silver spring, maryland**

*f*ELRATH HINES, WHILE APPLYING HIS SKILL AS A CONSERVATOR TO restoring and preserving one of the national collections of paintings in Washington, D.C., quietly and consistently produced an impressive body of precise abstraction. He created a delicate and original garden of colored geometry whose tensile balance and tuning are exquisite, musical, and transcendental. Impeccably crafted, his work possesses certainty and pristine clarity that never compromises its ease.

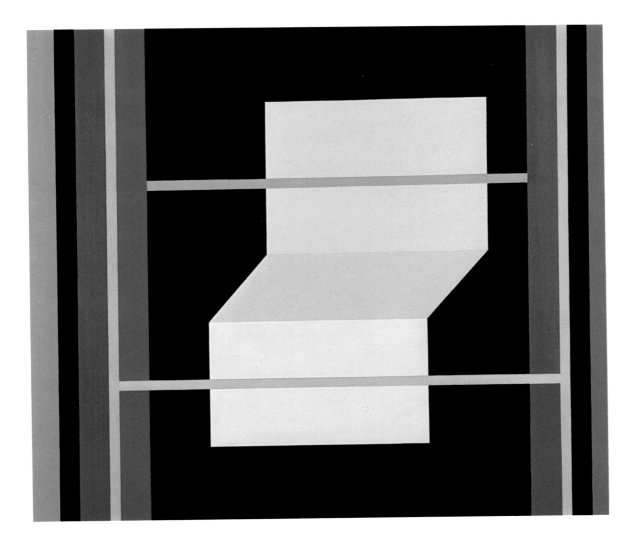

fig. 19. felrath hines, *midnight garden,* 1991, oil on linen,
52 x 58 inches (132.1 x 147.3 cm). collection of dorothy fischer, silver spring, maryland.

*mel katz*

**born 1932 brooklyn, new york
lives and works in portland, oregon**

LL MY WORK IS CONCEIVED THROUGH FULL-SCALE DRAWINGS AND realized as wall or freestanding sculptures. At times, my response to materials and their application can lead to ideas for the next work. In 1985, after completing several cast concrete and steel pieces, I was particularly taken with the Formica materials that lined the molds built for the casting process. Seduced by the range of Formicas and plastic laminates in general—colors, patterns, textures, and faux surfaces—I decided to make work applying my formal vocabulary with these mass-produced materials. The two pieces in this exhibition, completed in 1991, were the last of this series representing that marriage with strong attention to scale and the works physicality. M.K.

Mel Katz left New York in 1964 to live in Portland, Oregon. Trained as a painter, by the late 1960s he had evolved a sculptural vision. He is, however, less concerned with claiming dimensional space than in expanding that of painting and exploiting the contradictions of the hybrid. Contradiction and conundrum indeed are the ministry of Katz's doctrine to let no aspect of a work be expected. His recent sculptures are elegant, mindful, and madcap. He brings sensuality to a structuralist debate and punctuates it with patterns that bear no relation to the forms they identify. Plastic laminates, familiar from roadside diners and suburban kitchens, falsify with improbable combinations the materiality of each work's parts. Immaculate faux substances undermine expectations provided by the careful drawing of elements. Katz offers us Ingres's probity in the bill of Groucho's duck.

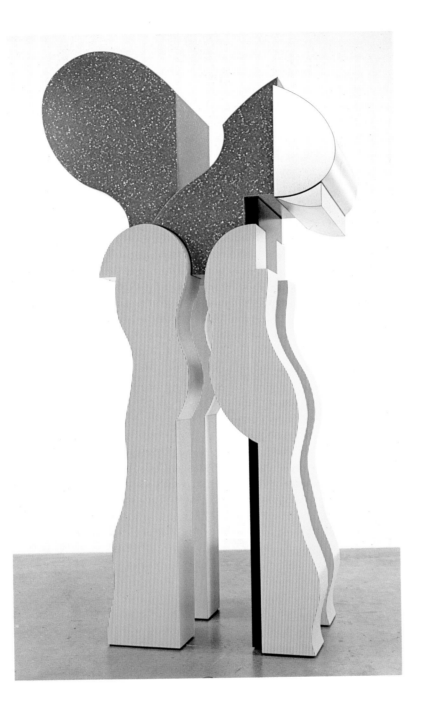

fig. 20. mel katz, *confetti stripes and aluminum too,* 1991, plastic laminate and vinyl, 96 x 46 x 31 1/2 inches (243.8 x 116.8 x 80.0 cm). laura russo gallery, portland.

*vera klement*

**born 1929 danzig free city (now gdansk, poland)**
**lives and works in chicago, illinois**

*i*BELIEVE PASSIONATELY IN THE POWER OF IMAGE, PARTICULARLY AS revealed through the medium of paint. Close as paint is to the inner stuff of our bodies, its liquidity and plasticity, transparency and ooze—its iridescence—make painting the perfect medium for coaxing image into being. Unlike the declarative concept, image resides in a state of indeterminacy between appearance/illusion and substance/body. It is that indeterminacy that allows painting to function as a philosophical questioning of the nature of the object, its presence and its coming into being. To that end, I paint objects outside of or apart from their settings, objects alone on a white, unpainted ground. I choose these with great care and have over the years accumulated some two dozen or so that I use in various combinations. They are objects that must be universally recognizable, belong to no specific time period, and, through the conduit of metaphor, be capable of yielding up a multiplicity of meaning. V.K.

Vera Klement understands the power of pictorial elements to engage the unconscious and serve metaphorically as a condensing agent of meaning. Klement's paintings are dense with encoded mystery. Desire, longing, loss, guilt, sorrow, and celebration are her vocabulary. Rivers, vessels, trees, graves, the turf that obscures the burial, and a cosmos to course through serve as her alphabet. A human presence, stated or implied, is always the catalyst in her abbreviated picture puzzles. Beautifully stated through the simplicity of virtuosic paint handling, she makes her intention perfectly clear by withholding the answers to the questions she raises. Finally, hers is a vision of the unobtainable.

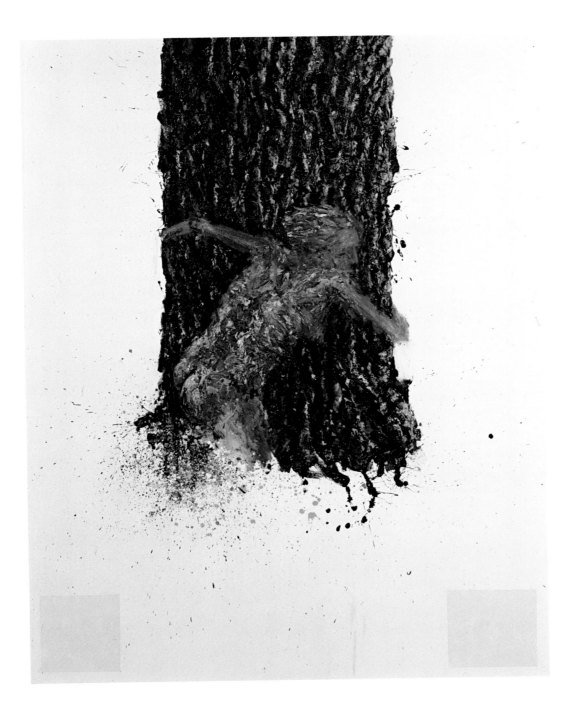

fig. 21. vera klement, *embrace*, 1993, oil on canvas,
78 x 60 inches (198.1 x 152.4 cm). roy boyd gallery, chicago.

**born 1924 clemson, south carolina**
**lives and works in detroit, michigan**

RT CHARTS THE COURSE OF TIME. IT PROCESSES AND APPLIES SIGNATURE to the uniqueness of human thoughts and perceptions. It asks for tolerance, it pleads and begs for freedom and peace, it seeks a better world by trying to understand even the minutest particle of the vast intelligence manifested in nature's order. The creative mind continues always to test the parameters of conventional knowledge, forever in pursuit of new vistas. Trying to understand life, death, the totality of existence, and the logic or order that governs our being is the form from which art extracts its meaning. The belief that all matter exists and operates in the service of nature is the basic tenet shaping the content of my imagery. The structural elements of line, shape, color, value, texture, and content are employed as echoes of humankind's motions in a time/space equation. I perceive my work as content message bearers whose language is formed through the unique psychological employment of these means. Past and current involvements with public art have shifted the focus of my work drastically to the cusp where space, aesthetics, and utility merge into a consummate energy. Systems of opposites operate in juxtaposition as optical energizers where these forces act in harmony as dynamic constructs of conceptual environments. C.M.

Charles McGee was made professor emeritus at Eastern Michigan University in 1987. Since his retirement his art has erupted into a volcano of renewed energy. His work has taken on physical dimension as his personal exuberance has broken the limits of the painted spaces that characterize his past. McGee has invigorated his model and become a total artist. He moves freely between paintings, sculptures, reliefs, drawings, and recombinant objects that resist classification. He is equally at ease with a sketch pad or designing a public garden. He speaks of finding his voice as an artist, recognizing it as his own and going wherever it leads him. McGee's voice is that of the optimist, the humanist, the moralist, and the fantasist. All things are equal on this earth he says; everything in its place serves its place with equal importance to the whole of life, and the complexity of it is thrilling. His art is in tune with his vision of the world, and everything in it happens at once. Leaping men and women are embedded in complicity with snakes and birds, lizards and flags, mice and geometry, caterpillars and colors, solids and voids, metal and pigment—all ecstatic in their own simultaneity.

fig. 22. charles mcgee, *syncopation*, 1993, polychromed aluminum,
72 x 96 x 12 inches (182.9 x 243.8 x 30.5 cm). collection of the artist.

born 1911 yorba linda, california
died 1993 portland, oregon

USIC IS THE MOST ABSTRACT OF ALL THE ARTS. IT IS THE ENVY OF ALL THE other forms. One listens to music and accepts the response. There is not the question: What does it mean? Yet the meaning is in the listening. Painting should be viewed with the same openness of mind and heart. Just experience the work, don't try to explain it. To explain is to remove the mystery: to remove the mystery is to remove the content. C.M.

Carl Morris was not considered for inclusion among the pioneering figures of Abstract Expressionism who were in Nina Leen's famous 1951 photograph of the group known as the Irascibles. It is by the very term "New York School" that his absence from that group portrait can be reconciled. Morris moved to Portland, Oregon, in 1941, after completing his formal education in Paris. He remained in Portland despite the well-intentioned and persistent advice of his close friends Mark Rothko and Barnett Newman that he move to New York. Robert Motherwell's cynical snipe that nothing significant was happening west of the Hudson River fell on ears tuned to a different symphony.

Morris recognized early the momentum toward total abstraction implicit in European modernist painting. Hearing but not heeding the call of New York's artistic foment, he transplanted the seeds of Action painting to the rich loam of the Pacific Northwest. It was not the appearance of the land that called to his temperament so much as the rootedness he felt there, a rootedness to the force of Earth as creator. Morris sensed his subject in the Gaea model of a generative, nurturing universe. He saw in the fractal forms of nature a reflection of the disassociative constructs of the Abstract Expressionist's paradigm from the opposite side of the mirror. Where the other originators adapted their forms to the predicament of anomie and wrestled with alienation and separateness from nature, Morris sought to amplify his sense of connectedness. He created a kind of temporal expressionism formed from plate tectonics, volcanism, and mountain building. Morris's very original brand of Abstract Expressionism rises from magma, it captures the slow cooling of primordial stuff and probes the firmament to eyeball the creator. On June 3, 1993, at the age of eighty-two, Carl Morris died; all evidence indicates he painted that day.

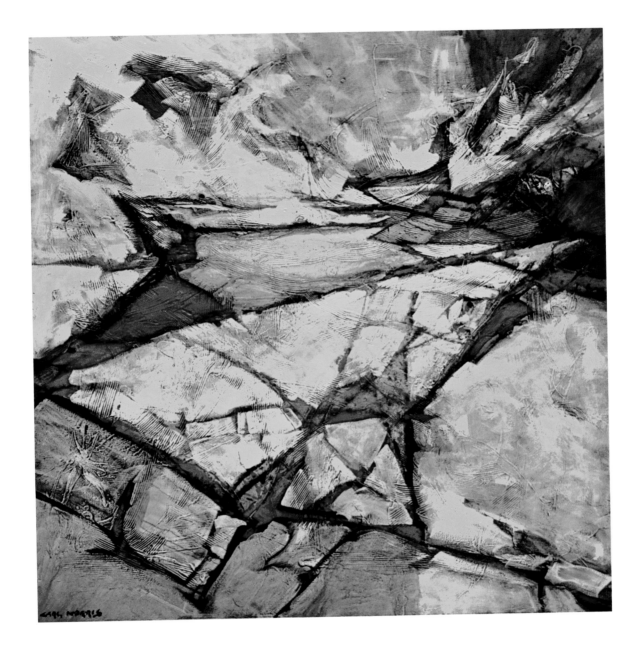

Fig. 23. carl morris, *#688—yellow sky,* 1990, acrylic on canvas,
85 x 73 inches (215.9 x 185.4 cm). estate of carl morris.

*florence pierce*

**born 1918 washington, d.c.**
**lives and works in albuquerque, new mexico**

Y ART IS MY REALITY. IT IS CONCERNED WITH TURNING INWARD AND toward the awareness of the mysterious and ineffable. Currently its forms are transformations of the triangle, square, and circle. These works are forms of silence and stillness—free from the noisy distractions of reality.

I have worked exclusively in polyester resin poured and cast onto Plexiglas mirrors for several years. They have a rare and incredible sensuousness and light that to me radiates a sublime, vibrant sense of power, beauty, and joy. F.P.

Florence Pierce was a member of the Transcendental Artists group formed in New Mexico in 1934 by Emil Bisttram. The mission of the group, like that of the American Abstract Artists group in New York and the Abstraction-Création group in Paris, was to promote the supremacy of nonobjective art and to disseminate awareness of its spiritual achievements. Pierce has continued to invest herself in a search for the meaning inherent in pure form, but she is engaged in uses of new materials for its realization. Her polyester resin constructions bring translucence and icy density to folded circles and fanned shapes of deeply buried metal foil and Mylar. They give the impression of having been constructed from the surface of a flame-proof re-entry module. Light passes through the thick, obdurate slabs of tinted resin to barely reveal the reflective topography of the base beneath. Pierce's altar-like reliefs are permeated with Arctic spirituality.

fig. 24. florence pierce, *fan #2*, 1988, polyster resin on mirrored plexiglas laminated to plywood,
48 x 72 x 2 inches (121.9 x 182.9 x 5.1 cm). collection of the artist.

**born 1909 waterbury, connecticut**
**lives and works in portland, oregon**

*i* WAS BORN A LONG TIME AGO SOMEWHERE BACK EAST. I WAS RAISED in several places and did not speak English until I was ten. Legend has it that I was introduced to art as a child. I have youthful memories of desires to escape the consequences. At twenty I dropped out of my living world to study art on campus under the most negative circumstances, in an ambiance charged with ignorance and hostility toward modern art. In spite of this, I finally earned a B.F.A. and so was of that generation that sought art through accreditation. I owe my education to many people, mostly immigrant ethnic friends of my childhood—anarchistic Italians, revolutionary Lithuanians, Russians, and Jews who guided me.

The Depression of the 1930s completed my education as an activist. Depression, war, and fascism were the background against which I viewed the objective world. My education would not have been complete without Boardman Robinson, with whom I enjoyed a fellowship at Colorado Springs.

I married a painter who enriched my life emotionally and intellectually, with love and conflict. I have been teaching and painting all my life. I chose to become a Northwest painter in 1947 when I settled in Portland. I found here a favorable environment where I could be free from the 'aesthetic' successes that obsess contemporary artists. My development rests on simplification and clarity, with stress on my personal needs and understanding. Though my taste in art is universal, I have a long history of social consciousness and struggle. My recent paintings belong to a cycle of work I title *Mockeries and Ecstasies on a Chauvinistic Theme.* M.R.

Michele Russo's artistic attention over the past fifteen years has been completely engaged by sex and the social ballet that accompanies seduction. In his consuming series *Mockeries and Ecstasies,* the male figures are dressed while the women are unclothed. Russo's view paradoxically addresses the predicament of men guarded by their coverings and buoyed by the sexually codified paraphernalia of their station and power (bowler hats, umbrellas, canes, and neckties), while his women, exposed and vulnerable, remain close to their unfettered nature and to the expected condition their image has held in art history. They are not, however, patronized as innocents in the roles they play. They openly uncover chauvinist misapprehensions by balancing symbolic motifs (a playing card, a walking stick, high-heeled shoes, an umbrella, or a floating tea pot) on their extended arms and legs as they simultaneously evoke a precarious challenge to their own unrealistic expectations. Russo's sexual mine field is never prurient or judgmental; he delights in our self-absorbed absurdity.

fig. 25. michele russo, *the juggler*, 1993, acrylic on canvas,
70 x 60 inches (177.8 x 152.4 cm). laura russo gallery, portland.

**born 1894 olean, new york**
**died 1993 elsinore, california**

*I* THINK, PERHAPS WHEN I STARTED PAINTING, I SAID TO MYSELF, 'WHAT have you got old man? You have a love of color. You understand line and you do know people.' J.S.

Jon Serl has been identified as an outsider; he has been associated with what is called "naïve," "primitive," or "folksy." Serl's assessments, however, of the world around him were by no measure technically uncertain or narrowly defined. His uses of painting were consciously devised to reveal complex aspects of humanity's sensual, psychic, and mythic status. His simple questions brought him to clear and motivating affirmations. Serl was entirely aware of the visionary power he possessed. He was not so much an outsider as an extraordinarily intuitive and gifted artist who had the good fortune to be left alone. For more than forty years his paintings were the privately cultivated crop in the secret garden of his probing observation. If, in admiring Serl's work, Chaim Soutine is brought to mind, or Marc Chagall, Odilon Redon, or James Ensor, the similarity is owed to shared primacy of vision; completely self-taught, Serl was his own man.

Serl was an American hero who managed a life style protected from what has become American: philosophically committed to individualism, he actively mourned its loss as a guiding principle. He was in no hurry, sought no celebrity, combated material acquisition, and stayed well tuned to his inner and outer environment. A latecomer to the craft of painting (he began at forty-five), he has independently and devotedly sought to reconcile in form and pigment the panoply of human and animal spirits that had occupied his vision for ninety-eight years. Unknown until the 1980s, his oeuvre evolved free of outside pressure. What he did, he did to satisfy a burning need to materialize insight; no one was watching. Now people have become aware of Serl's work and they are watching carefully. He has been shown widely in one-person and survey shows and even appeared on the "Tonight Show" (unfortunately mocked as a novelty and serving as Carson's straight man). His work is now being recognized for its remarkable accomplishment. Surprisingly, his late notoriety brought him to renewed awareness and diligence at the end of his life. Serl died in his sleep in July 1993, two years short of the century to which he seemed entitled. In life he embodied those qualities that reveal age itself to be empowering. Deeply enriched by the force of his own development, Serl used art as a vehicle for revelation. Society is the real outsider here; Jon Serl was on an inside track. He was a most authentic master.

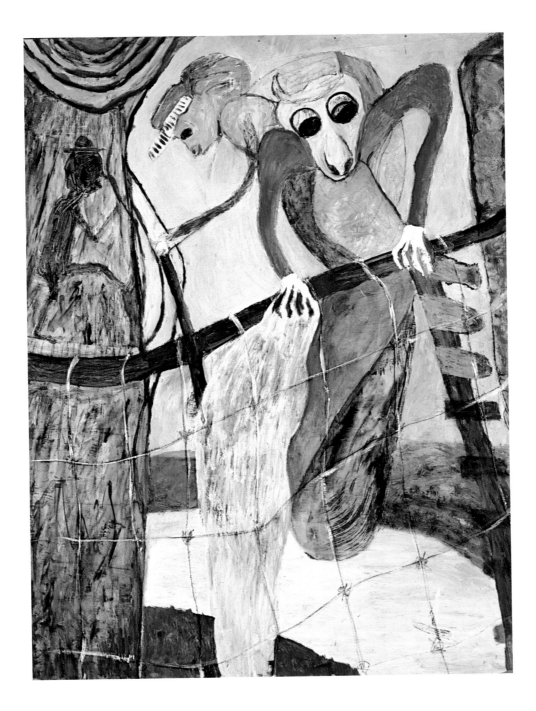

fig. 26. jon serl, *indian fisherman*, 1990, oil on board,
45 x 32 inches (114.3 x 81.3 cm). collection of sheri cavin and randall morris, New York.

*oli sihvonen*

**born 1921 brooklyn, new york**
**died 1991 new york, new york**

LI SIHVONEN OCCUPIES A SPECIAL PLACE IN THE *STILL WORKING* EXHIBITION. He was the first artist chosen for inclusion and he was, in fact, germinal to the idea for the show. Ironically, he died just two weeks after the seed grant was made available to develop the concept on a national scale.

His Chinatown studio was brimming with simple, playful, and decisive abstractions, the culmination of an investigation into optics and perception that was begun at Black Mountain College in 1946 and continued in Taos in the late 1940s and 1950s, where his graceful and luminous elipse paintings became identified with the Taos modernists. His ideas held continual excitement for him, and the last works have an inherent lightness and natural joy that amplify the skewed imbalance in a system that allows this highly original work to go unrecognized. But for the shift in fashion in the 1960s that brought critical attention away from clearly structured painting and briefly from abstract art in general, Sihvonen should have been a historical presence in American art.

fig. 27. oli sihvonen, *addendum,* 1990, oil on canvas,
96 x 56 inches (243.8 x 142.2 cm). estate of oli sihvonen.

*sal sirugo*

**born 1920 pozzallo, sicily
lives and works in new york, new york**

*i*HAVE BEEN INVOLVED IN MY ART WORK FOR CLOSE TO FIFTY YEARS. At the age of seventeen I arrived here from Sicily. A few years later I was drafted into the U.S. Army and, while on combat duty in Germany, I was severely wounded. During a three-and-a-half-year recuperation period in army hospitals, I was encouraged to continue to paint by hospital volunteers who were themselves artists and brought me materials. A month after being discharged from the army in 1948, I enrolled under the G.I. Bill in the Art Students League's summer school in Woodstock, New York, and after that the League's school in New York City. In 1949–50 I studied at the Brooklyn Museum Art School.

The beginning of my career coincided with the Abstract Expressionist movement. My large-size work was done on canvas or Masonite, using Luminal paint, casein, and acrylics. When limited funds made me forgo the use of paint colors, I began to explore the coloristic potential of black and white. After so many years of utilizing black and white, like the ancient Chinese painters, I have no limitations in its use.

In the mid-1960s I began working on paper, combining the remarkable qualities of all types of black inks on wet surfaces. The controlled and accidental fluidity of the medium dictates the direction of the paintings. The inks form 'heads,' 'eyes,' or imaginary landscapes. When I work I forget that I am painting and become completely absorbed in the pure visual sensations caused by the shapes gradually forming on the paper or canvas. My images portray what I am. The spontaneity of the ink flows that evolve into imaginary landscapes are visual pleasures. They are delicate and poetic compositions. The differences in black inks and gray tones achieve distinct depictions of nature in its vastness and complexity.

When my working area was reduced in size by necessity, the dimensions of my paintings grew smaller, but the works retained the same sense of scale as my large paintings. There is a seventeenth-century album of Chinese paintings titled *Within Small See Large*. That is how I view my work. S.S

Sal Sirugo makes paintings in which size is implicit. The grandeur of his vision resides in the spectator's head space. We are miniaturized by it and fitted to locales that are familiar in their absence of detail. Replete with nature's structure, knolls reflect on still estuaries, flora and ground fog fill evening silences, tempestuous skies summon Turner and Constable in formats no larger than a hand. The lack of chroma in Sirugo's places is barely realized as his tiny invocations are produced in subtle tones that evoke Arcadia.

Fig. 28. sal sirugo, *m-217*, 1991, ink on paper, 3 3/16 x 3 7/16 inches (8.3 x 8.9 cm). collection of the artist.

*david slivka*

**born 1914 chicago, illinois
lives and works in new york, new york**

Y RECENT WORK EVOLVES NOT OUT OF ANY SINGLE LINEAR PROGRESSION but from multiple sources. Change or growth over the many years is inevitable. My personal history and exposure to art history have left a deep residue of ideas and concepts in search of meaning. It has been a long journey and is still ongoing. I have gone from figurative work, to biomorphic abstraction, then to architectonic, Cubist-structured work. More recently, my work is again organic. The search is important as I develop and change, not just changing the style.

For some time I have abandoned the monolithic mass in my sculpture. The newer works, although linear in structure, most frequently suggest mass. My walks in the woods of eastern Long Island began to make me more aware of the rhythms and calligraphy of tree limbs. It occurred to me that I could use limbs and branches as raw materials to express some of my ideas. This meant cutting up, modifying, manipulating, and joining to construct into space. It became no longer necessary to make a maquette or drawing for sculpture. The sculpture becomes the drawing and vice versa. The spontaneous act of taking a linear fragment of nature and, through manipulation, adding others in order to project a series of lines into space becomes an all-engrossing search and discovery.

My concepts emerged without preplanning. Curiously enough, they began to take on meanings laden with symbolism and mythology. No doubt my fascination with Oriental art, dance, music (baroque, jazz, tribal, ethnic, among others), Picasso, Julio Gonzalez, Abstract Expressionism, Oceanic (Asmat and Sepik from New Guinea) and African sculpture must have played some part in the process. D.S.

David Slivka's sculpture evolved from the sensitive and probing portrait bronzes of his early career, and the haunting full-head death mask of his friend Dylan Thomas, into the beautifully crafted and balanced constructions of his middle years that were humorous juxtapositions of stained, painted, and natural woods set in jaunty conversation with unexpected elements of color and material. No phase of Slivka's work, however, seems preparatory for the regeneration manifest in his recent primal ganglions of wood, plastics, reed, and rope that stand on bandy legs like giant ritualistic neurons. The extraordinary skill and craftsmanship that make these sculptures possible go unnoticed for their sheer wildness. Slivka is on a roll; he is having the time of his life and we are the beneficiaries.

fig. 29. david slivka, *mangrove,* 1994, stained woods and rope,
height: 89 inches (226.1 cm), diameter: 72 inches (182.9 cm). collection of the artist.

*stella waitzkin*

**born 1920 new york, new york
lives and works in new york, new york,
and chilmark, massachusetts**

*j*UST AS COLOR, FORM, AND SPACE CAN BE MANIPULATED ON CANVAS and in sculpture, so it is with the written and spoken word. I communicate best visually because I see more than I hear. And in this way I tell stories by combining painting and sculpture. The works called *Details of a Lost Library* are collections of short stories and essays, novels, encyclopedias, and dictionaries—all without words. These books are the containers of my energy. S.W.

Stella Waitzkin lives in an overstuffed apartment in the Chelsea Hotel in New York in which nothing is what it seems. To visit her is to enter a world of trapped junctures; memory is frozen with the wisdom of centuries in diaphanous ice. Her world is a dyslexic's dream: stack upon stack, volume after volume of books forever closed, in sets and carefully organized, on shelves and tables, among Victorian cameos and nostalgic souvenirs, locked in sherbet shades of polyester resin, their contents unknowable and precisely known. Waitzkin has determined that surely if a book holds in reserve the material to inform as it sits in a bookcase unread but ready, so it will serve, no longer readable, as a locus, a place of content, an ultimate condensation of information. The diary next to the couch has all of its revelations intact. We trust this to be so, though we can have no access to the musings it contained. We trust the Funk and Wagnall's College Standard, dutifully ready and sealed forever, and the address book near the telephone that lists, as her memory must, the names of everyone she knows or has ever known. To say that Waitzkin is eccentric tells a piece of her story, but it does not account for her creative clarity and personal resolve to stop everything at the moment it occurred and keep it in a collection of time unpassed; beneath the dust, her world is ageless.

fig. 30. stella waitzkin, *details of a lost library*, 1950–93, cast polyester resin and mixed media, ca. 7 x 12 feet (2.1 x 3.7 m). collection of the artist.

# robert wilbert

**born 1929 chicago, illinois
lives and works in detroit, michigan**

*i* PAINT PICTURES WHICH SEEM IN NO WAY CRITICAL OF THE PAST. IN certain ways they might be as at home in the eighteenth or nineteenth century as in this.

A look at my work reveals an interest in the depiction of *things*, in the look of fruit, flowers, furniture, vases, bowls, toys, musical instruments, every kind of knickknack—all the familiar characters in the drama of still-life painting. As often, my paintings are of the human figure, and these are many times brought together with elements of still life. I think that the still life can be as animated, vital, noble as the figure, and that the figure can hold  the materiality, and the endurance of the still life. There is a question in the marriage of these motifs as to which dominates. I  make it a marriage of equals.

I paint from direct observation, and what I paint is *always* in front of me. What is shown in my paintings is an 'arrangement,' but more than that, an arrangement of things in a studio and not part of the everyday world. The degree of artificiality (these arrangements are not a 'slice of life'—do not refer to the dishabille of reality or its clutter) is part of the content of the work. Theatricality is something I accept.

What is combined in these arrangements is determined intuitively as well as by the necessity of the composition. My belief is that unrelated things belong together if they fit in some way, even if their identities work against their association. I like that these paintings are a marriage of the factual and the invented; that the color and tone are full but the paint handling austere—something rich and something lean.

I am old-fashioned enough to believe that art can inspire, that the artist as author has intentions that are relevant and should be respected. This suggests that I see the artist as having the possibility of heroic work. I think it is essential that artists risk the acceptance of the effort necessary in that realization. R.W.

Robert Wilbert is a realist. His realism is, as his friend John Egner said in a 1984 catalogue statement, "the result of endless measurement and comparison. It is the inevitable proof of a complex equation. . . . The quiet passion in the pictures is his understated joy and wonder and the tension is the scale of his awe taxing the modest means of its expression." Wilbert produces images that align with appearances and verify expectations. However, we demand of painting if it is to transcend its silence subtexts that engage our attention beyond what things are called. Wilbert is completely dedicated to studio painting; thus the practice. In the studio, arrangements of people and props produce a counter-reality that is consummately artificial. There is a double corollary sustained in bringing together people and objects whose significant histories amount only to their having been brought together. The artist produces an illusion of seamless continuity within which neither people nor objects should be. The ordering of things to serve the appearance of nature's randomness at the locus of artifice (the studio), while creating a trusted context, brings to Wilbert's work somber sorcery. Micro moments find permanence in sustained accidents of planned scrutiny. His tensile voice speaks of the contrariness in what we think we know the world to be.

fig. 31. robert wilbert, *gerry with a chicory bouquet,* 1993, oil on canvas,
50 x 40 inches (127.0 x 101.6 cm). donald morris gallery, birmingham, michigan.

**born 1929 youngstown, ohio**
**lives and works in santa cruz, california**

*t*HE IDEA OF MAKING A SCULPTURE OF FALLING WATER CAME, AS obsessions sometimes do, with modesty, giving hardly a hint of the depth of the challenge it was to present its development. Before this venture my work had an intention and character completely unlike the work shown here. So far as I know, falling water had never been used as a sculpture motif. Soon after beginning to work on it I found that few, of the skills I had acquired on earlier labors would be useful in the venture, nor would forms already existing in the historical index of sculpture practice serve it. It was only when I had disarmed myself, surrendering all preconceptions (and confidence), that the real promise of this concept began to reveal itself. In this region of uncertainty and exhilaration a way had to be found to convey continuous movement: the paradox of implied flow in a stationary object. This had to be sensed within strict confines of the behavior of the subject itself, yet it had to overcome the rigidity of the way a photograph abruptly freezes a moving image. In no way should it seem untruthful to the event. I found also that a surface of unequivocal purity, free of any sign of maker's hand and the prattle of texture, was essential in order to find the true registry of weight, mass, and balance.

Between 1962, when the first piece was attempted, and 1964, when the first was committed to bronze, over forty visions at about an eight-foot height made their way to the intermediate state of plaster from the original clay. Later they were deservedly buried in a landfill without regret. Their sins ranged from the too sober and instructive to the too artfully vain. They had been welcomed with hope and existed in doubt, until exposed as failures by the final emergence two years later of a work that identified itself convincingly as its namesake. Work on the first versions of this theme continued in Rome until 1967. This group had nine final versions in bronze and three in marble. In 1984 the second phase was begun in Santa Cruz; this presently numbers twenty-one versions.

In their evolution the works composed themselves into widely differing conformations. Some of a single strand; some begin at two sources and unite as one as they fall. Others, ribbonlike, turn from the wide to the narrow edge in their descent. The latest versions drop from an asymmetrical lip. The successful ones, share a common trait, that of perfect repose. Elemental and elusive, it must be found anew in every piece. J.Z.

Jack Zajac has, since 1962, crafted bronze and marble using falling water and its fluid form as his inspiration. The pouring elements stand erect like Giacometti's strident presences stopped in a moment of balletic conversion. They are mute silvery attendants: streaming slices dividing space and vitalizing their surroundings. Scale shifts ambiguously between an open faucet and Yosemite Falls. Arp, Brancusi, and Giacometti hold Zajac's attention and provide him a resource for original formulations. Like Noguchi, Zajac sees in nature the confluence  and emotion that can be generated through the dis-

Fig. 32. jack zajac, santa cruz series: *falling water*, 1984–91, cast bronze. stephen wirtz gallery, san francisco.

*ann gibson*

# living with the past

"OLD AGE IS FULL OF DEATH AND FULL OF LIFE. IT IS A TOLERABLE ACHIEVE-ment and it is a disaster. It transcends desire and it taunts it. It is long enough and far from long enough."
—Ronald Blythe, *The View in Winter*

"I've been on a roll for five years," remarked Florence Pierce at age sixty-eight of her luciforms (fig. 24). "This is my best stuff."[1] Frederick Hammersley, born in 1919, a year after Pierce, stopped making hard-edged paintings in 1969 but started again—only with organic forms this time—his "motor was still running."[2] He stopped painting again in 1981 and began once more in 1983. In 1991 he started a group of paintings that he calls his "hunch" series, which are done according to "the logic of feeling. Nothing was done unless it felt right." The series is about "being alive": "When I get there," he says, "I know it." Mel Katz's use of "visually stunning and thematically rich" consumer construction materials in his plastic laminate constructions, such as *Confetti Stripes and Aluminum Too*, 1991 (fig. 20), has led this abstractionist, in his late fifties, to meditations on the relationship of the vernaculars of kitsch and decoration to high art.[3] Sidney Gordin began painting his dynamic bio-geometries, such as #2-89 (fig. 16), in the late 1980s. For the thirty years prior to that, he had been occupied with sculpture.

Such innovations are typical of the artists in this exhibition, whose work is characterized not only by continued vitality, but in many cases by new developments that seem to have less to do with their age than with their innovative and involved interaction with their surroundings. Charles McGee's involvement with public art, for example, has drastically shifted the focus of his work, such as *Syncopation*, 1993 (fig. 22), as he says, "to the cusp where space, aesthetics, and utility merge." Such an instance runs contrary to the archetype whose validity Martin Kemp questions in an issue of *Art Journal* devoted to "Old-Age Style." As an example of what earlier art historians had expected of artists late in their careers, Kemp quotes Kenneth Clark: "Old artists are solitary; like all old people, they are bored and irritated by their fellow bipeds and yet find their isolation depressing." Similarly, Anthony Blunt, notes Kemp, saw in the late works of Poussin "the typical products of an artist in his old age. During the years in which they were painted he had become even more completely detached from the world."[4] As opposed to this model for Leonardo's late production, Kemp proposes an alternative model of activity and invention.[5]

Kemp's view of Leonardo's late work as confounding the stereotype of older artists as detached and depressed corresponds to a direction evident in gerontological studies and surveys since the late 1960s. By 1975, and again in 1981, national Harris polls found evidence that the loneliness and isolation that have been such a strong aspect of the stereotyping of old age are more a projection of youth onto old age than a perception that older people have of themselves. Of the persons *under* sixty-five interviewed in these polls, 65 percent thought that loneliness was a serious problem for the older generation; but only 12 percent of persons over sixty-five thought so.[6]

The first American sociologist to seriously study later life was G. Stanley Hall, whose *Senescence*, published in 1922, presented old age as a decline, despite the fact that some of his observations seem to counter this conclusion.[7] Interest in social studies of aging increased in the 1930s and 1940s. The Social Security act was passed by the U.S. government in 1935 to provide economic assistance to older people. The American Psychological Association established a Division of Adult Development and Aging in 1944,[8] as America struggled to support an increasing population of elderly people who could not provide for themselves. In this era of its institutionalization (significantly, the era in which Clark's and Blunt's ideas on the subject may have been formed), aging was seen more pessimistically than either before or afterward.[9]

In 1950 the Federal Social Security Agency sponsored a national conference on aging. Early studies that grew out of this conference, such as Elaine Cumming and William E. Henry's *Growing Old* (1961), developed what came to be called as the "disengagement theory": the idea that older people detach themselves progressively from others, decreasing both their social and creative interaction. Cumming and Henry saw successful aging as a process of withdrawal, an appropriate preparation for the inevitability of death.[10] One might claim that the work of some of the artists in this exhibition exemplifies just such disengagement. Vera Klement's *Embrace,* 1993 (fig. 21), for example, displays what she told one interviewer is "a central subject in my work: isolation."[11] And Michele Russo's solitary figures, boats alone on the water, and even single hats on a shelf call to mind the loneliness of a final journey.

**studio of miriam beerman, montclair, new jersey, december 1993.**

**83**

By the 1960s, however, disengagement theory was being questioned by influential researchers such as Erik Erikson and Bernice Neugarten, and it was finally discredited as a sufficient explanation of aging's phenomena. Gerontologists who criticized the theory suggested that the condition of individuals in later life depended more on either fixed personality traits or developmental, social, and environmental factors than on the aging process itself.[12] Indeed, it seems insufficient to explain the complexities of even the work of artists like Klement and Russo, who might be said to thematize disengagement. It might be noted of the Danzig-born Klement that solitary figures have not only dominated her work for thirty years, but early on, especially, her figures before landscapes recalled the melancholy and longing that pervade Caspar David Friedrich's paintings of lone figures. Russo, too, has pursued his single images on dark grounds for decades, not only in recent years; in addition, women have represented for him not only solitude, but his own internal mysteries, so that their representation is an intensification of a theme still expanding, rather than, or at least in addition to, a simple statement of disengagement.[13]

Most historians would now agree that to interpret the work of artists like Klement and Russo solely according to their presumed anticipation of death would be to narrow it unconscionably. By the late 1960s, such judgments were beginning to be seen as generally unfair and as incorrect perceptions of older people, and American health professionals agreed that the stereotypes that led to these judgments should be eliminated.[14] "Ageism," a term coined in 1968, was defined as "a systematic stereotyping of and discrimination against people because they are old, just as racism and sexism accomplish this with skin color and gender."[15]

However, reactions to the prejudices of ageism tend to be flawed by an unexamined assumption that age is irrelevant. The danger in this approach, as in a number of the approaches to racism and sexism that were paralleled by the development of critiques of ageism, is its potential for denying difference. As gerontologist Thomas Cole has pointed out, emphasizing the "construction" of old age has sometimes led to an alternative mythology: that old people are just like the young in everything but chronology.[16] During the 1970s enlightened health professionals often insisted that proper aging resulted in an old age that was sexually active, productive, and self-reliant. This has generated an atmosphere in which physical and sociological dif-

jack boul in his studio, bethesda, maryland, march 1994.

ferences that accompany aging are either not admitted, or admitted only as failures. At the present, in a society in which tolerance for the vicissitudes of aging (i.e., changes in the immune system and the mechanical properties of lungs)[17] has been discouraged because of anti-ageist repudiation of the myths of dependency, decay, and disease, unrealistic optimism has promoted an unfortunate intergenerational conflict. In the present era of reduced American military and economic power, many youths

84

see their elders as a part of a gerontocracy that enjoys privileged economic status. The problems of the relation of different phases of the life cycle to one another, and of the meaning of aging have become urgent. Solutions will require an approach to old age that refuses a dualism we can no longer afford: the either-or solution of a "good" productive old age versus a "bad" dependent one.[18] The view of old age suggested by Ronald Blythe in *The View in Winter*, that it is "full of death and full of life," suggests a difficult understanding, but one that may prove to be not only the most positive in our present situation, but also absolutely necessary.[19]

In a commentary on the essays in the 1987 "Old-Age Style" issue of *Art Journal*, Julius Held claimed that "a good argument could be made for the limitation of such a study [a study of the transformations that take place in the art of artists as they get older] to those artists who not only grew old but also remained active and flexible."[20] *Still Working* provides the opportunity for just such a study. Artist Charles McGee's assertion, for instance, that "art charts the course of time," and Michele Russo's observation that "consciousness and awareness comes with time"[21] call attention to what may appear to be the obvious paired facts that art is always made in interaction with its time, and thus charts it, and that older artists (Russo is eighty-four) have more experiences on which to draw than do younger ones. But even here there is no overt agreement among artists. When asked, "What is the difference between a young and a mature artist?" Jon Serl replied, "There isn't any."[22] Nevertheless, although Serl himself projected a persona whose "most remarkable adventure of all is taking place right now," he was also undeniably still growing and changing.[23] Despite his assertion that "I'm a crazy man,"[24] the route that he took to arrive at paintings such as *Indian Fisherman*, 1990 (fig. 26), suggests that a study of his career might reveal just such transformations as Held surmised. Serl's latest work is less apt to prove that he was crazy than it is to prompt reactions such as longtime collector John Gold's: that Serl was "a very smart man who's been through a phenomenal amount in his life [Serl died at ninety-nine] and all of it comes together in his pictures—which grow increasingly ambitious every year."[25]

Variations on the themes announced in McGee's and Russo's statements, and seen in the work of the artists in this exhibition like Klement, Gordin, and Serl, demonstrate the relevance of a sampling of the current production of these older artists. In the variety and paradoxes offered by its themes, its physical presence, and the relationships between these elements, the art in *Still Working* can serve as a basis for finding ways to break free of the idea that old age is *either* all downhill or totally controllable.

In his advocation of a study of artists who remained "active and flexible," Held did not fail to suggest that such a study should nevertheless focus on the relation of artistic developments to the transformations that take place in artists' work as they age. In advocating the need for scholarly investigation of the relation of an artist's position in the life cycle with her or his continued productivity, Held took a position parallel to that of contemporary gerontologists who feel that some accommodation must be made between the undeniable physical and social changes that accompany aging and the also undeniable differences in the ways that individual humans understand how these changes affect them. Four artists in this exhibition—Pierce, Hammersley,

**85**

Katz, and Gordin—in particular serve as examples not only of continued vitality but of artists whose later careers are marked by new developments. Understanding their current production as proof that age is not a factor in creativity would seem to corroborate the anti-ageist theories of the 1970s: that, like younger artists, these artists are still developing, changing, trying out new things. But more detailed attention to their histories reveals that, despite their incorporation of novel elements, their later works are also continuous with earlier developments in their careers in ways that would prove the short-sightedness of any attempt to present their current work as unadulterated innovation. One could cite in this regard Pierce's career-long association with the transcendental modernism of the Taos community, for instance; Hammersley's continued attention to nonobjective form; the commonalities of Katz's current sculptures with his animated geometric paintings of the 1960s; and Gordin's early history as a painter (*before* he turned to sculpture), and his lifelong exploration of the legacy of Cubism and Constructivism, which is amply evident in his work in both media.

In fact, the pattern of development of most of the artists presented here demonstrates both continuity and flexibility. Many, such as Felrath Hines, whose immaculately constructed forms present themselves in spaces that can be read alternately as either cosmic depth or the most material of flat planes (fig. 19), and Morton C. Bradley, Jr., who since the 1950s has been gathering ideas and notes for his precisely constructed sculptures (fig. 7), demonstrate a concentration that has lasted for decades. The same can be said of Abstract Expressionist Carl Morris, of whom a reporter claimed: "Instead of waning as he grew older, Morris' painting gained strength, power, and subtlety. His most recent shows at the Laura Russo Gallery, vigorous and arresting, won him new admirers."[26] Nevertheless, to the end of his life Morris displayed a continued devotion to Abstract Expressionist tenets such as the superiority of experience to explanation.[27]

Yet another aspect of such sameness-and-difference may be read in such paintings as Guy Anderson's *The Seeding*, 1986 (fig. 2), and Claire Falkenstein's figural orgies (fig. 15), where the seemingly unplanned spontaneity of gestural brushstrokes seamlessly presents economically represented human figures tenderly pocketed in (or, in the case of Falkenstein, riotously emerging from) strata of paint. Such works activate a rhetorical, or figural (not figura*tive*), device common to the work of many of these artists: the oxymoron, or paradox. Literary critic and theorist Kenneth Burke has suggested that a metalevel of meaning is in operation in such ambiguous constructions, which can be read simultaneously in contradictory ways (here, Anderson's and Falkenstein's "unpremeditated" human figures).[28] Statements that transcend logical possibility, "that run against the boundaries of language," have been understood by some thinkers as a gesture toward the existence of that which cannot be expressed as *truth*, but only as feeling: the metaphysical or the mystical.[29] But although paradoxical constructions are mystifying in the sense of their inaccessibility to logic, this very criterion enables them to establish an arena where apparently nonreconcilable opposites can, with effort, be held simultaneously in the mind without having to be synthesized—just as the idea of older artists' necessary differences from younger ones

does not preclude the idea that experienced artists may also produce work whose insight, craft, and retrospective scope is beyond the capability of youth. Such oxymoronic construction is present in Katz's meshing of kitsch and high art and in Hines's collapse of immense space and flat surface. It exists, too, in the way Bradley's inspiration, developed from utterly logical and disciplined scientific procedures, has produced some of the most playful and decorative work in the exhibition. But it is present too in Pierce's dependence on the way light is refracted off Plexiglas mirrors through polyester resin to produce a luminous "spirit," in the ineluctable precision with which Hammersley's chance intuitions produce the disciplined stylistic consistency of his "hunch" paintings, and in the way that a lifetime of practiced craftsmanship enables Gordin to produce the impression of effortlessly dynamic speed and spontaneity in his latest paintings.

This potential for radically discontinuous interpretation informs any authoritatively singular reading of most of the works in this exhibition. It rears its head in the apparently contradictory relation between Jack Boul's carefully observed *Cows in a Gully*, 1992 (fig. 6), on first glance surely the work of an artist whose interest in his subject matter is paramount, and his emphatic statement in this catalogue that he is interested "in the ways shapes merge. in color before it becomes a rendered thing. in how the canvas is divided, how you enter and move around, how you turn the corners in a painting." Not a word about cows, trees, or landscape. Similarly, it is pre-

studio of sal sirugo, new york, october 1993.

sent in David Slivka's statement that by using actual limbs and branches as elements in his sculpture, such as *Mangrove*, 1994 (fig. 29), "the sculpture becomes the drawing and vice versa." Sal Sirugo—see his *M-217*, 1991 (fig. 28)—discovered in the 1950s that, as Corinne Robins has noted, "all his work had a double meaning, that an abstract painting can also be a landscape and that there is no simple demarcation between black and white."[30] Mala Breuer is explicit about her awareness of the tension between the fragile oil and wax surfaces of paintings such as Untitled, 1992 (fig. 8), and the determination and continuity registered in their ceaseless vertical orientation: "In life there is always opposition causing tension. The lines in my painting are static, straight, separating the expression of spontaneous forms in repetition and variation."[31] In her statement for this exhibition, she suggests her paradoxical

**87**

intention most clearly: "My painting is about being formed from formlessness."

In old age, as in other periods of life, humans are vulnerable in time to both mental and physical disease, and to death. Like illness and death at any point in life, aging reveals what Western thought has for centuries seen as a fundamental conflict between desire and ambition, spirit and body; but in old age these tensions operate with the added voltage of being at the limit of physical existence. Aging is full of contradictions, a condition that cannot be eradicated by either the wonders of modern medicine or positive attitudes toward growing old. A number of artists in this exhibition who currently formulate themes involving paradox do so in relation to the element of time, either the time of society or the more personal time of autobiography.

detail, *27 tears,*
vera klement, chicago,
november 1993.

Perhaps the most naked avowal of anxiety in relation to the passing of time is denial. Both Jack Zajac in his striking falling water pieces (fig. 32) and Stella Waitzkin in her cast resin sculptures (fig. 30) appear to present nostalgic symbolic resolutions to the passing of time. But for each the impossibility of their ambition is paramount. Challenged by "the paradox of implied flow in a stationary object," Zajac's statement that he is concerned that his sculpture should "in no way ... seem to be untruthful to the event it portrays" tells us he is aware of the seductions of simple wish fulfillment. Waitzkin interweaves a sense of personal time with the collective history of the books she has cast for her ongoing (since 1950) piece, *Details of a Lost Library.*

Personal time is meshed with more universal implications in the works of Constance Cohen, too, whose self-portrait in *Rowing in Eden,* 1981, as Lynne Warren has pointed out, suggests not so much a goal of self-revelation as the more generalizing and "poetic projection of her possibilities as a woman and an artist."[32] The personal references in Robert Wilbert's paintings (such as *Gerry with a Chicory Bouquet,* 1993 [fig. 31])—to family members, familiar objects, his studio—generate a different kind of tension: not the tension between the particular and the universal, as in Cohen and Waitzkin, or between stillness and movement, as in Zajac and Breuer, but rather between spatial relationships "solid as the composition on a Roosevelt dime" that the artist locks in place,[33] and the subjective expression and imaginative energy that seems to spurt from his unfamiliar colors, improbable poses, and odd conjunctions of the

businesslike and the obsessive.

Miriam Beerman's *December (In Memory),* 1992 (fig. 5), might well serve as the focus of a number of themes present in the work of many of the artists in *Still Working.* Her title, *December,* is an overt metaphor for old age, and memory is often evoked as one of the attributes of the elderly. But the conjunction in Beerman's figure between its slumped position and its tensed fingers and apprehensive expression also suggests that the breadth of the title's "in memory" refers to the artist's stated urgency

> to express those archaic themes as being a part of present history. The plagues which God brought down upon the Pharaoh and the Egyptian people seemed to have returned in various guises. They were the Holocaust, Hiroshima, darkness and death everywhere. They were, besides, the threat of nuclear and natural disasters which come upon us suddenly and without warning.[34]

In addition, Beerman used collaged cloth in the upper central area of the painting and on the arm of the figure. Not tactfully and discreetly worked in, the found elements wound the already agitated surface of the painting, scoring it with references to its making, and thus to the artificiality of its relation to the events it recalls. Ernest Acker-Gherardino, Don Baum, Sherman Drexler, and David Slivka also employ found objects: Acker-Gherardino's *Cloak of Homelessness,* 1990 (fig. 1); the cutting board in Baum's *Odysseus,* 1992 (fig. 4); the bricks, stones, and fragments of concrete that Drexler uses in works such as *Three Grand Figures,* 1994 (fig. 12), to offer refuge and form to his images of women; and Slivka's limbs and branches. They too alternately bridge or block (like Beerman's collage) art's ability to span time and place. As Acker-Gherardino tells us in his catalogue statement, which is as redolent a metaphor for aging as it is for homelessness, he calls his found junk pieces "dump works" to call attention to the vast beauty of the destroyed and decayed things our society produces in its penetration and use of nature.

Hans Burkhardt has also dealt in his collaged images with memory and death, as in *Black Rain,* 1993 (fig. 9). His *Desert Storms* series, which uses wood, rope, and tar embedded in fields of paint as debris or emblems of mortality, continues the dynamically "poisonous concentration of surface, full of the pus of anxiety" of the surface of his earlier Vietnam paintings, in which he used actual skulls as collaged elements.[35] For critic Donald Kuspit, Burkhardt's gestures as well as his found objects acknowledge the unbridgeable distance between his painting and his subject matter.[36]

Art's memorial function, evoked in Beerman, Waitzkin, and Burkhardt, has also found a place in some of Robert Barnes's series. We memorialize persons and events to which we wish to link ourselves over the gap of time. Like Beerman, whose memorial paintings most often reflect her search for artists obsessed with their work,[37] Barnes's more narrative presentation (see *Ludlow Silkie,* 1987 [fig. 3]) also reflects his interest in artists whose life and art were notably intertwined. Barnes is fascinated, too, by grand eccentrics such as Beau Brummel, Lord Byron, Arthur Craven, Percy Bysshe Shelley, and Jeremy Bentham, whose lives took on the attributes of art.[38]

Given Barnes's consistent positioning as "eccentric" himself, due to his interest in areas outside what has been considered to be the focus of American art, his interest in historical eccentrics does, however, appear likely to have been generated by a search for community similar to Beerman's interest in obsessive artists.

Perhaps the most difficult question to address for many older artists is that of continued work in a direction whose premises now appear to be flawed. What of artists like Edward Dugmore who has pursued throughout his career the revelations of self at the heart of Abstract Expressionism (seen in the miraculous freshness of his every-stroke-a-struggle *Guad Quartet 132, 1984* [fig. 13]), and Roberto Estopinan, whose *Camille Claudel* series (fig. 14) actually seems to acknowledge the cruel and worshipful fragmentation of the female figure that occupied so many avant-garde heroes as a search for cultural origin?[39] Contemporary historians such as Michael Leja and Griselda Pollock have impugned similar projects respectively as the internalization and naturalization of modern man's anxious and desperate subjectivity, and as the assertion of mastery over the desired object, coupled with an escape from history.[40] What can we say, now, about the continued production in our time of works like Julius Hatofsky's delicious and vicious banquets of painted form (fig. 18); about the strangely delicate and imperiously intellectual appeal of Oli Sihvonen's *Addendum, 1990* (fig. 27); or of the coupling of minimal inevitability with an expansive play of color and space exhibited in Martin Canin's *Untitled, 1993* (fig. 10)? What do we do with such observations when we may also agree with critics like Pollock and Leja, who have claimed that appreciating art for its aesthetic appeal alone constitutes the fetishization of art's materials, procedures, and effects—a defense mechanism against acknowledging and acting on psychic, economic, political, and social problems, and the interpolation of ideological subjects?

This, I think, is where our own ability to deal with difference is severely tested, as is younger America's potential to deal with the needs—and the power—of older Americans now challenged by the question of whether to, or how to, amend the present Social Security system. Dugmore, Estopinan, Hatofsky, Sivohnen, and Canin cannot be put into the same box; they have had different histories, goals, and audiences. Just as older Americans do not all have the same needs or abilities, thus the same claims on the nation's support, so each of the artists in *Still Working* will have different claims on each viewer's esteem. Moreover, our ability to estimate their achievements and to enjoy their success depends on our being able to get into a dialogue with the work, that is, to regard it in such a way that we are vulnerable to it.[41] This means giving it a chance to change us, as well as (not instead of) our judging it. This is living with (not in) the past.

Notes are on pages 181 - 82.

90

*harry rand*

# the uses of obscurity

*a*N EXHIBITION LIKE *STILL WORKING* PROBABLY COULD NOT HAVE appeared earlier than the present decade. Official academies had to wane senescent, the avant-garde had to fade to a wisp of Romanticism, then an inflation of artistic quality stormed international society and demoted both skill and earnestness in order to supplant these values with artists and architects who work mainly with their mouths. This sad climate affords the distance to mount not a *salon des refusés* but a remnant of conscience.[1] One crucial fragment of the former ethos has survived recent debasements, and by this slender but perduring filament hangs this present enterprise. The current exhibition depends on the abiding health of a legend, fame-as-justice, and its debunking. This denunciation is in the spirit of modernism, while the implicit revelation of the underlying assumptions presupposes the cheeky candor of postmodernism. At the very least, *Still Working* depends for a sympathetic reception on the audience's awareness that the show's organizers aimed to unearth one of the primary aspects of the mythology by which society now operates—and has for a couple of hundred years. This kind of brazen inspection is not usually considered an institutional function, although the show has been embraced by prestigious institutions.

Until recently, the job of examining society's assumptions was the primary function of the "underground," the avant-garde, gadfly of the establishment. The avant-garde's bookish and artistic wing, the intelligentsia, impertinently thrust its notions into the public's face, which responded with discomfort, then questioning, and eventually accommodation. Exultation arrived with general understanding and then enrollment in the new value scheme; finally, complacency set in—before the whole cycle started up again. Yet even the avant-garde, for all its dogged effrontery of tradition, operates by unquestioned mythology, not following a purely rational inquiry. One notion that proved a tenet of faith recounts a critically hypnotic narrative of the resurrection of the deserving but obscure artist. The idea that "time will tell" anchors a belief system that has propelled the avant-garde and also, in a quasi-religious fashion, worked its way into the heart of mainstream culture. The prototypes of this story so dominate our vision of culture's proper functioning as to be almost as invisible as water to a fish.

At the idea's core pulsesa concept that might be called the van Gogh syndrome. The artist, scorned in life, finds few kindred spirits, scant economic support, no favorable critical coterie, is misunderstood and reviled; pushed to culture's very periphery, the artist dies in obscurity and—in the ideal versions—in wretched conditions. The more debased and miserable the life and death of the artist the grander the subsequent

retribution. In this fable, posthumous transformation proves as important as the misery of the lived life. Biographical congruence to this story adds luster to the cherished artwork as a paradigm of quality; obscurity equals uncompromised quality. Suffering is transformed into merit, excellence. The proof seems ubiquitous. Today van Goghs sell for the equivalent of warships. The life and scourging of Jackson Pollock only added to his art's eventual acceptance, as did the miserable career of Arshile Gorky, the bitter death of Mark Rothko—and many others. Yet Vincent van Gogh remains the best and archetypal example. Unlike even Mozart, who enjoyed celebrity during his life but whose ignominious death was assimilated into the Romantic hagiography, the more oblivion the artist is forced to eat the greater the vindication in the afterlife. It does not take much to discover the appeal of this story.

Although some religions harbor minor tales of this posthumous isometry, such as the Japanese cult of Kitano Tenjin, the quintessential version of this story is the life, teaching, suffering, death, and resurrection of Jesus. The narrative of Jesus' life pervades every aspect of occidental culture, and critiques of the New Testament (the analytic methods and the form of the homiletic and hermeneutic) supply the basis for non-formal logic, for reasonableness if not outright rationality. This New Testament aesthetic and method of reasoning supplies the folkloric test against which high culture must measure its accomplishments. The fabric of occidental thought is shot through with this story. Accordingly, fairy tales are full of instances of the low made high and

**studio of david slivka, new york, october 1993.** Justice thereby reinstituted in the world (*Cinderella*). In modern children's stories (*The Ugly Duckling*) this retaliation by time lingers a common theme and is thought a salutary model to instill—despite its wildly atypical resolution and the expectations thereby set up.[2]

Despite its cultural pervasiveness, the story of the low made high or the restitution of the disenfranchised (e.g., the discovery of King Arthur) is not essential to the development of the canon of the occidental arts. Formerly the premodern arts did not explicitly engage in a critique of their inherited values, and therefore the standards by which to judge the arts were known to all and talent was generally not undiscovered or misattributed. Certainly in antiquity the arts were relatively angst-free occupations. The master sculptors and painters of the ancient world do not come down to us as

neurotics, ill-adapted socially, or unappreciated in their time. These artists ran large ateliers with assistants and business directors. Their operations were akin to the modern vertically integrated gallery that promotes its artists (and may solicit from them specific products), merchandises its wares, and attempts (through press manipulation and the conning of cooperatively gullible investors who, for social reasons, wish to masquerade as collectors) to make and control markets. In the Middle Ages circumstances did not change much from antiquity; things progressed this way to the threshold of the Renaissance. Melchior Broederlam (active 1381–1409) painted noblemen's shields, banners for banquets, and other temporary decorations, as well as the altarpieces and fine art pictures by which we know him and espy the glimmerings of the modernist personality.[3]

The artist was first a high-class decorator, as the serious musician was a high-class entertainer.[4] In the visual arts the idea of the Genius gradually displaced the Decorator/Entertainer until the artist's job was no longer *primarily* to display a canny artistic intelligence in the manipulation of (mainly inherited) forms, but to present the author's personality, whole, unaltered, authentic. Authenticity became the hallmark of the modern(ist) artist (in Eugène Delacroix's early work, and in music, at the *latest*, by Beethoven's Third Symphony), and with psychological genuineness arrived the possibility to be artistically successful yet generally incomprehensible. This is the matrix from which was born the van Gogh syndrome. It was possible to be a good or even a great artist in the midst of complete misunderstanding and concomitant obscurity.

Certainly in the past, maladaptation was possible (if detrimental) for the successful artist, but not as a constituent of the art. From the fifteenth century we know of Hugo van der Goes's (d. 1482) clinical depression and his retreat to cure his illness amid the shelter of a cloister. To this mix of creativity and pathological depression, modernity contributed the normative status of the unfathomable and unadapted art; the artist's strivings were properly positioned opposite to his audience's. In this Romantic paradigm, unlike the ideal of any other historical moment, celebrity itself became suspect: how could an artist be good and yet generally please even the critically informed public? To do so implied a fawning promotion of outworn assumptions, ideas already accepted as society-wide presumptions, hence kitsch. Yet there is no discernible reason why Jack Boul, for example, should be any less vaunted than many another contemporary realist. Commercially successful artists of far less sensitivity pound out their landscape recitations aided more by promotional publications than the vitality of their vision. Boul's malady is not restricted to the arts. (It has been noted that professional sports teams get more press, regardless of their performance, if they are located in a media center.) Recent American art has scattered from the cosmopolite coasts to the regions without becoming suspiciously Regionalist, and, with effort, these dispersed artists can dwell as rurals or suburbans without becoming provincials, linked by rapid travel and informed by electronic media. Yet media prejudice against geographic dispersion persists.

By offending the audience, the sure mark of the avant-garde appeared in derision (a stigmata administered by the press), and only the avant-garde was capable of quality in this schema based on *initial* rejection. Hence obscurity was not a flaw of promotion and

entrepreneurship, but a positive value—up to a point. The whole mythology hinged on the artist's eventual recognition and elevation. Importantly for the present case, local or regional reputations do not equal fame. Thus the works of Sidney Gordin, Frederick Hammersley, or the late Felrath Hines if managed differently might yet have much larger followings. Within their localities these names are revered.

Despite the pasts' frenzy to associate with celebrity, the former, premodern, sort of hero worship was decidedly class based. The successful artist was an ornament of the aristocrat in whose circle he might survive, more-or-less well. To prosper, no artistic critique of aristocracy, or society's nurturing of the ruling class, could be too harsh or analytic. Consequently, Voltaire fed at the table of royalty only so long as manners and wit concealed his thought's revolutionary assumptions, and sometimes even that was tolerable when amusement could be had at the expense of succeeding generations—spendthrift. (*Après nous le déluge* was not coined by Ronald Reagan.)[5] The giddy tone of aristocratic amusement descended down into the upper middle class that consumes much of today's contemporary art, and for such an audience a real avant-garde examination is uncomfortable, although the van Gogh syndrome remains appealing. Despite the myth of an artist's posthumous recognition, which rights the wrongs and slights of contemporaries, the generational roster of fame is more-or-less set during a productive lifetime, then reshuffled endlessly—which makes the stakes really high. Art historians, critics, and certainly the public rarely discover and acknowledge a long-dead unknown, with the exception of a few van Goghs or Vermeers. Generally only a few names come to stand for each era, and failing to make that list while alive mostly equates to eternal obscurity.

The dilemma is not lost on the marketplace. The collector is enticed into believing that acquisitions are shrewd investment hedges against the future. In this racket, whatever price can be foisted on the unwary buyer is assured to be a fraction of future worth ("remember van Gogh"). The scheme offers no place for the genuinely haunting images of a Jon Serl, unless such imagery can be fastened to some social or extraneous issue.

The concentration of fad-shaping in the hands of a few market makers is especially astonishing after twenty years of hyping "pluralism." Ultimately diversity, tolerance, and expanded definitions evaporated because "pluralism" in the arts depended on marketing marginal products when the real goods were not available—and finding rubes to buy and exhibit these accented impersonations of art. When trafficking with investors posing as patrons, the contemporary dealer and the press cannot tolerate real obscurity, real ignominy, real crankiness. Accordingly, a clutch of petulant, semi- or (totally) unschooled, prodigies are trotted out instead of the avant-garde that the public has come to expect.

Despite the current exhibition's avowed deficiency of fame for its subjects, no such ersatz artists are featured in *Still Working*, which serves as a touchstone to discover the bogus. The "still" in the exhibition's title should tip off even the most slack-jawed observer that momentary crazes are not at issue. Is Hammersley really less than some other hard-edge painters, for instance? Or are market forces at work? By way of illustration, Constance Cohen's terse pictures are never as forced as the products of the "discovered"

94

and celebrated naïves who now pass for folk artists—under the rubric of "outsider" art. How well behaved Cohen's pictures are, and therefore how unfashionable. Her works' clarity, devoid of psychopathology, does not claim a false and impossible primitiveness in the age of television; so without delusions to excuse her or feigned ignorance, only the pictures remain—the sublimate of art most spectators are least equipped to ponder.

The counterfeit avant-garde artist imitates cantankerousness; this much is essential for commercial promotion. Mock rage resembles the genuine irritation with the condition of art and society felt by a bona fide avant-garde artist. Today bad manners will do instead of talent, and gallery hype can fill in the difference. Lack of artistic finish (and the impossibility of defending the artistic product with the criteria, canon, standards, or taste of the past) flouts the gone intelligentsia's incisive mirroring of conditions. Hence there is little time to savor the contemplative delicacy of which Roberto Estopinan is capable. Reticence is certainly unfashionable; let him but slash his finished pictures in mock anguish and he'd have to beat the rubes clutching big bucks away from his door. Quietude itself is suspect: where is the clamoring for attention, for fame? The new celebrity, in short, does not resemble the former triumph of avant-garde dynamicism over societal inertia. There are no Beethovens or Goyas home; consequently, obscurity cannot mean what it once did. The causes of fame have changed and accordingly the reasons forobscurity.

**hans burkhardt with film crew, hollywood, california, january 1994.**

Finally, another assumption about the relative weight of celebrity and obscurity veins *Still Working*. Fame has always seemed, on some level, a reward for meritorious conduct, for daring, for virtue, for hard work, for gumption. There remains the widespread assumption that if an artist, or indeed anybody, is rewarded by being singled out for renown he must have done *something* worth the compensation. This moral judgment outlasts everything we learn about celebrity after leaving formal schooling because part of the job of schooling (no matter how successful at instilling a sense of probing critical interpretation) is to impart an almost religious theory of worthiness in the grading system and to inculcate a baseless notion that meritoriousness rules in the world beyond schooling. That the rich or powerful accomplished

**95**

something, however esoteric, to warrant their liberation from labor supposes that creating wealth involves hard work and risk—even when chicanery is often the rule. Schools teach that politicians are noble, even as models of nothing less than ambition; their biographies are shelved near those of scientists and artists when it is plain that any office can be filled by an undead corpse. Yet genuine invention is rare and not necessarily rewarded. In fact, sometimes it is penalized.

Claire Falkenstein, best known as a sculptor, is one of the truly underrated artists working in America today. She is a genuine explorer of space. Her reward has been to labor with a fraction of the reputation she should enjoy and that she merits. She struggles against the massive weight of all of Western culture—as do other artists in and beyond this exhibition—and for reasons of gender, timing, style, and perhaps bungled merchandising hers is hardly a household name. Her condition as an artist only mimics patterns long established. The illusion that eminence is the recompense of virtue is further reinforced for the public by humble lives of saints—who, after all, become famous, are beatified, and are elevated to Heaven, and whose feast dates stud the calendar. Here again, humility and suffering seem annulled by eminence, indeed immortality. So clearly is a prestigious reputation the justly expected pay for honest toil as a creative artist that

studio of sherman drexler, newark, new jersey, october 1993. those in *Still Working* remain suspect for not having achieved that which all schools teach is a virtue: fame. That is to say, perhaps these artists deserve their obscurity. This is more than annoying; it is an unfounded prejudice that must shrived.

*Still Working* recognizes that, like science or other productive endeavors based on dialectical innovation, artistic "progress" is made by lesser lights as well as by the clutch of names that constitute the public consciousness of art history. Without the idea of art's making headway against history—of its self-augmentation and self-repletion—such an exhibition would have little meaning. As a survey, *Still Working* allows the public to evaluate the artists other artists mention. Fame is subtracted from the issue. Not that celebrity does not have its uses. Fame, arriving even at the last moment, would have saved the lives of van Gogh, perhaps Jochen Seidel and Arshile Gorky, and a refreshed reputation would certainly have helped Rothko. Modulated

pressure from the marketplace might have saved the life of Nicolas de Staël.

Fame would do some of the artists in *Still Working* some good, and perhaps award another measure of confidence. Here we collide with another shallow yarn. That success can broaden an artist's enterprise is witlessly overlooked in preference to the fable of artistic misery-as-creative-spur. No one knows how many Monets were destroyed for want of rent money. Instead the myth holds that poverty and obscurity are the stuff upon which creativity feeds. Rent money, a full belly, and medical care for the kids are only partly the point. In fact, the artist can be driven to a wonderful concentration of means when secure that the audience is actually paying attention—and certitude of the audience's indifference accounts for the cluttered look of youthful art when "everything" is crammed into each work. The student, the ephebe, the journeyman, can never tell if anybody will see the work, and that suspicion causes an anxiety that only increases with years of obscurity.

Just as a lifetime of scientific work can be gainfully invested in labors meaningful only to other scientists, certain artists fulfill the requirements of art's intellectual honesty by not dropping what they are doing to adopt the latest fad. Somebody must exhaust art's implications, as (to mention some artists not in this show) de Staël and Giorgio Morandi recovered materials latent in Paul Cézanne, Anthony Caro mined the potential in David Smith, and Seidel explored what was dormant in Willem de Kooning. Mere novelty is hardly the point. The qualitative debate must always echo between peak achievements, but the heights that art can reach are sustained by many who are never celebrated. That is not a virtue, nor is it a necessity. These distances graph the tragic in art. Ultimately and unavoidably, *Still Working* concerns fame, and the lack of it, obscurity.

Notes are on pages 182 - 83.

*erica d. passantino*

# where past and future meet:
## the janus-faced nature of the studio

*t*HE MODERN STUDIO IS A PLACE OF SOLITARY INTROSPECTION–NO LONGER the renaissance workshop, the salon of the academicians, or the garret of Parisian bohemia that spawned an entire industry in music and literature. Two American artists have left eloquent statements about their studios—Georgia O'Keeffe in a painting, *My Shanty, Lake George,* 1922, and Alfred Stieglitz in a photograph, *Little House,* of around 1933.[1] Representing their respective studio buildings at Lake George, both works are at once *of* a place and *about* a place, and each is an image of the artist's self as well. With its brooding palette and sinuous forms, the painting speaks about the painter's art and mood. The photograph, no less expressive, shows a building crisply defined by light and shadow, the essence of the photographer's art. Both have half-open doors that reveal only darkness. The artist's life within is not open to view, and outside demands stop at the door. Inside there is no "art world." As Barnett Newman said: "The scene is the artist working in his studio; everything else depends on this."[2]

This Janus-faced place of darkness and of light is "imagination's chamber" but also the place most fearful in its demands.[3] Here the artist confronts success or failure, inspiration or despair. The studio is Janus-faced as well in that it contains the dualities inherent in the making of a work of art, a process at once conceptual and tactile, intellectual and emotional, revealing and obscuring. Sometimes the material evidence of this process adds a still-life quality to the room—a glistening heap of metal shavings, notes scattered on a desk, piles of discarded paint tubes, hundreds of brushes arranged in jars like flowers in a vase. They tell about an act that Vera Klement has called both erotic and philosophical. For Mala Breuer it is a spiritual event that parallels, and in turn elevates, life itself. Edward Dugmore insists that it is entirely unconscious, while for Frederick Hammersley it is the rigorous application of logic and a classicist's need for balance.[4]

The studio is Janus-faced, too, in that it is the knot in the ribbon of time, the point in the present where memory and experience inform the future. For artists who can look back on decades of work, memory fuels this process and becomes the storehouse of imagination. Specialists believe that as we age, forms of memory arise that integrate personal history into the greater whole of the history of society and culture, patterns of reminiscence that occur "at a stage in which the individual reviews life necessarily self-consciously and seeks to reconcile lifelong conflicts through acceptance and recognition of a meaningful whole of past experience," or, in Erik Erikson's view, in late life we have the choice between wisdom and despair.[5] Therefore, the question as to an idea's origin addresses a wide range of sources. Was it born now, captured from the

**98**

hurricane of visual stimuli that daily assault our eyes, or was it called forth from the depth of memory—a shred of conversation, a passage of myth, a debate about the nature of surface, space, or edge? Is it descended from the compelling power of Abstract Expressionism or from the academic tradition? Dada? Geometric Abstraction? Surrealism? Hans Hofmann, Willem de Kooning, Josef Albers, Henri Matisse? The American scene? Léger's visit? Duchamp's reticent and yet formidable presence—his absence? Does the work of art created at the close of the century hold within it the resolution of the age, and did the decades keep their promise to American art?

Regardless of style or manner of work, a private dialogue with the medium lies at the heart of the effort, and if that dialogue has lasted decades rather than months or years, and the words have not grown stale but rather deliberate, convincing, and fresh, then intent and achievement move ever closer toward each other, and in Donna McKee's words, the resulting work of art "expresses the tension between physical existence and life of the mind and spirit."[6] The greatest surprise for the viewer—and often for the artists themselves—is the breadth of new possibilities that are being explored for their own sake, driven neither by market considerations, current trends, nor the need to build a career. If then this intense exchange happens in the studio, the place assumes an importance second only to the work of art itself, indeed at times becoming the work of art, as one example in the exhibition shows. Talking about this "mystery of environment," Alexander Lieberman asks: "What relationship exists between the painting and the vision of reality that daily the artist has before his eyes?" And Robert Motherwell answers that in a studio, *everything that you make is related to the room in which you are working:* to the scale, to the light, to the color of the walls . . . the view within, the view without."[7]

More than a year ago, when the exhibition *Still Working* began to take shape, the question arose as to how the visitor could share in the visual excitement, this feast for the eyes found in the studio environment and in the process of selecting works for the exhibition. Photography appeared as the intermediary, the way to let the viewer meet the eye and hand that struggled for the object in the gallery. In turn, another work of art, the photo essay by Larry Fink, was created.

With few exceptions, this exhibition reflects an almost classical approach to artistic production. It is a celebration of painting, drawing, and sculpture as they are created in the studio. Absent are site-specific works or those using electronic devices. Yet there is a distance traveled from the still-life quality of Jack Boul's space to the detachment that leads Morton Bradley to eschew production entirely. At times the very walls become conveyor of ideas, such as the Native American prayer sticks and ceramics that surround Florence Pierce or the few prints tacked to Martin Canin's otherwise bare studio walls, a far cry from the wild assortment of props that give Robert Wilbert's studio the same appearance of transported reality that inhabits his paintings. In the artist's visual inventory, everything is up for evaluation.

## studios of the mind

The studio need not be a place and the work of art need not be an object created in the context of traditional production. The twentieth century has telescoped changes in the methods of artistic production that took centuries to develop, a gradual individuation where the artist is the actual locus of the work of art, as he or she converts spiritual substance into matter or words. And it is the gallery, the exhibition, rather than the studio, that become the true place of validation. Without a handmade product, or an object that reflects the standard notion of authenticity, the traditional sequence of idea, product, and market has been changed, or indeed eliminated.[8]

**Morton C. Bradley, Jr.** Morton Bradley's "studio" resides in thought, at once mystical and rational, about the laws that govern geometry, color, and motion. He calls his visions "findings," for he believes that through these interlocking space-frames, a synthesis of geometry and color-space, he merely makes nature's laws visible. Bradley never draws or constructs his pieces but conveys his ideas through word and gesture to his collaborator of many years, Linda Priest. Her small maquettes, or "sketches," are often based on multiples of the Platonic solids, their proportions based on the golden section. Joseph Parker and Harald Robinson manufacture the full-scale pieces, which are then painted in colors determined—not chosen—by imposing the basic configuration over a sphere covered with the Munsell color chart. The interrelationships of location and proportion determine the ratio of coloration. Bradley's titles, however, are poetic homages to music, philosophy, or mathematics—*The Great Machiavellian Knot, Staccato, Homage to Kepler,* or *Plato.* In a room above Priest's studio, numerous pieces are suspended from the ceiling; slowly, and in astral silence, they rotate, their construction and motion mirroring the perfection of the universe.

**Ernest Acker-Gherardino** Then again, the studio might reside in the demolition fields of the Bronx, where the wrecker's ball and time have created objects out of the debris of our industrial proclivity. Fragments, violently crushed or corroded, await the selective eye of Ernest Acker-Gherardino, whose studio of the mind combines a modernist formal aesthetic with the melancholy sensibility of the postindustrial age. He calls his discoveries "dump works." Are they instances of America's own archaeology, the postindustrial era's first encounter with its erstwhile golden age? Acker-Gherardino scours New York neighborhoods and installs the objects he finds in his apartment or on his terrace among other works of art, photographs, and objects rich in personal associations, and in so doing assigns them artistic validation. By studying their gradual deterioration, he contemplates the passage of time. With the calm of the Eastern mystic, he observes in himself "the disappearance of the ego, the merging with the work. . . . One becomes a conduit." Whereas the moment of discovery is the determining aesthetic event, the metamorphosis of the object's further decay offers another instance when "the present is abandoned and they return to nature."[9]

**Don Baum** Mies van der Rohe's first lakefront apartment building, an icon of the modernist aesthetic, is where Don Baum lives and works. The walls reflect his career as a curator and teacher: works by students, friends, or "outsider" artists are installed in visually and intellectually enticing juxtapositions. Baum's selections, at times dis-

**100**

turbing or irreverent, betray a keen sensibility and a razor-sharp wit. Very few of Baum's own works are to be seen here—one of his small houses reminiscent of reliquaries or ancient dwellings and a later portrait assemblage. Driven by visions both personal or cultural, and fascinated by the remnants of popular culture, he builds his sculptures out of old cutting boards, paint-by-number panels, and paintings on velvet, which he finds at yard sales. He limits his creative involvement to assembling them into new objects of great expressive power and surrealist estrangement. Their sentimental scenes and gaudy colors purposely obscure Baum's personal attachment to model or content as well as his preoccupation with the house as sanctuary of the spirit and as the space of private and public ritual.[10]

### the studio in the home

The most intimate association between art and life is achieved when home and studio are one. A desk by the window, a room, an upper story allow the artist to retain close contact with daily endeavors, as did Constance Cohen in her records of the lives of mothers and children. At times it encourages imagery that emerges from cultural memory, such as the landscapes of Sal Sirugo, the drawings of Roberto Estopinan. Hans Burkhardt's mountainside house perpetuates the atmosphere of his Swiss heritage. Art can also spill from the studio into all of daily life, taking over every available space, as Miriam Beerman and Frederick Hammersley have discovered. In Jack Boul's case, the comfort of home extends harmoniously into the place of work.

**Jack Boul** Jack Boul's work space is a classic painter's studio. His easel, meticulously arranged brushes, and a monotype press in one corner reflect a time when a painting's destination was most often a private collection. He is oblivious to the need to be "modern" and centers his focus on the Italian light of early Corot, the moist greens of Courbet, and the lush foliage of Constable. However, far from considering himself a traditionalist, he confronts the issues of contemporary art in his own manner: "I'm interested in gestures, divisions, how you turn corners. . . . I'm interested in a number of things besides just the subject."[11] His Arcadian world of cows in pastures or paths along the edge of a wood is like a refuge. Darker visions are expressed in moving monotypes that commemorate the human horror of the holocaust; they are his *memento mori*. Although Boul lived and worked among them, he never felt challenged by the techniques or large scale of the art created by the so-called Washington Color School painters. Instead, he is convinced that "some of the best things I know are small; a Vuillard, a Corot, a Vermeer say it all."

**Roberto Estopinan** Living in a New York suburb, Roberto Estopinan and his wife, the poetess Carmina Benguria, have created an environment that reflects the graceful dignity of the Spanish-speaking world. His sculpture studio occupies the basement, but throughout the house are signs of his work as a draftsman. Originally a Cuban diplomat and a friend and contemporary of such artists as Alejandro Obregón of Colombia and Jesús Soto and Alejandro Otero, both of Venezuela, Estopinan developed his art within a classical tradition, enriched by several extended stays in Europe. Spanish, too, is his works' celebration of beauty at that painful but exquisite point where life

meets tragedy and death. The delicate strokes of his drawings equate the sensual caressing of a body and conjure the beauty, passion, and tragedy of Rodin's muse, the artist Camille Claudel. The torso theme, which has occupied him in sculpture and graphics, came to him in Italy in 1980, when he was invited to participate in the international homage to Miró. Another recurring motif, the "erotic bone," arises in drawings as well as sculptures and mingles the sensuality of the Claudel drawings with the appearance of prehistoric bones or fossils, "as if the sculpture searches for its origin."[12]

**Constance Teander Cohen** Originally from Iowa, Constance Cohen is descended from Swedish immigrants and carries within her the gentle mysticism of the Northern romantics. For forty years she has lived and worked in a house in Evanston with her husband, the painter George Cohen, raised their children, and created paintings of dreamlike distance or bemused observation. Their immediate imagery is drawn from everyday experience—swimmers, lifeguards, children—or inspired by the family's stay in Italy that brought her surrealist visions of decaying antiquity. Cohen cannot imagine painting before she knows exactly how the composition will materialize; she studies the blank canvas and knows what it will hold: "I definitely see the painting." Her titles sharpen the message of her subjects, often a poetic interpretation of women's lives, such as *Eve's Dream, Women Playing with Childhood Toys,* or *Rowing in Eden,* the latter derived from a poem by Emily Dickinson. A self-portrait as a young girl, hanging over her seat in the dining room, is a daily reminder of her own youth, and paintings and sculptures of her children—in playpens, as adults and practicing musicians—make their presence felt, their stages of growth captured like commentaries on a life lived.

**Sal Sirugo** Sal Sirugo lives in Manhattan and works by the window among racks of completed drawings that testify to his single-minded dedication. Some of his works are so small that they are drawn with the help of a magnifying glass mounted over his drafting table. His vision, however, is vast, meditative, and absolutely intuitive, and the abstractions especially reflect the artist's kinship with Abstract Expressionism. He works in series, heads, eyes, or landscapes, but allows the individual images to become what they demand to be—works of intense spiritual power, Arcadian dreams in velvety darks and luminous mists. Sirugo often stains his paper with tea or coffee and, working on wet paper, adds ink with an eyedropper, fine brushes, or Q-tips, directing the flow of the spreading ink. This careful listening to the medium gives the resulting ink drawings the appearance of being open to metamorphosis, as though they were part of the growth of primordial swamps or bogs out of which all of life once emerged. He has discovered that sometimes the smallest form, a dot on a blank sheet, can imply the largest expanses of the universe, and having understood this, Sirugo acts with trust, knowing that "all is accident, but in the accidental there is control."

**Frederick Hammersley** Patrician, warm, erudite, Frederick Hammersley is endowed with a keen sense of history and a lyrically humorous view of the world. His paintings and drawings, as well as photographs of his family and youth are spread throughout his house. The walls are painted in luminous colors and like his paintings seem inspired by the study of countless color samples that identify his paint jars, their order and harmony almost works of art in their own right. Hard-edged, organic

abstractions have occupied him since 1981, their monumentality and visual impact belying the small scale. Associated with Los Angeles Abstract Classicism, Hammersley contemplates the meaning of the classical tradition—balance, measure, as well as unity of time and place, and yet his method is spontaneous and follows what he calls the "logic of feeling." This intuitive process imbues both color and form with a musical lyricism. Although generally flat and highly finished, occasional shapes show a painterly transition from one color to another, adding the element of time, of volume and growth, and leaving a visible trace of the artist's hand. Figure drawing is the foundation of his work; there he discovered the pictorial equivalence of subject and background that fuses his compositions as tightly as a painting by Ryder. Hammersley builds his own frames (he calls them "bit players"), meticulously carved, stained, and leafed. Titles, too, are chosen after completion, and they are derived from long columns of word associations such as *Payday*, *Small Wonder*, or *Money from Home*.

**Miriam Beerman** In stark contrast to the sun-filled radiance of an Albuquerque afternoon, the gloom of eastern winter corresponded aptly to the shadowy demons and visions of disaster fueling Miriam Beerman's art. She works in a large suburban home that belies in its comforts the private fears and sense of isolation as well as the terrifying imagery of the holocaust that haunt her. With superb craftsmanship, she has moved from animal subjects, their velvety darkness as noble as a work by Velázquez, or creatures as demonic as Goya's, to an intense expressionism with agonizing human imagery. The surfaces are tortured and increasingly laden with paint that is sometimes mixed with wax. One work is inscribed with the words "Death Knows Me," and her titles, especially, reflect the fusion of historic and personal imagery: *The Flea* from the *Plague* series, *Corridors of the Soul*, or *Gulag (Feeding the Muse)*. Drawings and collages are hung throughout the house, and her paintings' scale long ago exceeded that of the skylighted studio on the upper floor, now occupying every room, at times even the floor. Their size underlines the urgency of Beerman's insistent message about a human reality that has grown more horrifying than any nightmare or biblical plague.

**Hans Burkhardt** The studio and home of Hans Burkhardt overlook Los Angeles from a hillside; rich vegetation adds to the romance of place. Over the years, and in backbreaking labor, the artist carved terraces and built a house, its stone walls, sturdy woods, and saints set into niches creating a nucleus of his cultural heritage, the Alpine mountain homes of his native Switzerland. In poignant contrast is the sheer tragedy expressed in his art, images of death and mourning for innocent victims of global conflicts—a commitment that reaches back to the Spanish Civil War. A recently completed series of paintings, *Black Rain*, represents an emotional outcry, a fusion of grief on many levels: for women and children killed on a hill in El Salvador; for our nation's violence both private and public, symbolized by a tattered flag with a white stripe representing both mourning and hope. Finally, it is a gathering of private memories, of his sister's death many years ago and the recent loss of his wife. His art grew out of a passionate expressionism and the influence of his mentor Arshile Gorky, who remains at the center of his thoughts. Peter Selz has written that Burkhardt "extended the structures of Abstract Expressionism into the realm of political engagement."[13]

**the loft studio**

Artists whose first influences date to the heroic age of Abstract Expressionism were formed by that era regardless of their eventual choices. Often they were the students, friends, or admirers of Willem de Kooning, Clyfford Still, and Arshile Gorky (names frequently heard in conversation), and for them the studio remains the place of refuge. Their sense of self was formed during an art-negating time that considered contemporary art, abstraction in particular, foreign and possibly subversive. Explanations for this need to turn inward range from the intellectual to the political. On the one hand, the public programs of the 1930s had prepared the ground for the study of culture in the abstract, thus inviting the depiction of ideas and symbols rather than appearances. Others find reasons in postwar society's acceptance of public myths convenient to the idea of progress, material success, and wholesomeness, which compelled artists to create myths of their own and express them in "heroic mythic pattern and ancient rituals."[14] This broad vision often led to large works requiring spacious studios. Therefore, the urban loft may well be America's contribution to the iconography of the studio.[15]

If the artist lives in the studio—as opposed to having a studio in the home—the intense confrontation between art and life is palpable upon entry. Like children in a family, new works take their place within the community and become a constant presence.

**Edward Dugmore** Until their recent move to Minneapolis, Edward Dugmore and his wife, Eadie, lived in a New York loft. His Abstract Expressionism was formed as much by his studies with Clyfford Still, his lifelong friendship with fellow student Ernie Briggs, and the environment of the New York avant-garde. Now, though barely settled in their house, Dugmore had arranged a jumble of objects on a cabinet: pre-Columbian figures, rocks, and shells collected over many years; they were evocative as much for their formal qualities as abstract shapes as for their associations with the past. In touching them, he proved that memory "comes like a wave carrying with it the whole of life experiences."[16] Furthermore, he expressed his belief in the intuitive instant in a note pinned to the wall, one line of which reads: "There is only the immediate; all else is illusion." In a moving moment he invited visitors to help unwrap the painting that was in progress when Briggs died, many years ago. Overcome with grief and despair, Dugmore had scraped the paint off the canvas, retaining only the strokes made at the moment of learning the news. Now he placed his hand on this passage and in a generous gesture invited those around to join in the greeting.

**Julius Hatofsky** An artist-teacher at the San Francisco Art Institute since the early 1960s, Julius Hatofsky brought with him from New York a highly developed Abstract Expressionist vocabulary as well as the atmosphere of studio life. The first thing that strikes the visitor upon entering Hatofsky's large loft is a majestic painting that extends the length of the studio wall. It is a work-in-progress that has occupied Hatofsky for several years. Winged and curved at the top, it is reminiscent of Italian Baroque altarpieces at their most voluptuously space devouring. Other works cover every surface—large abstractions in billowing sprays of color or figure compositions that take their apocalyptic narrative from Dante or Blake and recall the locked density of

Ryder as well as the dramatic, voluptuous coloration of Delacroix. Although he does not generally give his works titles, Hatofsky has created a series of glowing, melancholy gouaches called *Dance of the Spirits;* he explains that they are so named "because my friends are all dead." Generous in scale, passionate and visionary in expression, Hatofsky's art is highly personal and stands in marked contrast to the artist's gentle reticence.

**Sherman Drexler** Sherman Drexler's studio space was once a factory. Now it is filled to capacity with hundreds of tiny dancing nudes and animal figures that emerge from the crevices of stones or concrete blocks and comport themselves on every available surface. They appear all the more minuscule for the presence of looming paintings, such as *Jacob Wrestling with the Angel,* or others depicting life-size horses. Drexler moves among them with great agility, a dancer among dancers. His joy is visible, so also is his endless, melancholy search for form in found objects, as though he were conjuring the forces that first drove the cave painters to animate their surroundings. Drexler remembers his astonishment when, visiting caves in France, he discovered that the eloquent forms command the space in a mysterious confluence of image and environment. In his own work, too, the figures' stance and gestures capture the entire surface allotted them, and energy radiates to the very edge of the block. In groupings, their motion extends from piece to piece, a frozen instance in a sequence of events, reminiscent of early photography.

**Vera Klement** Most artists in this exhibition share a sense of freedom driven by a flood of new ideas. Vera Klement puts this experience into words: "What amazes me as I age is that I get them for nothing; I don't have to ask questions." Depending upon a painting's requirements, she works on the floor or walls of her downtown Chicago loft, originally an office building, where she lives and works. She places a stroke and returns to the sofa by the window to contemplate the next; walking and painting—"that's what I do all day," she says. According to their process of production, the works move from the studio section to the long gallery space, there to be studied and judged against their peers. Her work combines cool intellect with passion born from personal and universal terror. Motifs hover on unprimed canvas, symbols that are isolated from one another by the white chasm. She explains: "I paint only objects; even a landscape is an object because it is isolated on the white." The very tactile forms betray the emotion of the act of painting itself, while the geometry of repeated shapes avoids sentimentality. Each painting is an "event." She used to need narrative, but not any more. "*Then* you had to be obscure; *now* I paint what I think to be communicable."

## the studio as the second home

When the workplace is separated from private life, it takes on a more pragmatic, spare quality and is often located in former industrial, manufacturing, or office spaces. The focus is singleminded, and the environment reflects some of this concentration.

**Sidney Gordin** Like several other artists, Sidney Gordin left New York for the West Coast, where he taught at the University of California, Berkeley, for almost three decades. In the course of his career, he has moved from sculpture to painting and back again, and his studio reflects both a sculptor's involvement with heavy materials and the painter's concern for color: drawer upon drawer of Gordin's worktable

ernest acker-gherardino in his apartment, new york, october 1993.

ernest acker-gherardino, new york, october 1993.

guy anderson in the galleria dei gratia, la conner, washington, january 1994.

guy anderson in the galleria dei gratia, la conner, washington, january 1994.

robert barnes, bloomington, indiana, november 1993.

robert barnes, bloomington, indiana, november 1993.

don baum, chicago, november 1993.

don baum, chicago, november 1993.

miriam beerman in her home/studio, montclair, new jersey, december 1993.

miriam beerman in her home/studio, montclair, new jersey, december 1993.

jack boul, bethesda, maryland, march 1994.

jack boul, bethesda, maryland, march 1994.

morton c. bradley, jr., and linda priest, bedford, massachusetts, november 1993.

morton c. bradley, jr. at the compton gallery, m.i.t. museum, cambridge, massachusetts, november 1993.

mala breuer, abiquiu, new mexico, january 1994.

mala breuer, abiquiu, new mexico, january 1994.

hans burkhardt, hollywood, california, january 1994.

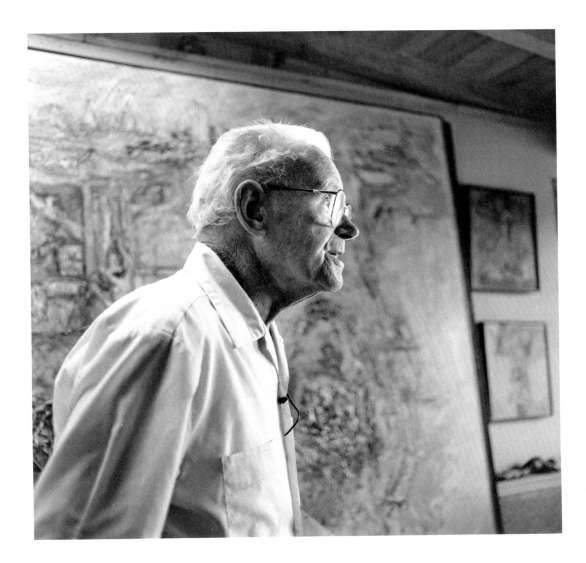

hans burkhardt, hollywood, california, january 1994.

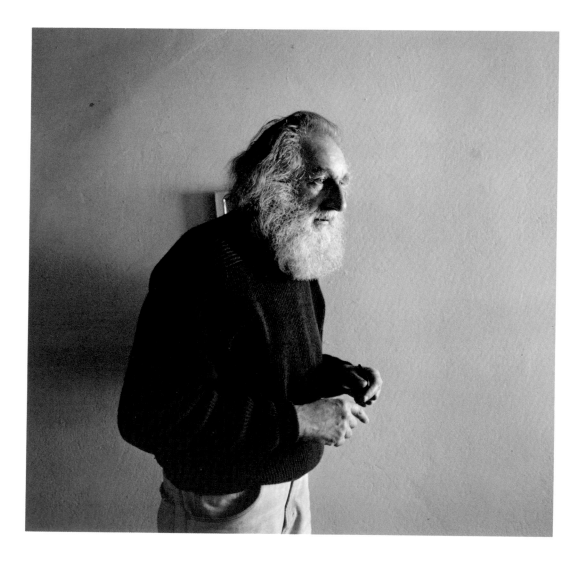

martin canin, rhinebeck, new york, january 1994.

martin canin's studio, rhinebeck, new york, january 1994.

constance cohen, evanston, illinois, november 1993.

constance cohen, evanston, illinois, november 1993.

sherman drexler, newark, new jersey, october 1993.

sherman drexler in his studio, newark, new jersey, october 1993.

edward dugmore, minneapolis, minnesota, november 1993.

edward and edie dugmore, minneapolis, minnesota, november 1993.

roberto estopinan, woodside, new york, october 1993.

roberto estopinan, woodside, new york, october 1993.

claire falkenstein, venice, california, january 1994.

claire falkenstein and assistant jill covall in her studio, venice, california, january 1994.

sidney gordin, berkeley, california, january 1994.

sidney gordin, berkeley, california, january 1994.

frederick hammersley, albuquerque, new mexico, january 1994.

frederick hammersley's apartment/studio, albuquerque, new mexico, january 1994.

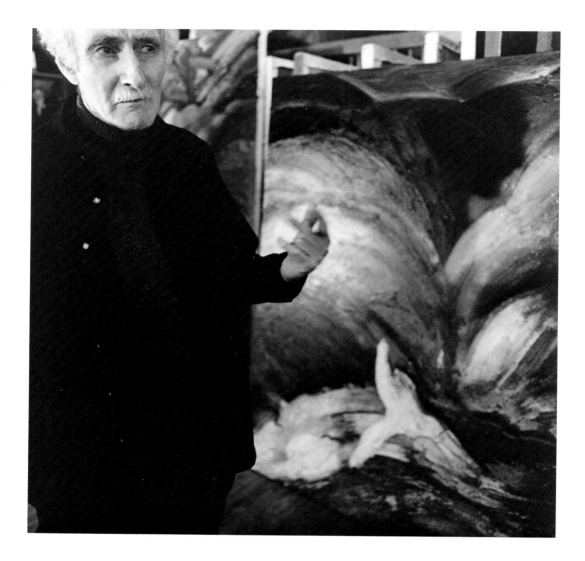

julius hatofsky, san francisco, january 1994.

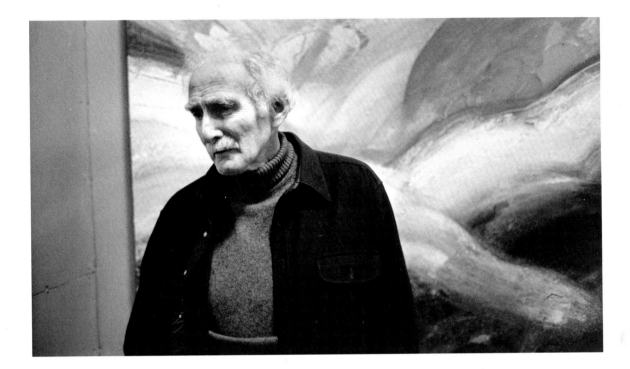

julius hatofsky, san francisco, january 1994.

mel katz's studio, portland, oregon, january 1994.

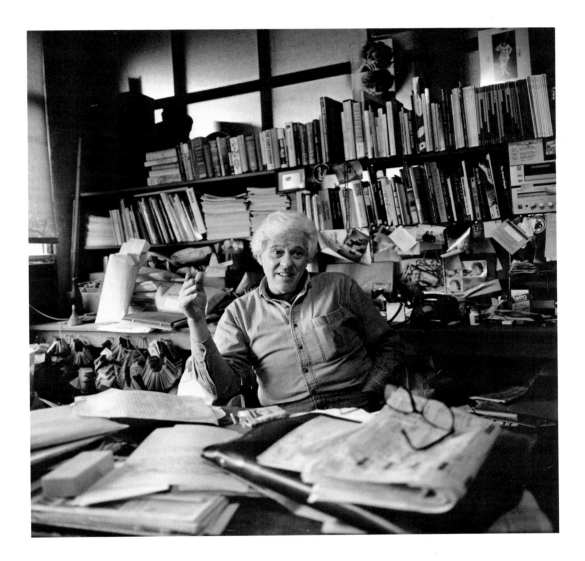

mel katz in his studio, portland, oregon, january 1994.

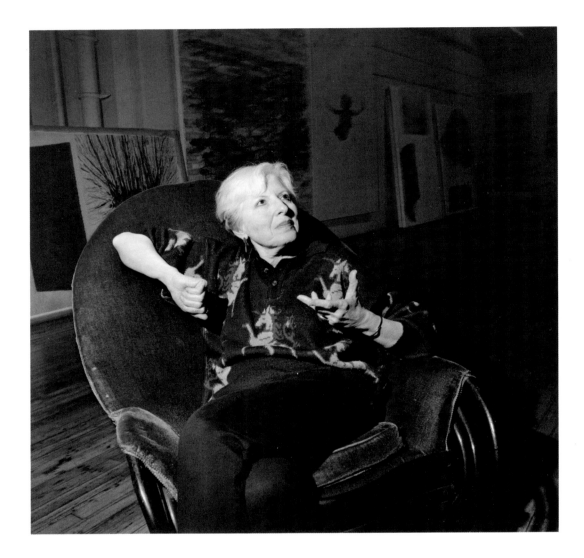

vera klement in her studio, chicago, november 1993.

vera klement in her studio, chicago, november 1993.

charles mcgee 's studio, detroit, michigan, november 1993.

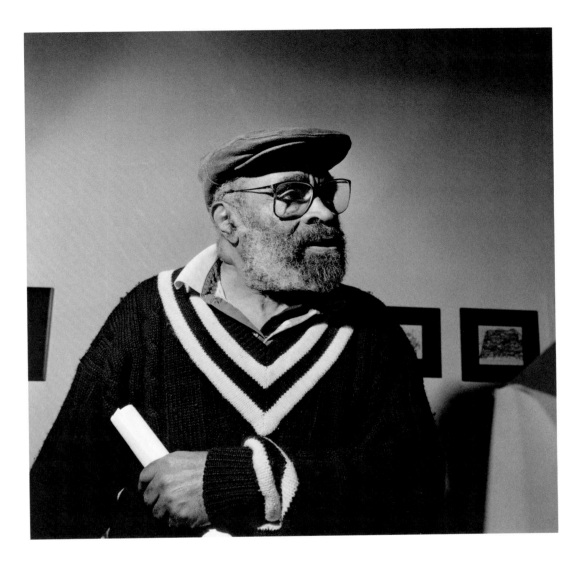

charles mcgee , detroit, michigan, november 1993.

florence pierce's studio, albuquerque, new mexico, january 1994.

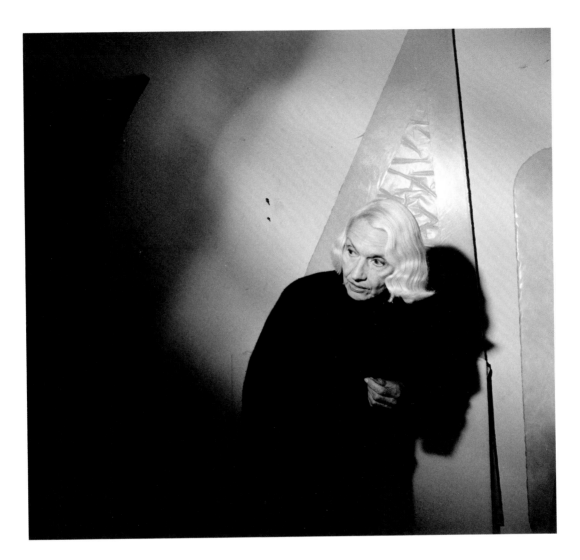

florence pierce in her studio, albuquerque, new mexico, january 1994.

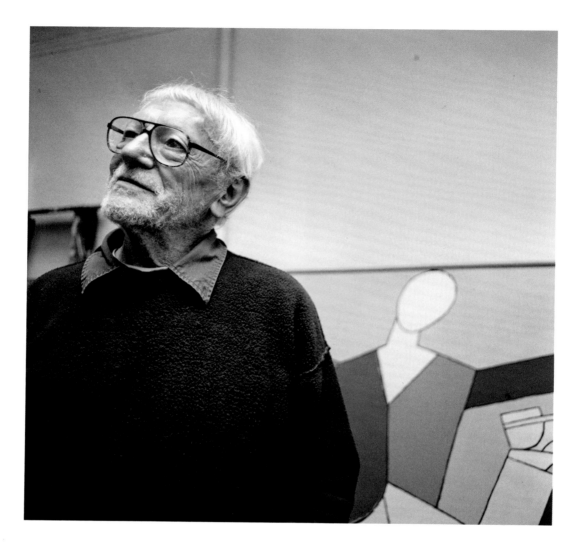

michele russo in his studio, portland, oregon, january 1994.

michele russo's studio, portland, oregan, january 1994.

sal sirugo in his studio, new york, october 1993.

sal sirugo in his studio, new york, october 1993.

david slivka in his studio, new york, october 1993.

david slivka, new york, october 1993.

stella waitzkin's works in her apartment, new york, october 1993.

stella waitzkin with erika passantino and stuart shedletsky in her apartment, New York, October 1993.

robert wilbert in his studio, detroit, michigan, january 1994.

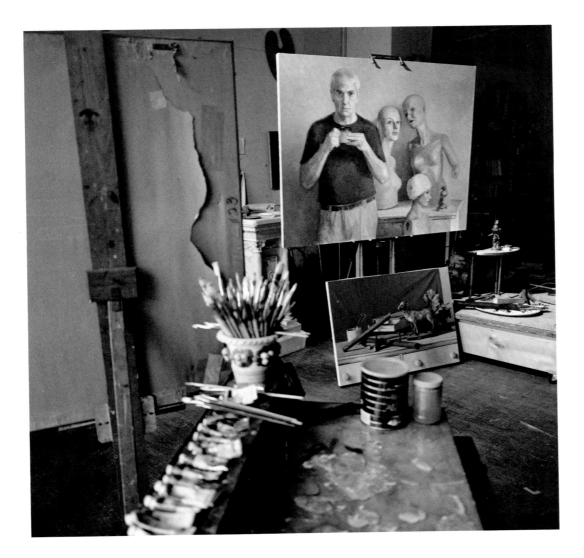

robert wilbert's studio, detroit, michigan, january 1994.

jack zajac in his studio with erika passantino and stuart shedletsky, santa cruz, california, january 1994.

jack zajac, santa cruz, california, january 1994.

hold jars labeled with color samples, arranged in gradations of shades like color studies by Josef Albers. His work recalls the classic era of modernism around 1922, when the Russian Constructivist exhibition created a sensation in Berlin, had repercussions in Paris, and eventually inspired the American Abstract Artists group in s New York; they in turn were important to Gordin. Today, his geometric abstractions show an almost sculptural interplay of solid and void. Hard-edged verticals and horizontals divide the surface, their colors contrasting or enriching one another in subtle ways and provoking pulsating energy. Fine lines dance above it, now receding into depth, now curving or sharply angled, thereby enlivening the composition. Gordin has consistently refined this language and explains: "Strange, recent works have fewer of the free forms because I work longer and longer, and they become more precise."

**Michele Russo** A friend and student of Boardman Robinson and a social activist since his WPA days in Connecticut, Michele Russo has concentrated on the human figure drawn from the model. In his paintings, line and hatching of these drawings became first broad strokes, later delicate black outlines, a meticulous graphic net over blank canvas that simulates the rhythm of jazz. He has worked on several series, the most important of which, *Hop, Skip, and Jump,* has occupied him for so long he has forgotten its origin. He is deeply affected by Italy, the mystery of its ancient caves, its images of female saints, and the rich tradition of figure painting. His own works depict dancing nudes—often accompanied by clad men—in forms reduced to graphic essence; at times, the bowler hat alone symbolizes the male and high-heeled shoes the female. He comments on his images of the human comedy, the dance of the sexes: "We artists are humanists; we adore beauty." In his studio, a turn-of-the-century office building that is now a local art center, numerous evocations of the human figure are installed in an offhand way—saints, dolls, and dolls' heads set into old tin cans like sculptures in shrines. Like his paintings, they lack all self-conscious pretensions but in their absurdity and juxtaposition heighten the mystery of the human image.

**Robert Wilbert** This subject occupies Robert Wilbert as well. He often heightens the study of a living presence by adding to his paintings china figurines or bald mannequins with frozen and meaningless gestures. Working in a representational manner, he manipulates both volume and space to balance the needs of depth against those of the painting's surface. His colors have a muted delicacy; they, too, remove the images from reality into the neighborhood of surrealism, without approaching the absurd, however. He asserts his belief in the richness of the visual experience and the heroic potential inherent in the tangible world. In his studio, its vast windows overlooking downtown Detroit, Wilbert has assembled a wild and spirited *wunderkammer,* or treasury, of knickknacks, vases, tables, costumes, a stuffed dog. All are actors in his compositions, brought together to become a still life that is also an intense and finely tuned probing into the nature of reality and illusion in art. Recently retired from his years of teaching at Wayne State University, he is turning to his own image within the context of his props and studio setting, thus heightening the drama of the confrontation between subject and object and giving testimony to his intense sense of belonging.

**Robert Barnes** With a studio on the campus of the University of Indiana, Bloomington, Robert Barnes's two lives as a teacher and artist mingle comfortably.

His studio is richly equipped to provide him intellectual and emotional source material: volume after volume on art, design, architecture, and esoteria such as Oriental tattoos or Mithraic mysteries; poetry and Graves's myths feed his need for word and image that derive from the dark side of the surreal, the romantic, and the melancholy, especially Rome's last centuries and the heritage of his own ancestry, Scotland. On one wall, carefully assembled like a votive corner, is a mirror of self in the form of self-portraits: as a young man of mythic dreams; as a boxer bruised by a fight, nose broken, head bandaged—next to it a photograph of the young Mohammed Ali, and just beyond a reproduction of Ryder's *Moonlit Cove*. Tacked over his easel is a small skeleton. Working very slowly, Barnes enters the realm of painting through various small oil sketches strewn about. From there he moves to the large canvas, ready to work in his spontaneous manner, letting narrative forms emerge within the composition, gradually and in free association, allowing them to grow out of the act of painting itself.

### sculptors' studios

"If it's process you want, here it is," said David Slivka, pointing out the studio sections that map the sequence of production from the contemplative space—a desk, a comfortable chair—where ideas are born, through sections with heavy tools, materials, and debris to the final display area. This emphasis on the craft is especially true in the case of Slivka and Charles McGee. With the exception of large commissions, for which they produce maquettes, they work alone, thus controlling the entire process. For Stella Waitzkin, her life itself is the process. She produces individual casts and installs them in her apartment, which is now filled beyond the point where she can inhabit it. On the other hand, Jack Zajac and Mel Katz must rely on the cooperation of others—the foundry, the metalworks, or the laminate shop. Sculpture of this kind requires planning, a certain amount of trust, and the ability to communicate ideas to others, be it through drawings or words. At a certain point, there are no second thoughts.

**David Slivka** Using nature's inventory—oak, cherry, sassafras—David Slivka builds thickets of growth—pure white, ephemeral, and celebratory—that reach skyward and harbor objects like treasures. They are a new departure for him. An associate of the Abstract Expressionists, he shares belief in spontaneity and intuition, which he combines with a craftsperson's respect for structure and material. He removes the bark from branches found on Long Island, cuts them into segments, and pegs them onto vertical supports that are half air roots, half dancer's legs. He does not work from sketches, but lets the wood pieces and the moments' vision guide him, explaining that "the forms grow out of the necessities of gravity." In his Manhattan loft that has been his studio for twenty-two years, Slivka has been working on the final stages of *Mangrove*. With a long pole he rotates the piece, causing the branches to undulate in a rhythm of structure and void. He recalls a trip to Sanibel Island where he had seen mangroves moving in the wind, their dense growth revealing glimpses at creatures hiding inside. Like an indulgent lover, he laments the time his meticulous work requires. Many a new idea had to be abandoned in the obsessive commitment to a piece more than two years in the making.

**Charles McGee** Part full-scale metal shop, part gallery, Charles McGee's studio is

a place of joy, where all of his interests find expression: music, photography, drawing, and sculpture. Maquettes for public commissions fill the space, and pieces for a large relief wait to be painted and mounted. The son and grandson of South Carolina sharecroppers, he came to Detroit in 1934 to become a carpenter and welder—the source of his superb craftsmanship. After extended study in Barcelona, he worked as an artist-teacher at Eastern Michigan University, Ypsilanti, for almost two decades. In his art he retells his grandparents' stories, his own childhood memories, and instances of African folk tales. His reliefs are a celebration of life, youthful to the point of jubilation. Metal cutouts of birds, snakes, egg forms, or human figures project from the background, their vibrant colors and intricate ornamentation interacting with their shadows. McGee sees himself and his work as part of the totality of life: "Nature has endowed me with the propensity to make these things," and, therefore, he feels compelled to celebrate all things natural in his sculpture. He trusts his instinct and his mastery of the craft. Materials only suggest; the artist carries them where they will take him: "After all these years," he says, "that's how pieces are made."

**Mel Katz** Like Michele Russo, his friend and fellow New Yorker, Mel Katz transferred some of the ambiance of SoHo lofts to Portland, where he has been living and teaching art since the early 1960s. He has maintained this atmosphere in the downtown studio that he has occupied for almost as many years. Originally, his sculpture quite literally grew out of abstract paintings, which became painted reliefs and finally grew into large freestanding constructions clad in Formica. In fact, these objects retain clearly delineated, flat surfaces defined by sharp outlines that betray his belief in the importance of drawing. Each is to be read individually but understood in volume. Recently he has moved on to metal sculptures, and their outlines and surface texture, too, remind of their origin in drawing, as the sketches on the wall prove. In his monumental Formica-clad pieces, Katz questions what is real, what is not real, in art and enjoys the estrangement of form or material from their common purpose. Now and again the Formica patterns add a painterly quality or illusion of space to the surfaces, which nevertheless do not stray too far from the kitchen countertop. Titles, such as *Confetti Stripes and Aluminum Too,* are often drawn from the names of several laminate patterns used for one sculpture. They stand in ironic contrast to the monumental dimensions of the works and extend the expressive qualities into the realm of cartoons or Pop art. In their posturing, these giants evoke images of the strong man in the circus who heaves inflated barbells into the air, freezing in his gesture when the music stops.

**Jack Zajac** Light from the nearby Pacific streams into Jack Zajac's studio, adding to the sense of Mediterranean humanism that emanates from his sculpture. The artist celebrates life by isolating an instant of its flow—columns of falling water frozen in lustrous bronze, or animals at the moment of ritual death—imagery that reaches back to Greece and Rome. The water pieces first occupied him in the mid-1960s, and he returned to the theme in the 1980s. Literal, pragmatic, and elegant, they are removed from representation and translated into totemic images of time and motion. Zajac works in plaster, creating a mold from which the sculpture is cast in three pieces. Thereafter, he adjusts the form, "trying to get it closer to what you imagine." Patina is devised in the foundry and applied under his supervision and active participation.

Like sentries, the finished pieces stand in his studio, their Gothic reach counteracting the motion of water's flow. In their extreme verticality they take on a fragile poise and strength that also suggest the undulations of muscles and sinews over bones. In spite of their monumentality, they are conceived with the knowledge of Pop art. Zajac calls them "monuments to things hitherto not thought worthy of commemoration."

**Stella Waitzkin** In New York's venerable Chelsea Hotel an entire apartment has become a work of art so pervasive that the artist no longer occupies it. Since the early 1960s, Stella Waitzkin has created resin casts that she installed in shelves reaching from wall to wall, from floor to ceiling, on every conceivable surface enveloping the viewer in a claustrophobic and mesmerizing totality she has titled *Details of a Lost Library*. Vaguely transparent casts of books express her view that "words are lies," only gesture is true. Faces and figures in luminous shades emerge in bas-relief from these books as though they were their very essences. There is the Dante series and the clock series titled *Who Dies?* dating from a period of mourning when time stopped, compelling Waitzkin to arrest it in casts of dining-room clocks. *Cutting and Fitting, Prenuptial Agreements,* and *Bible Stories* are titles of other sections. *Holocaust Stories* replicate furnace doors. In their entirety the rooms are a diary of personal experience, but also of cultural memory, laying bare the spiritual presences that share the rooms with Waitzkin. Any part of this environment is by necessity a fragment, for it is the story of a life, the artist and the work woven together in an obsessive, symbiotic existence.

## the spirit of place

There are places, be they cities or isolated retreats, so rich in atmosphere as to impose themselves on the art created in their midst. Perhaps artists choose them for their beauty, their meditative stillness, or perhaps for the inspiration that comes from observing the human comedy at close range.

Ever since the early years of this century, artists have come to New Mexico for the beauty of the land, the crystalline light, and the sacred traditions. They brought with them current styles and views, which gradually developed into new forms of expression. Artists who settled there after World War II often shared an admiration for Kandinsky and for Neo-Platonic notions, according to which spiritual realities lie beyond the visible world and find their equivalent expression in abstract art.

**Mala Breuer** A house near the Chama River, set among the red and white rock formations of New Mexico, reflects the spiritual qualities that animate Mala Breuer's art. Harmony is achieved through spare essentials—wood, stucco, and tiles—and whites, ochers, and grays dominate. The same serene subtlety animates Breuer's paintings. She considers her latest works the most successful—new growth, both intellectually and emotionally. Countless minute strokes on bare canvas evoke the meditative process of creation. She compares them to "assertions, a necessity, a spiritual act." They give the surface a vital energy and represent "the creative, spiritual life force which never dies." On tiny squares of paper—works of art in their own right—she tests the colors and her palette knife before working on the canvas. She explains her aim: "No matter how fragile, the lines take on strength when surrounding paint becomes more dense—they lose importance when the surrounding paint is animated,

speaking its own language—counterpoint."[17] The intensity of this effort causes her to turn inward; rarely leaving her house, she draws strength from her surroundings in a glass-enclosed spot from which she sees the magnificence of nature and the transportingly radiant light of New Mexico.

**Florence Pierce** As a young painter, Florence Pierce came to New Mexico and joined the Transcendental Artists group, an association of artists seeking to enrich the abstract vocabulary of European modernism with Native American traditions, theosophy, and Jungian psychology. For Pierce, these ideas became the leitmotif of her art, and in 1981 she turned to large relief sculptures cast in resin. Triangles, pyramids, and arcs evoking the passing of stellar bodies have light as both their medium and their content. Working from drawings and using mirrors as her "canvas," she pours resin into molds and onto folded paper, creating a surface that is opaque but translucent; she can now predict the results. The casting takes place in the "labor room," referring to the specific event of the object's creation but perhaps also, in a mystical sense, to female wisdom celebrated in Tantric mysticism. Although attuned to Neo-Platonic notions that geometric forms express spiritual harmony, she does not measure proportions, explaining that they have become intuitive. Her works, monumental and still as Arctic peaks, relate to Kandinsky's rising triangles and to Native American sacred objects, such as the prayer sticks in her collection, which she replicates in large scale and subtly varied shades of white. Speaking of her art's origin in ritual, she explains, "these things are all about stilling the mind; they are all contemplative."

**Martin Canin** The spirit of place, a hillside setting in New York State, affects Martin Canin's art and daily life as well. His studio, a converted barn, is reached by a walk through a meadow which, during a visit in the fall, was carpeted in radiant yellow foliage, a harbinger of the artist's own involvement with color. Inside, a triangular painting hovers on the tall and white expanse of wall like one of Malevich's geometric icons. It reflects a contemplative calm, a mixture of passion and intellect that is Platonic in its reductive simplicity. Shaping his canvases into triangles or parallelograms, and applying fields of color, Canin studies color's expressive power, its ability to fluctuate under changing light and form. He adjusts, refines, and observes the residual vibrations of shades that radiate from below the thinly applied layers. He studies the interaction of neighboring colors with the finely tuned eye of a Josef Albers. With an intense sensibility for all visual stimuli, he gives meaning to everything around him. Every room in his house is a study in the interrelationship of space and view and their enhancement through color; in his studio, however, white walls invite contemplation and draw all energy toward the paintings. Each feature or image that is "allowed in" is there as the result of intense scrutiny, judgment, and discrimination.

**Guy Anderson** A slight man with darting eyes and an impish smile, Guy Anderson pronounces himself a "champion of the figure," which he renders in almost sculptural form within abstract configurations reminiscent of cells, seeds, or aqueous organisms. Anderson's studio occupies the upper floor of his house, and to reach it, he climbs an outside stair, brushing past branches of cedar and pine, past small sculptures and ceramics set into mosses and ferns. Two very large paintings on wood boards are also left exposed to the elements, one the *Journey of the Trilobite*, the

other *The Myth of Sisyphus*. Over time, they acquire texture and patina, and every spring, in a patient and mystical "conversation" with air, light, and rain, Anderson paints them anew. Indoors, the simplicity approaches the ascetic, yet his obvious joy in antiques, in poetry and music proves him the nonchalant aesthete. Tacked on the walls or stacked in rolls are drawings and paintings from various stages of his career. They reflect his recurrent themes—birth, death, fate, and creation—that derive from human experience as ancient as Greek tales.

**Claire Falkenstein** Entering the courtyard that leads from Claire Falkenstein's house to her studio, the visitor passes sculptures resting on stones, their web of bronze now entangled with thickets of flowers and growth. The kinship between art and natural forms suggests that one inspired the other. The painting studio is flooded with light, and Falkenstein's works seem to have absorbed great quantities of it. Floating touches of color on white ground peer through a graphic screen characteristic of her fountains and gates. "I am a drawer," she explains, stressing how line serves her to create structure, interval, and space. Her paintings show figures struggling in a web of lines or recall the riders of the Parthenon frieze. Others have writhing clusters of nudes and centaurs that swirl into the sky as though abducted by clouds. In these visions, Falkenstein offers a glimpse at an apocalypse or perhaps at an apotheosis of the classical tradition, a final manifestation of Arcadia. Here, too, happens the transference of visual experience into art, for, stepping onto the balcony, one sees the human comedy of a beachside town in California that is played out daily before the artist's eyes: a swirl of riders, walkers, musicians, and meditators that passes by on Ocean Front Walk.

Any exhibition, aside from its content, raises several underlying questions: What does the art on the walls say about the society that created it and comes to see it? What were the artists' intentions, what were the organizers' aims, what were the visitors' expectations? In an exhibition, the selection of which was determined by the artist's age, these questions and expectations take on a universal and at the same time intensely personal significance. We wish to see ourselves, we wish to draw hope and courage, we wish to draw energy from art and artists. The issue of *altersstil* has been discussed elsewhere in this book. It remains true that experience and depth of memory give these artists a richer storehouse of images on which to draw and keener insight into the human existence. For that, they are our national treasures. Like a gift, they spread before us the past as a legacy for the future, their voices and visions giving life and passion to what would otherwise be mere historical fact. They stand witness for that which we should never forget and that which we cannot. In Vera Klement's words, they answer the question that is easily understood in times of horror, violence, and suffering, "Why paint?" with another, "What shall I paint?" They are emphatically determined that, now more than ever, art must be made, must be seen, must be reckoned with. In their works they have probed the far side of what is visible and have brought back their understanding and determination. Most of all, they help us sense where we should go.

Notes are on pages 183 - 184.

167

# the myth of the old age style

*selma holo*

Y ABIDING INTEREST IN THE OLD AGE STYLE IN ART WAS TRIGGERED lively discussion I had with the collector Norton Simon about the desirability of purchasing a Rembrandt portrait for his museum in Pasadena. Until that conversation I had assumed that such a style not only existed, but that it was, always had been, and would continue to be deeply valued in the world of art. It was one of the first of many probing talks I was to have with Simon, and in it he challenged some basic assumptions that I had taken quite for granted.

The time was 1978. I had just been named curator of acquisitions at the Norton Simon Museum of Art, and I felt I was only fulfilling my responsibility when I explained to Simon that he had no choice but to purchase the gorgeous Rembrandt that had just come on the market. The painting in question was a very late one in the artist's career—expressive and freely executed. I insisted that we simply had to have it, that it was "cheap" at about $2 million, and that it could only go up in value. I continued, graduate student that I then was, to instruct Simon in the importance of the works created at the end of Rembrandt's life. After a few minutes Simon took the floor. First, he pointed out that he had been collecting art for about twenty-five years by then, and that my statement about enduring and increasing value (whether spiritual or financial) only revealed my naïveté. He went on to explain that when he had begun to buy pictures "you couldn't give away a late Rembrandt." What everybody wanted in those days was the early work, the highly finished, refined, almost photographic paintings that had made the young Rembrandt the rage in Holland. Furthermore, according to Simon, the reason the late style was popular in the 1970s was that our contemporary culture was in love with itself. Filled with narcissism, it valued works of art in its own image: expressionistic, exuberant, rule-breaking. We needed to validate an individualistic and nonconformist ethic. Simon said he had watched the taste for the early Rembrandt works decline while taste for the old age style developed. He had no doubt that this trend could and would reverse itself at some point. He therefore concluded that he saw no reason to spend the money demanded by the dealer on the basis of a period simply being "in style."

Simon's lesson was hammered in still more deeply when I observed the radical change in taste that occurred with regard to Pablo Picasso. Within months of our conversation there was a wild swing in the appreciation accorded Picasso's late works. Until that time they had been almost universally scorned. It was transfixing to witness

a virtual confluence of scholarship, market forces, museum shows, and Zeitgeist unfold and transform the *347 Suite* (that riotous, orgiastic explosion of an octogenarian's life force) from trash into treasure. I was brought to my knees when I learned that Simon had purchased the complete series *before* the tide had turned. He had done this when it was out of fashion—at a low price.

Once again the umbrella of taste seems to be expanding with regard to the production of older artists. The makers and breakers of the artistic canon are beginning to include formerly derided paintings of the aged Giorgio de Chirico, Francis Picabia, and even Marc Chagall in the realm of masterpieces. The critic Robert Rosenblum has recently noted this 180-degree turnaround. Of Chirico's late historical revivalism and of his outrageous handmade reproductions of his own early *chef-d'oeuvres* of the 1920s Rosenblum writes: "Could this be a timely, vital message in a postmodern world where Warhol, among others, made the devaluation of unique originals an integral part of seeing and making art appropriate to the age of Xerox and fax?" Rosenblum attributes the new acceptance of the kitsch themes of the late Picabia to our acceptance of David Salle and others of his generation. Most surprisingly, he speaks of the disappearing prejudice against the old Chagall's work, "whose fruit-juice colors and syrupy dream spaces used to look like vulgar sellouts after the hard-edged rigor of his earlier Cubist-inflected work." "But the emergence of such Italians as Clemente and Chia," Rosenblum goes on to say, "with their fluid geographies and free-wheeling imaginations, gave these late paintings a fresh topicality, prophetic of liberated rainbow fantasies to come."[1] One can only expect that we will next see the still maligned last works of Salvador Dali elevated into the corpus of serious art. I await the rationale for such an ascension, knowing full well that it will reflect and validate, or be validated by, concurrent trends in contemporary art and society; it will function as a kind of self-justification and self-congratulation.

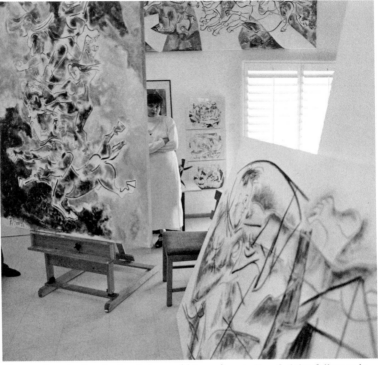

**studio of claire falkenstein, with her assistant, jill covell, venice, california, january 1994.**

I have not stopped thinking about the subject of the old age style since that discussion with Norton Simon, although I have moved from issues of taste to the essential question of whether such a style exists at all. It seems that I have not been alone.

The question of whether or not there is an "old age style" has surfaced time and again in the histories of fine art and literature of both the Western and Eastern worlds. In the West, the record begins in ancient Roman times with Pliny the Elder stating:

> The latest works of artists and the pictures left unfinished at their death are valued more than their finished pictures. . . In these we see traces of the design and the original conception of the artists, while sorrow for the hand that perished at its work beguiles us into the bestowal of praise.[2]

Cicero himself, in his dialogue *Cato Maior de Senectute,* argued that the increasing benefits of intellectual reason and spiritual virtue that come with old age far outweigh considerations of physical decrepitude.[3] Giorgio Vasari, many centuries later, during the Italian Renaissance, encouraged the notion of the *ultima maniera* in his well-known and often-quoted passages on Titian in his *Lives of the Most Excellent*

**studio of edward dugmore, minneapolis, minnesota, november 1993.**

*Painters, Sculptors, and Architects.* Whether or not an *ultima maniera* exists has continued to be a sporadic subject of lively discussion in books, journals, and essays to this day. Some of the artists most frequently referred to are Picasso, Joan Miró, Francisco de Goya, Gianlorenzo Bernini, Claude Monet, and Henri Matisse. But these great names represent only a few of the major figures thought to have achieved a notable *ultima maniera,* an *Altersstil.*

The old age style is consistently characterized as possessing a bravura technique resulting from a simultaneous mastery of craft, an impatience with it, and a transcendence of it. In other words, "It looks simple, but it isn't." There is usually some physical debilitation noted in the descriptions of the style, a handicap that is then written off as insignificant because of the enriched spiritual, quasi-mystical state the artist is said to have entered. In Eastern art history, because of its Confucian respect for the aged, as well as its Taoistic involvement with the individual achievements connected to advanced age, there has also long been a traditional assumption among art historians that, as T. C. Lai concludes, "in Chinese painting, the painter's art improves with age. There are few exceptions."[4] The qualities so admired by most Chinese writers are surprisingly close to those lauded by Western art historians and critics. The art historian Jerome Silbergeld notes:

> Perhaps the most striking testimony of the popularity of these qualities comes from the famous modern artist Huang Pin-hung (1864–1955), who by his eighty-ninth year had virtually gone blind and was painting in a rough and incomplete manner, yet powerful in its effect. When he recovered his eyesight after surgery at age ninety, rather than restoring clarity to his paintings, he further developed and consciously exploited the roughness of his recent works.[5]

Oddly enough, both Western and Eastern art historians of our own time are now beginning to be suspicious of the notion that an old age style exists. We are currently hearing questions such as the one raised by Catherine M. Soussloff concerning Bernini:

> Whether or not the individual art historian believes in the idea that there is a similarity among the old-age styles of all artists, in art history old-age style has been seen as an inevitable phase in the development of all aged artists. Based on what we actually know of the works and lives of artists, is this a valid model or is it a result of a dependence on a deterministic and progressive model of history, life, and art?[6]

Silbergeld, in his article "Chinese Concepts of Old Age and Their Role in Chinese Painting, Painting Theory, and Criticism," muses about the assumption of the old age style in this particular Asian context:

> The problem is the multiplicity of historically derived styles normally practiced by Chinese artists, often at the same time or in a single phase of their career, which masks their true artistic "identity." ...Although traditional and modern criticism both suggest the validity of old-age style as a phenomenon, they support the conclusion that there is no simple or consistent thing as an old-age style. . . . Old-age styles—to the degree that they represent artistic styles altered by the aging process— are as varied as the effects of old age itself.[7]

Perhaps it is the stylistic methodology that is itself so limiting. Fortunately we are living and working at a time when the most interesting scholarship finds itself investigating the wholeness of the human experience in order better to understand artists and their work. Style had its place as an arena of inquiry, but it can no longer be seen as the exclusive path to the kind of knowledge we are seeking. The insistence on a progressive, linear, and inevitable stylistic development is as vulnerable to attack as the idea that there is a single physical, moral, or ethical course that an aging human being will take as he or she evolves and lives through the fullness of a life. There are artists who live long lives and who show no evidence of the characteristics of a so-called old age style in their work, thereby defying the notion of this kind of stylistic inevitability. A close look at Titian reveals him to be an artist who, despite Vasari and the romantic desire for an *ultima maniera*, does not choose to be so classified.

Nevertheless, Titian is usually the first artist to be brought forth to prove the existence of a late style. It therefore behooves us to look at some impressive scholarship on this subject by Charles Hope. After acknowledging the extreme sketchiness of certain passages in several of Titian's last works, after pointing out the ill-defined, impressionistic treatment of detail in several of these works, including *The Crowning with Thorns* (Alte Pinakothek, Munich), Hope goes on to prove that these are all unfinished pictures left in Titian's studio at the time of his death. Hope's argument inexorably suggests that Titian was still working in the manner to which he was accustomed, and

that he remained "essentially a conservative painter, retaining a preference for elaborately worked surfaces and relatively high finish."[8] Hope never denies the appeal and influence of these last seemingly spontaneous, certainly luminous works on succeeding generations, but he does deflate the notion of an old age style in Titian's oeuvre.

How does one deal with Goya in this context? Francisco de Goya, the passionate Spanish artist, indeed spent some time producing so-called sketchier, splotchier pictures near the end of his life. The *Black Paintings,* now in the Prado, are a fine example of this explosive imagery painted at a time when the artist was not only aging and going blind, but also in a time of extreme political unease. All of this being the case, it is also true that as a young artist Goya already loved the heavily loaded brush, sometimes even applying paint with rags in broad swipes such as those making up the images on the San Antonio de la Florida dome in Madrid. Indeed, there is probably more of a gap in style between Goya's private pictures and his commissioned works than there is between his youthful and his late paintings. Finally, the imposition of an old age style on Goya leaves no room for explanation of one of his very last paintings, the *Milkmaid of Bordeaux* (Prado, Madrid). Here is a picture even more limpid, serene, fresh, and brilliantly painted than were those earlier works in San Antonio de la Florida, or even than those in the early tapestry cartoons (also in the Prado). One could allow oneself to be convinced that *Milkmaid* was the work of a young man who had never known a debilitation or a sorrow. There is no evidence of a technical or spiritual crisis here. The ancient Goya seems merely to have been progressing into another period, one beyond any style attributable exclusively to the passage of the years.

Picasso, Goya's countryman and admirer, also lived long but followed no linear evolution in his body of work. The *347 Suite* reveals no diminution of or scorn for technical virtuosity. Rather, what it makes manifest is Picasso's lament for the diminishment of his sexual powers, a lament as filled with humor as it reeks of bitterness. As Gert Schiff points out, the series is a proclamation that his "procreative powers may have waned, [but] his creative energies, if anything, increased. . . . In the end, making art for him replaced making love, and the sexual act became a metaphor of artistic creation."[9] Art allowed Picasso to retain his absolute self-confidence, his arrogance even, never giving us the satisfaction of fitting into our still elusive old age style.

A few decades earlier, Monet, blessed with none of the arrogance of Picasso's advanced years, worried lest his last creative efforts not live up to his expectations. Having already spent so much time, paint, and canvas trying to capture shifting light, now in his monumental lily pond series from Giverny he pressed forward, toward truly new ways of interpreting the universe. Monet said: "I have taken up some things which it is impossible to do: clear water with grass waving at the bottom. It is wonderful to look at, but to try to paint it is enough to make one insane."[10] Leo Steinberg writes of the immense courage that Monet brought to his paintings when,

> in his later years, he seemed to have found the cause of that fascination and to have faced what it implied: that a ground-line which arbitrates between the actual and its false mirror image separates two absolute equivalents, like the

midline of a Rorschach blot; that the hierarchy of things more or less real is not determined by degrees of tangibility; that all those things are real which fully form the content of experience.[11]

Monet's encounter with old age opens another chapter in his own personal aesthetic journey, a chapter overflowing with the power of experience, intellect, and the desire to communicate his discoveries by means of his art. His success with those last works is due to the enormity of those accumulated powers. The canvases might superficially lead the all-to-anxious spectator into a stylistic category, but to think about them in such terms is to miss their meaning. To see only what is immediately apprehensible denies the very thrust of Monet's inquiry into the profound nature of the visible world.

There are many other "styles" that have come down to us from the great masters. Matisse, for example, bounds into old age, leaving behind the much mastered, brilliant, known, and loved images and inventions of his mature years for his revolutionary cutouts. Whether small or monumental, these creations are linear, technically virtuosic, and stun the viewer with heights of skill coming from a newly conquered medium: scissors and paper. The cutouts are pure inspiration. As the contemporary British painter Sir Howard Hodgkin has recently pointed out, they demonstrate an ever-increasing "moral courage," a constant "raising of the stakes," a "going to the edge where it was possible to fall and yet to rise."[12] Such courage is usually associated with youth. It is important to acknowledge it when it rears its head at more advanced stages of life.

studio of mel katz, portland, oregon, january 1994.

Miró, on the other hand, with his great final abstractions, rages with a kind of furious violence against the onset of death. These paintings have an intellectual purpose that can be better seen as a "next" style than a last one. Art historian John Golding recognizes in Miró some of

the greatest visual achievements of our time... Miró [being] the only European artist of his generation to face successfully the challenge of new, revolutionary American art of the 1940s. [Miró] said "What I seek in effect is a motionless

**173**

movement, something that would have been the equivalent of what is called the eloquence of silence, of what Saint John of the Cross designated by the words, I think, 'silent music.'"[13]

Golding adds, "He achieved it."[14] We would be minimizing Miró's leap into his immensely eloquent dialogue with the much younger Americans by circumscribing it as an "old age style." Why would we even wish to deny the intellectual power and the free choice behind Miro's final savage imagery? Why are his drips and stains not considered examples of a brave new style, yet another in a succession of aesthetic challenges he met and conquered?

The only link that remains intact among these old age artists, who fail to comply with our need for them to represent a certain style, is the artists' transcendent quest for immortality by means of their work. This is as true of Titian, struggling on as ever before, as it is of Picasso subverting the standard understanding of old age by etching

**studio of vera klement, chicago, november 1993.**

as if engaged in the sexual act itself. Goya, on the other hand, seems to have entered into a stage of absolute serenity and groundbreaking color harmonies when he died. Monet robustly attempts to capture infinity in his lily pond. Matisse invents a new medium for himself. Miró howls. To quote Hermann Hesse, artists young and old are all engaged in "rescuing a moment from the dance of death." There is an infinity of ways to attempt to accomplish this goal.

One could go on and on describing the differing styles of important artists who lived and worked over a long lifetime. Usually, the nature of their creative production did change as they aged. Sometimes, as with Rembrandt, their work seems to fit the myth of the desired style. But any honest analysis of the old masters shows that each had his own path to follow. It should therefore not be too surprising that the artists of our own day exhibit the same resistance to restrictive, romanticizing categories in their creative work. Like the old masters, our contemporaries continue to surprise and delight by their individual responses to the passing of the years. That they do so is a gentle and much needed reminder that artists will not be controlled by art history or by art historians—at least not while they are still working.

Notes are on page 184.

*jeffrey wechsler*

# portrait of the artist as father william

"YOU ARE OLD, FATHER WILLIAM," THE YOUNG MAN SAID,
"And your hair has become very white;
And yet you incessantly stand on your head—
Do you think, at your age, it is right?"

When Alice responded to the Caterpillar's demand that she recite "Father William," she knew that her attempt was "not quite right." This particular example of the many whimsical subversions of Victorian verse and culture offered by Lewis Carroll in *Alice's Adventures in Wonderland* comes to mind in the context of the general theme of this publication and the exhibition on which it is based: the determination of individuals (here, artists) to continue their activity into their later years, sharpening their abilities and accepting new challenges. Carroll's "Father William" comes down squarely in support of the elderly gent's antics; just as importantly, it seems to show Father William taking, at first, a slyly self-deprecating tone. Does the young man believe his father to have gone soft in the head due to his age? Well, the father knows better, but why not play along for a while with the misperceptions of this less-experienced lad:

"In my youth," Father William replied to his son,
"I feared it might injure the brain;
But now that I'm perfectly sure I have none,
Why, I do it again and again."

In fact, not only does Father William have all his wits about him, but he is able to summon the forbearance to temporarily play the fool and handle the situation with irony, probably in the hope that the son will eventually grow out of that all too common prejudice of youth, the assumption of inability or incapacity in the older generation.

This assumption also has its effects on the art world, with results sometimes specific to the machinations of this specialized section of society. Certainly in the American art world, the treatment of older artists can be viewed as a subset of the so-called cult of youth often attributed to this country, with its auxiliary societal phenomenon, our craving for the "new," whether in fashion, popular entertainment, or car models. The elderly artist, it is sometimes thought, has no more to contribute: the old cannot be the harbinger of the "new."

Consider the following particularly cruel instance of what we may call here the

"Father William syndrome," the unwarranted underestimation of people of advanced years. Older artists may certainly be afflicted, as may people of any profession, with physical and mental conditions that impede their work. Willem de Kooning, for instance, now suffers the debilitating effects of Alzheimer's disease. Just before the affliction truly affected his ability to paint, he produced a series of works that involved many fewer pictorial elements than he employed previously; several languorously elegant strokes were set on relatively "empty" white surfaces. When de Kooning's illness became generally known, there emerged some suspicion that these less complex works were the result of the artist attempting to paint while in a deteriorating mental condition. For de Kooning, superficial aspects of a late painting style merged with unfounded speculation to undercut a body of his late work. In fact, a tendency toward simplified yet highly refined variations on earlier themes is not uncommon among elderly abstract painters. Secure in their technical accomplishments, such artists purposely abandon earlier bravado and develop contemplative late styles marked by reduced imagery and relaxed painterly execution. A European parallel to de Kooning is the veteran German abstractionist Hans Hartung, who after a life of precocious linear Abstract Expressionism (his earlier gestural abstractions date to the 1920s) ended his career with atmospheric fields of black and muted tones punctuated by a feathery line or two.

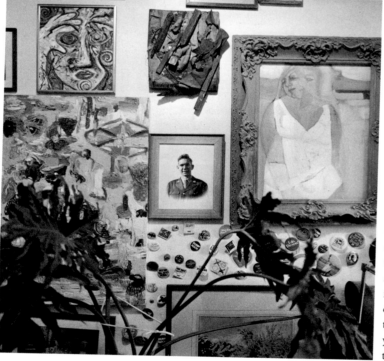

**studio of ernest acker-gherardino, new york, october 1993.**

The respect offered in other societies to individuals embodying long experience and great effort and achievements sometimes seems lacking in ours. In many Asian cultures, for example, individuals with maturity and wisdom hard won over many years are held in great esteem, in art and in other fields. The importance of the continuity of traditional imagery and techniques in China, for example, makes direct generation-to-generation contact a vital link to an artistic culture that spans millennia: to a serious young artist respecting that tradition, the elderly artist-teacher is a figure of veneration. It is an action of high honor when a teacher chooses to give a favored brush to a worthy student; this gesture acknowledges that the continuity of tradition is greater than any individual, and in a sense poignantly makes real the symbolic notion of "passing the baton" of tradition from one generation to the next.

In the United States, although one does not find outright denial of the existence of older artists, neither does one find any consistent effort to appreciate them. We know the senior artists are there, but we must rediscover them one by one, since by and large—though they may be producing fine work—they have entered an odd region of artistic limbo rather peculiar to the twentieth century. In an era of astonishingly rapid development and turnover of styles, both the hastening tempo of artistic innovation and the great quantity of recognizably different methods and modes of art making agitate against the continued prominence of a particular individual. This occurs on several levels, from international and broadly historical, to local and contemporary.

In centuries past, the transformation of style proceeded at a pace that seems stately and deliberate compared to that of our times. The history of art before the mid-nineteenth century could be reasonably measured in grand sweeps, in aggregates of decades, if not entire centuries. An artist of the Renaissance could live a full life within its chronological and stylistic boundaries, as could one of the Baroque, and even the Rococo when including its earliest and latest manifestations. Titian lived for over ninety years, yet was a man of a distinct artistic epoch; he made a personal stylistic contribution in his last years, consistent within the historical context accorded him by posterity, by elaborating his essential techniques and tendencies to a logically extreme refinement. The career of Giovanni Bellini, an exemplar of Italian Renaissance painting, spanned the fifteenth century and entered the sixteenth; toward the end of his life, to participate in the newest trends popular among younger artists, he needed to accept not a variation in style but in subject matter, from strictly religious themes to secular and allegorical ones.

Artists of the twentieth century, however, have not had the luxury of maturing and growing old in step with the development and decline of specific styles with which they had become associated in their youth. As modern trends and "isms" tumbled forth, the shelf-life of historical relevancy for a style rapidly diminished. The glory days of Fauvism, Cubism, Suprematism, Dada, Abstract Expressionism, and Pop art are, in general, measured within the time span of a decade or less. Thus, an oeuvre that changes little outwardly over time may be perceived as being stuck in the past, instead of reflecting a long-term commitment to, and investigation of, a particular manner or image. When viewing the work of artists who have maintained allegiance to such modes over a lifetime, the modern observer frequently undergoes a reflexive, retrospective pigeonholing of the object. Recent paintings by Roy Lichtenstein, for instance, still carrying the Ben Day dots and flat colors of his early work, immediately evoke thoughts of Pop art and "the sixties." Where the work of modern artists actually overlapped the turn of this century and continued well into it, the sense of historical dislocation can be stark. The reputations of Pierre Bonnard and Edouard Vuillard were established within the Intimist or Nabis-related mode of Post-Impressionism in the 1890s. Therefore, the paintings by these artists from the 1930s and 1940s that were frequently placed in the Museum of Modern Art's Post-Impressionist galleries startled the viewer when the dates of their creation were learned from the labels. Think of it: the old Bonnard, untouched, it would appear, by Cubism or Constructivism or Surrealism or anything else, continued to paint his light-

dappled paeans to nature and the human form while Joan Miró painted his *Constellations* and Jackson Pollock, Clyfford Still, and Mark Rothko were creating their signature styles of Abstract Expressionism. These late Bonnards, lush and vibrant and critically well regarded though they may be, cannot overcome the perception of the artist as a nineteenth-century figure. The elderly Bonnard is lost in time, his twentieth-century accomplishments, attained through the experience of age, rendered anachronistic, historically invisible.

Alternatively, a mature artist who has gained great acclaim for working within a significant style may be given a hard time for deciding to move on and create in a different manner. When Philip Guston left his nonobjective style around 1968 to develop a highly personal mode of purposefully cartoonlike figuration, he was accused in some circles of turning his back on the high principles of the Abstract Expressionist mode with which he was associated and within which he was considered one of the more refined and sensitive practitioners. To one critic, Guston's treachery against high art was inexcusable, and the artist was severely reprimanded in a *New York Times* article titled "A Mandarin Pretending to Be a Stumblebum."[1] Between the cases of Bonnard and Guston, one can see the outlines of a perplexing double-bind for older artists: persevere with the same style too long and you may be pegged as an artist of the past; change drastically from a successful style and you may be attacked for abandoning the past.

Of course, the situation for older artists is not a uniformly bleak one. There are those who have maintained steady reputations, even high-profile ones, for many years. On balance, though, the senior artist finds many obstacles to long-term visibility on the current art scene. One central problem is the widespread reluctance of curators of contemporary art to include older artists in thematic exhibitions even when their work is applicable to the intent of the exhibition. To some extent, the art world is still caught up in the endless pursuit of the significant new style, the trend that will somehow prove historically memorable and gain immortality in future textbooks on art. This notion persists despite the rather obvious fact that most of the trends offered for name recognition in the past quarter century—from Pattern painting to New Image painting, from Neoexpressionism to Neo-Geo—will not survive the withering editing process of history. Furthermore, in looking for the emergence of a new style, exhibition organizers assume new trends are developed by new (young) artists. This attitude is equally prevalent among personnel in commercial galleries and public museums. Thus, even when the essence of "hot topic" exhibitions on the art scene can be identified as simply an exercise in contemporary variations on very old themes—such as 1993 Whitney Biennial, which focused on the current interest in art on social and political subjects—an overwhelming percentage of the artists selected for representing this trend are young.

The 1993 Whitney Biennial was even more than usual a young people's show, as if only youth could address important societal issues of the day. Yet there are many Father Williams out there who mounted the barricades of social protest and commentary decades earlier and are part of a great tradition of socially conscious art that goes back well before the modern era. How interesting it would have been to compare,

through side-by-side examples, the perspectives and approaches of artists just making their entry on the art scene with those who lived through the period of American art most historically linked to the exhibition's theme: the 1930s and early 1940s—the most vigorous years of social realism. One might have seen artists whose fervor against war and injustice is still passionately expressed, such as Hans Burkhardt, who painted skull imagery and affixed actual skulls on his canvases long before these motifs became fashionable. As critic Susan Ehrlich has written, Burkhardt "extended Action painting into the realm of political protest where few of his peers . . . were willing to tread. In decrying the horrors of war and injustice with a somber palette, angst-laden figures, and rough application of tactile paint, he prefigured the Neo-Expressionist course of artists such as Anselm Kiefer, Julian Schnabel, and Markus Lupertz."[2]

Recent work by Burkhardt and others might also have demonstrated at the Whitney Biennial—which was given over to installations, photography, video, and written texts—the continued ability of painting to evoke emotion and carry messages. Or take, for example, the hot topic of the suppression and expression of frank or multivalent sexuality. Imagine, amid the placards and signs and video monitors, coming across the precisely painted declarations of eroticism, homosexual and heterosexual, and denunciations of censorship contained in the pictures of Paul Cadmus, who at the age of ninety still confronts controversy. In the Biennial environment, his work would also serve as a useful reminder that all protest art need not be obscure or strident. True, Cadmus's recent works still contain powerful and up-to-date imagery: preachers breathing hypocritical hellfire have now been joined by Jesse Helms among the sanctimonious choruses of naysayers. But there

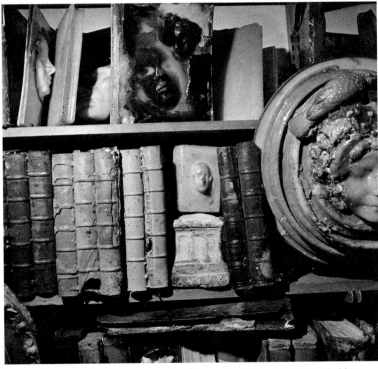

studio of stella waitzkin, new york, october 1993.

is also an evolving sense of equanimity and summation, an invitation to accept the sheer naturalness of all forms of sexuality within a framework of peace and community. One recent Cadmus painting is virtually a modern idyll, wherein lovers of all kinds and of various races (and even a traditional nuclear family) ride naked and serene in a vessel on a calm sea.

Cadmus's recent work exemplifies how the observations and understandings accumulated over a long life become intellectual and emotional tools of the trade for the older artist; they allow the artist to fashion, without averting one's eyes from the real-

**179**

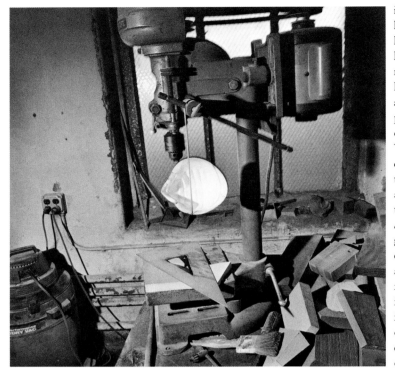

**studio of david slivka, new york, october 1993.**

ity of ongoing conflict, touchingly human resolutions to society's problems with the studied acceptance of long experience. Sexuality, political repression, multiculturalism: Cadmus has seen it all and comments on it all, and the young kids at the Whitney party would have benefited by this oldster's presence. But Father William and friends are rarely welcome at such affairs; what could those old codgers have to show us, anyway? The bittersweet aspect of the situation is that exhibitions like *Still Working,* when they occur, do a great service by reminding us of the enormous depth and breadth of skill and spirit that exist in a reservoir too rarely tapped. But such an undertaking also should leave us, the laborers in the art world, rather abashed for our neglect. Let us face it squarely: an exhibition based upon the patently obvious premise that artists produce worthy work in their later years is a glorious event and a celebration of personal creativity—and it is also an admission of guilt, one of our occasional atonements for our long periods of insensitivity.

Have we rediscovered the oldsters, yet again? Have we asked them enough questions? Father William could tolerate three assaults from his son on the plain truth of his accomplishments and then took no more:

> "I have answered three questions and that is enough,"
> Said his father; "don't give yourself airs!
> Do you think I can listen all day to such stuff?
> Be off, or I'll kick you downstairs!"

Art historians and curators, take heed.

Notes are on page 184.

**180**

# Notes

*Unless cited otherwise, quotations are from the artists' statements in this catalogue.*

## Gibson

1. John Richardson, "Florence Pierce Catches the Light with Luciforms," *Albuquerque Tribune,* October 25, 1986.
2. Frederick Hammersley, statement of July 19, 1989, quoted in *The Alcove Show: Frederick Hammersley, Jim MaGee, Ramona Sakiestewa, and Paul Sarkisian* (Santa Fe: Museum of Fine Arts, 1989), 2. See also essay by David Turner, "The Alcove Show," in ibid.
3. John S. Weber, *Mel Katz, Selected Works, 1964–1987* (Portland, Oreg.: Portland Art Museum, 1988).
4. Martin Kemp, "Late Leonardo: Problems and Implications," *Art Journal* 46 (Summer 1987): 94.
5. Ibid., 100.
6. Louis Harris and Associates has conducted two polls for the National Council on Aging: *The Myth and Reality of Aging* (Washington, D.C.: National Council on Aging, 1975), and *Aging in the Eighties: America in Transition* (Washington, D.C.: National Council on Aging, 1981). The National Council on Aging is a confederation of social welfare agencies that plays a substantial role in legislation. This extrapolation is drawn from comments on those polls in Charles Russell, *Good News about Aging* (New York: John Wiley and Sons, 1989), 30.
7. See Thomas R. Cole, *The Journey of Life* (New York: Cambridge University Press, 1992), 212–26, for a discussion of the effect of Hall's work.
8. *One Hundred Years: The American Psychological Association,* ed. R. and B. Evans et al. (Washington, D.C.: American Psychological Association, 1992), 189.
9. See W. Andrew Achenbaum, *Old Age in the New Land* (Baltimore: Johns Hopkins University Press, 1978), chap. 6, esp. 109–13.
10. "Aging is an inevitable, mutual withdrawal or disengagement, resulting in decreased interaction between the aging person and others in the social systems he belongs to"; Elaine Cumming and William E. Henry, *Growing Old* (New York: Basic Books, 1961), 14. This perception was perpetuated by such studies such as one by L. Dean, who documented an increase in the emotion of loneliness that corresponded with a decrease of the emotions of anger and irritation in a survey of two hundred men and women aged fifty to ninety-five in Kansas City. See L. Dean, "Aging and Decline in Affect," *Journal of Gerontology* 17 (1962): 440–46.
11. Vera Klement to John Himmelfarb, cited in James Yood, *Locations of Desire* (Chicago: State of Illinois Art Gallery, 1990), 11.
12. See, for instance, Erik Erikson, *Insight and Responsibility* (New York: W. W. Norton, 1964); and B. L. Neugarten and R. J. Havinghurst, "Disengagement Reconsidered in a Cross-National Context," in R. J. Havinghurst et al., eds., *Adjustment to Retirement,* 2nd ed. (The Hague: Van Gorkum, 1969), 138–46. For specific disagreement with disengagement theory, see Arlie R. Hochschild, "Disengagement Theory: A Critique and Proposal," *American Sociological Review* 40 (October 1975): 553–69. For further bibliography, see Christine Day, *What Older Americans Think* (Princeton: Princeton University Press, 1990), 30–33. See also Virginia Richardson, "Developmental Changes in Psychosocial Involvement among Adults in 1957 and 1976," and Linda Noelker and Zev Harel, "The Integration of Environmental and Network Theories in Explaining the Aged's Functioning and Well-Being," in M. B. Kleiman, ed., *Social Gerontology* (Basel: S. Karger, 1983), 40–49, 84–95, for observations that refute the inevitability of disengagement in old age. My thanks to Professor Abraham Monk, Columbia University, for recommending this volume to me, and to Professor Daniel Monk, SUNY Stony Brook, for obtaining the recommendation.
13. Yood, *Locations of Desire,* 11; Mary Priester, *Michele Russo: A Fifty-Year Retrospective* (Portland: Oregon Art Institute and Portland Art Museum, 1988), 15.
14. Cole, *The Journey of Life,* 227.
15. Psychiatrist Robert N. Butler coined the term "ageism" in 1968 in his article "Age-ism: Another Form of Bigotry," *Gerontologist* 9 (1969): 243–46. The definition here is from Butler's Pulitzer Prize–winning *Why Survive? Being Old in America* (New York: Harper and Row, 1975), 12.

16. Cole, *The Journey of Life,* 229.

17. Horton A. Johnson, ed., *Relations between Normal Aging and Disease* (New York: Raven, 1985), vii.

18. I am indebted to Thomas Cole for his formation of the postmodern problem of aging. See his *The Journey of Life,* 227–39, for a fuller discussion of the necessity of thinking beyond such dualism.

19. Ronald Blythe, *The View in Winter* (New York: Harcourt, Brace, Jovanovich, 1979), 29.

20. Julius Held, "Commentary," *Art Journal* 46 (Summer 1987): 129–30.

21. Michele Russo with Jane VanCleve in *Michele Russo at Marylhurst: Paintings and Drawings, 1940–1984* (Marylhurst, Oregon: Marylhurst College for Lifelong Learning, 1984), 13.

22. Jon Serl quoted in Dorrit Kirk Fitzgerald, *Four Viewpoints: Florence Arnold, Helen Lundeberg, Jon Serl, and Beatrice Wood* (Irvine, Calif.: Irvine Fine Arts Center, 1991), 7.

23. Kristine McKenna, "Inside the Mind of an Outsider," *Los Angeles Times Calendar,* November 12, 1989, 3.

24. Jon Serl quoted in Robert L. Pincus, "The World According to Serl," *San Diego Union,* January 18, 1987, E-8.

25. John Gold quoted in McKenna, "Inside the Mind of an Outsider."

26. Barry Johnson, "Art World Loses One of Its Luminaries," *Portland Oregonian,* June 4, 1993, B6.

27. Ibid.

28. Kenneth Burke, "Symbolic Action in a Poem by Keats," *Trans/formation* (New York) 2 (1944): 164–65.

29. Ludwig Wittgenstein, "A Lecture on Ethics" (1930), *Philosophical Review* 74 (1965): 11–12. Wittgenstein famously gestured toward this in his tacit acknowledgment of the metaphysical, along with his refusal to discuss it: "What can be said at all can be said clearly, and what we cannot talk about we must pass over in silence"; preface to his *Tractatus Logico-Philosophicus* (London: Routledge and Kegan Paul, 1961). For a discussion of Wittgenstein's early belief in the impossibility of anything but a poetical representation of the mystical, see Jorn K. Bramman, *Wittgenstein's Tractatus and the Modern Arts* (Rochester, N.Y.: Adler, 1985), 15–25.

30. Corinne Robins, "Sal Sirugo," *Arts* (January 1977): 22.

31. Mala Breuer, "My Painting," unpublished handwritten statement, 1988, collection of the artist.

32. Lynne Warren, *Chicago Artists in the European Tradition* (Chicago: Museum of Contemporary Art, 1989), 8.

33. Robert Wilbert quoted in David Barr, *Robert Wilbert: Portrait and Figure Paintings* (Birmingham, Mich.: Donald Morris Gallery, 1984), unpaginated. The idea that Wilbert's solid spatial relations are in conflict with values expressed by other aspects of his construction and subject matter is also from Barr.

34. Miriam Beerman, in *Primal Ground: Miriam Beerman, Works 1983–1987* (Montclair, N.J.: Montclair Art Museum, 1987), 3.

35. Peter Selz, *Hans Burkhardt: Desert Storms* (Los Angeles: Jack Rutberg Fine Arts, 1991), n.p.

36. Donald Kuspit, *Catastrophe According to Hans Burkhardt* (Allentown, Pa.: Muhlenberg College, 1990), 11.

37. Beerman, *Primal Ground,* 3.

38. Dennis Adrian, *Robert Barnes, 1956–1984: A Survey* (Madison, Wis.: Madison Art Center, 1984), 18.

39. For Dugmore's motivation as release and reunification with the self, see his catalogue statement in this volume. For this estimation of Estopinan's work, see Judith Weiner, "Roberto Estopinan: The Quest for Self-Knowledge," and Carlos Franqui, "The European Presence of Roberto Estopinan," in *Estopinan: Sculpture and Related Drawings* (Birmingham, Mich.: Schweyer-Galdo Editions, 1983), 17, 20–21.

40. Michael Leja, *Reframing Abstract Expressionism: Subjectivity and Painting in the 1940s* (New Haven: Yale University Press, 1993), 329–30; Griselda Pollock, *Avant-Garde Gambits, 1888–1893: Gender and the Color of Art History* (London: Thames and Hudson, 1992), 66–67.

41. Hans-Georg Gadamer refers to the somewhat analogous achievement of what he calls "the effective-historical consciousness" as a "fusing of horizons" in *Truth and Method* (New York: Crossroad, 1984), 267–74. In his useful discussion of Gadamer, David Hoy quotes a further relevant passage directly from the German edition: "Openness for the other also includes the recognition that I must let something in myself count against myself, even if there were not other who would make it count against me"; David Hoy, *The Critical Circle: Literature, History, and Philosophical Hermeneutics* (Berkeley: University of California Press, 1982), 60.

## Rand

1. That is to say, *Still Working* does not promote a campaign to unite the show's artists into any larger program; they are not part of a group, they share no program or outlook, and they are far ranging aesthetically. This is a rump parliament of art, not self-selected, but chosen by critics and the obedient marketplace. That the artists in *Still Working* are not uniformly good cannot undermine the show's conception any more than the original Salon des Refusés could.
2. The righting of wrongs may proceed even to inquisition God's justice, theodicy. Of sublunary justice, if such a thing is possible, we may recall Simone Weil's plea that to base claims for the truth of conduct on "rights" is to "evoke a latent war and awaken the spirit of contention. To place the notion of rights at the center of social conflicts is to inhibit any possible impulse of charity on both sides" (Simone Weil, "Human Personality" [1943], in *Selected Essays, 1934–43* [Oxford: Oxford University Press, 1962], 21). Cautioning against the idea of "fairness," Donald Phelps advises us to "beware the sentimentality of judges," by which I take him to suggest a heavy thumb on the scales of justice to achieve by other means what the legal process cannot (Donald Phelps, "Lord Have Mercy," in *Covering Ground* [New York: Croton Press, 1969], 101). From these and a thousand other deliberations arises the awful conflict between art's inherently conservative position, based on the tyranny of Quality, and the best artists' progressive instincts, which feelings will align them with liberalism(s).
3. Since the diverse arts do not progress in lockstep, in this admixture of high art and entertainment are discovered the same characteristics of artist-entertainer that survived in music into Hayden's generation.
4. The latter can be observed by noting the transformation in the three overlapping generations of Hayden, Mozart, and Beethoven.
5. This hoary French proverb (sometimes *"après nous le déluge"*) has been variously attributed, most zestfully to Louis XV. Let history judge whether my Reagan reference is far wrong.

## Passantino

1. *My Shanty, Lake George,* oil on canvas, 20 x 27 inches (50.8 x 68.5 cm), Phillips Collection, Washington, D.C. The photograph is a gelatin silver print, 9 3/8 x 7 3/8 inches (24.0 x 18.8 cm) (D771), National Gallery of Art, Washington, D.C., Alfred Stieglitz Collection.
2. Quoted in Alan Solomon, *New York: The New Art Scene* (New York: Holt Rinehart Winston, 1967), 9.
3. See the title of the book by Alice Bellony-Rewald and Michael Peppiatt, *Imagination's Chamber: Artists and Their Studios* (Boston: Little, Brown and Company, 1982). Robert Motherwell (in "A Process of Painting," lecture presented at the Eighth Annual Conference of the American Academy of Psychotherapists, New York, Oct. 5, 1963) speaks of the terror of having to change studios and of the time lost when the artist is required to adjust to a new environment; see *The Collected Writings of Robert Motherwell,* Stephanie Terenzio, ed. (New York: Oxford University Press, 1992), 140.
4. Klement, "Speakeasy," *New Art Examiner,* January 1994, 12; Breuer, "About My Painting," handwritten statement, New York, 1980. Dugmore and Hammersley are from conversations that I had with them in winter 1993–94, as are all subsequent quotations from the artists in the exhibition, unless cited otherwise.
5. Ronald J. Manheimer, "Voices of Memory, Forms of Meaning," in *Some Day When I Get Time: Perspectives on Creativity and Aging* (Washington, D.C.: National Council on Aging, 1985), 17. Erik H. Erikson, *Childhood and Society,* 2nd ed. (New York: W. W. Norton, 1963), 268–69.
6. Donna McKee, "Art at a Limit: Transcending the Limits of Age," in *Some Day When I Get Time,* 8.
7. Alexander Lieberman, unpaginated introduction to *The Artist and His Studio* (New York: Viking, 1970). Motherwell, *Collected Writings,* 140 (italics are the artist's).
8. The Swiss artist Thomas Huber establishes studios and creates works within public and commercial establishments. See the recent exhibition centering on the idea of the studio and artistic creation at Kunsthaus Zürich and Huber's exhibition catalogue, *Der Duft des Geldes* (Darmstadt: Verlag Jürgen Häusser, 1992).
9. Letter from Acker-Gherardino to the author, Jan. 13, 1994.
10. Baum was inspired by his studies of non-Western houses and by his readings of Gaston Bachelard's *The Poetics of Space,* trans. Maria Jolas (Boston: Beacon Press, 1969), as cited in Sue Taylor's intro-

duction to *Don Baum: Domus,* exh. cat. (Madison, Wis.: Madison Art Center, 1988), 10.

11. "There's Just One Little Thing . . . ," unpublished pamphlet compiled by Jack Boul's students, Washington, D.C., 1993, 11.

12. Carlos Franqui, "The European Presence of Roberto Estopinan," in *Estopinan: Sculpture and Related Drawings* (Birmingham, Mich.: Schweyer-Galdo Editions, 1983), 20.

13. Peter Selz, *Hans Burkhardt: Desert Storms,* exh. cat. (Los Angeles: Jack Rutberg Fine Arts, 1991), 8.

14. Stephen Polcari, *Abstract Expressionism and the Modern Experience* (New York: Cambridge University Press, 1991), 3. We need only remember that this was the time when museum directors, led by Alfred H. Barr, Jr., were compelled to publish a manifesto on the validity of modernism, and Barr lost his job as director of MoMA, the same time he was picketed by members of American Abstract Artists for not sufficiently supporting abstract art in its American manifestation. On myth-making, see David Craven, *Myth-Making: Abstract Expressionist Painting from the United States,* exh. cat. (Liverpool: Tate Gallery, 1993), 11–12, who names three public myths: the conspiracy of subversion, the superiority of the private sector, and the efficient managerial hierarchy.

15. Bellony-Rewald and Peppiatt (in *Imagination's Chamber,* 173) state: "Up until the 1930s, when the loftlike atelier made its tentative debut, the leading American studios closely resembled their European counterparts."

16. Manheimer, "Voices of Memory," 15.

17. Letter from Breur to the author, Jan. 15, 1994, and enclosed statement, 1980.

## Holo

1. Robert Rosenblum, "Anyone Who Doesn't Change His Mind Doesn't Have One," *Art News,* November 1993, 148–49.

2. Pliny the Elder, *Natural History* 35.145; quoted by David Rosand, "Editor's Statement: Style and the Aging Artist," *Art Journal* 46 (Summer 1987): 91.

3. Cicero, *De Senectute* 3.9; cited in Catherine M. Soussloff, "Old Age and Old-Age Style in the 'Lives' of Artists: Gianlorenzo Bernini," *Art Journal* 46 (Summer 1987): 116.

4. T. C. Lai, *Huang Bin Hoang (Huang Pin Hung), 1864–1955* (1980); quoted by Jerome Silbergeld, "Chinese Concepts of Old Age and Their Role in Chinese Painting, Painting Theory, and Criticism," *Art Journal* 46 (Summer 1987): 106.

5. Silbergeld, "Chinese Concepts of Old Age," 106.

6. Soussloff, "Old Age and Old-Age Style," 119.

7. Silbergeld, "Chinese Concepts of Old Age," 107, 108.

8. Charles Hope, *Titian* (New York: Harper and Row, 1980), 166.

9. Gert Schiff, "Picasso's Old Age: 1963–1973," *Art Journal* 46 (Summer 1987): 125.

10. Quoted by Leo Steinberg, *Other Criteria: Confrontations with Twentieth-Century Art* (London: Oxford University Press, 1972), 235.

11. Ibid., 237.

12. Martin Filler, "Howard Hodgkin Is Tired of Being a Minor Artist," *New York Times,* December 5, 1993, 43.

13. John Golding, "Sophisticated Peasant," *New York Review of Books* 40, no. 21 (1993): 51.

14. Ibid.

## Weschsler

1. Hilton Kramer, "A Mandarin Pretending to Be a Stumblebum," *New York Times,* October 25, 1970, B27.

2. Paul J. Karlstrom and Susan Ehrlich, *Turning the Tide: Early Los Angeles Modernists, 1920–1956* (Santa Barbara, Calif.: Santa Barbara Museum of Art, 1990), 50.

# biographies of the artists

## Ernest Acker-Gherardino

*Education*
Cooper Union, New York, 1962
Harvard College, B.A., 1948

*Solo Exhibitions*
The Wall, New York, 1990
Outer Space, New York, 1989, 1988,
1987, 1986, 1985
Jack Morris Gallery, New York, 1979
Steve Bush Exhibit Room, New York, 1979
Cooper Union Gallery, New York, 1972, 1970

*Selected Collections*
Northeast Power Coordinating Authority,
New York
Phillips Collection, Washington, D.C.

*Professional Activities*
Co-Director, Leger de Main Exhibition
Association, New York

## Guy Anderson

*Education*
Studied with Eustace Ziegler, Seattle

*Solo Exhibitions*
Pulliam Deffenbaugh Nugent Gallery, Portland,
1992, 1991
Bellevue (Washington) Art Museum, 1990
Francine Seders Gallery, Seattle, 1990, 1989, 1987,
1984, 1982, 1980, 1979, 1978, 1977, 1975, 1973, 1971, 1970
1001 Fourth Avenue Plaza Building, Seattle, 1989
Port Angeles (Washington) Fine Arts Center, 1987
George Belcher Gallery, San Francisco, 1979
Retrospective, Seattle Art Museum and Henry Art
Gallery, University of Washington, Seattle, 1977
Whatcom Museum of History and Art,
Bellingham, Washington, 1974
Tacoma (Washington) Art Museum, 1973, 1968
Otto Seligman Gallery, Seattle,
1965, 1963, 1959, 1957, 1954
Kenmore Gallery, Philadelphia, 1963
Smolin Gallery, New York, 1962
Michael Thomas Galleries,
Beverly Hills, California, 1962
Orr's Gallery, San Diego, California, 1962
Seattle Art Museum, 1960, 1945, 1936
College of Puget Sound, Tacoma, Washington, 1954
Zoe Dusanne Gallery, Seattle, 1952

*Documentaries*
"Upfront," KOMO-TV, 1983
"American Skyline," National Public Television, 1982
"Northwest Visionaries," 1978
"Three Artists in the Northwest," KCTS-TV, 1976

*Selected Collections*
Art Gallery of Greater Victoria,
British Columbia, Canada

Brooklyn Museum, New York
City of Seattle
Davis Wright Tremaine, Seattle
Henry Art Gallery, University of Washington, Seattle
Junior League of Seattle
Lakes Club, Bellevue, Washington
Meany Hall, University of Washington, Seattle
Metropolitan Museum of Art, New York
Municipal Gallery of Modern Art, Dublin, Ireland
Museum Boymans–van Beunigen,
Rotterdam, Netherlands
National Museum of American Art, Smithsonian
Institution, Washington, D.C.
Santa Barbara (California) Museum of Art
Seattle Art Museum
Seattle Arts Commission
Seattle Public Library
Spokane (Washington) Arts Commission
State Capital Museum, Olympia, Washington
Tacoma (Washington) Art Museum
Tacoma (Washington) Arts Commission
University of Oregon, Eugene
Utah Museum of FineWashington  Arts,
Salt Lake City
Washington State University, Pullman
Whatcom Museum of History and Art,
Bellingham, Washington

*Commissions*
Bank of California, Seattle
Bothell (Washington) Public Library
Edmonds (Washington) Public Library
First National Bank, Seattle
Hilton Inn, Seattle-Tacoma International Airport
King County Arts Commission, 1987 Honors
Award Commission (Washington State Convention
Center)
Opera House, Seattle Center
Port of Seattle International Trade Center, Seattle-
Tacoma International Airport
Skagit Valley Courthouse, Mt. Vernon,
Washington

*Awards and Grants*
Governor's Art Award, 1983
John Simon Guggenheim Foundation, fellowship,1975
Governor's Award of Special Commendation, 1969
Louis Comfort Tiffany Foundation, resident
scholarship, 1929

## Robert Barnes
*Education*
Slade School of Art, University of London,
1961–63
Hunter College, New York, 1957–60
Columbia University, New York, 1957
University of Chicago, B.A., 1952–56
School of the Art Institute of Chicago, B.F.A., 1952–56

*Teaching*
Indiana University, Bloomington, 1965–present
Indiana University, Bloomington, summers 1961, 1960
Visiting Artist, University of Wisconsin,
Madison, 1968
Visiting Artist, Kansas City (Missouri)

Art Institute, 1963–64

## Solo Exhibitions
Struve Gallery, Chicago, 1992, 1989, 1986
Art Museum, Indiana University, Bloomington, 1991
Natasha Nicholson Gallery, Madison, Wisconsin, 1989
Retrospective, Art Museum, Florida International
University, Miami, 1986
Retrospective, Hyde Park Art Center and
Renaissance Society, Chicago, 1986
Retrospective, Madison (Wisconsin) Art Center, 1986
Retrospective, Herron Gallery of Art,
Indianapolis, 1986
Retrospective, Artist's Choice Museum,
New York, 1985
Allan Frumkin Gallery, New York, 1985, 1983,
1979, 1977, 1975, 1969, 1965, 1963
Frumkin/Struve Gallery, Chicago, 1984, 1981
Marianne Friedland Gallery, Ontario, 1978
Allan Frumkin Gallery, Chicago,
1978, 1971, 1964, 1963, 1960
Galleria La Parisina, Turin, Italy, 1974
Galleria Fanta di Spade, Rome, Italy, 1973
Allan Frumkin Gallery, Chicago, exhibition
organized by Quincy (Illinois) Art Club (traveled to
David Strahn Gallery, Jacksonville, Illinois;
Georgia Museum of Art, University of Georgia,
Athens; Krannert Art Museum, University of
Illinois, Champaign; Western Illinois University,
Macomb; Illinois State University, Normal; East
Kent University, Richmond, Illinois; Springfield
[Illinois] Art Association; Civic Fine Arts Center,
Sioux Falls, South Dakota; Indiana University,
Bloomington), 1971
Herron Gallery of Art, Indianapolis, 1968, 1967
Galerie du Dragon, Paris, 1967
Coe College, Cedar Rapids, Iowa, 1967
Reed College, Portland, 1966
Fine Arts Gallery, Indiana University,
Bloomington, 1965

## Selected Collections
Albrecht-Kemper Museum of Art, St. Joseph,
Missouri
Art Center College of Design, Pasadena, California
Art Institute of Chicago
David and Alfred Smart Museum of Art, University
of Chicago
Indiana University, Bloomington
Indianapolis Museum of Art
Museum of Contemporary Art, Chicago
Museum of Modern Art, New York
National Gallery of Art, Washington, D.C.
Weatherspoon Art Gallery, University of North
Carolina, Greensboro
Whitney Museum of American Art, New York

## Awards and Grants
National Endowment for the Arts, 1982
American Academy of Arts and Letters, purchase
prize, Childe Hassam award, 1971
School of the Art Institute of Chicago, Guri Siever
award, 1963
Fulbright Grant, 1962–63, 1961–62
Art in America Magazine, New Talent award,

1962
Copley Foundation, award, 1961

# Don Baum

## Education
Michigan State College, East Lansing
School of the Art Institute of Chicago
School of Design, Chicago
University of Chicago

## Teaching
School of the Art Institute of Chicago, 1988–91
Hyde Park Art Center, Chicago, 1955–65
Art Department, Roosevelt University of Chicago,
1948–84 (department chair, 1970–84)

## Solo Exhibitions
Betsy Rosenfield Gallery, Chicago,
1992, 1989, 1987, 1984, 1982, 1980
Siena Heights College, Adrian, Michigan, 1990
Art Gallery, Rockford (Illinois) College, 1989
Art Center, Battlecreek, Michigan, 1989
Grand Valley State University,
Allendale, Michigan, 1989
Gallery Camino Real, Boca Raton, Florida, 1989
Madison (Wisconsin) Art Center (traveled to State
of Illinois Art Gallery, Chicago; Illinois State
Museum, Springfield; Krannert Art Museum,
University of Illinois, Champaign), 1988–90
Galerie Darothea Speyer, Paris, 1985
Hyde Park Art Center, Chicago, 1981, 1961
Bridge Gallery, New York, 1965
John L. Hunt Gallery, Chicago, 1965
Ruth White Gallery, New York, 1957

## Awards and Grants
Illinois Arts Alliance, Sidney R. Yates Arts
Advocacy award, 1989
National Endowment for the Arts, grant, 1984
School of the Art Institute of Chicago, Honorary
Doctor of Arts, 1984
Art Institute of Chicago, Pauline Palmer prize, 1984
Cliff Dweller's Club, Chicago, award for
outstanding contribution in the arts, 1977

## Professional Activities
Curator, Urgent Messages, Chicago Public Library
Cultural Center, 1988
Member, International Exhibitions Committee,
Washington, D.C., 1977–79
Curator, Made in Chicago: Some Resources,
Museum of Contemporary Art, Chicago, 1975
Member, Board of Trustees, Museum of
Contemporary Art, Chicago, 1974–86
Chair, Exhibitions Committee, Museum of
Contemporary Art, Chicago, 1974–79
Commissioner, U.S. entry, São Paulo Bienal, 1973
Trustee, Koffler Foundation Collection,
Chicago, 1971–82
Visual Arts Consultant, Illinois Arts Council,
Chicago, 1970–82
Curator, "Don Baum Says": Chicago Needs
Famous Artists, Museum of Contemporary Art,
Chicago, 1969

Curator, *Illinois Painters I,* Illinois Arts Council, Chicago, 1967
Board member and director of exhibitions, Hyde Park Art Center, Chicago, 1956–72

## Miriam Beerman

### Education
Rhode Island School of Design, Providence, B.F.A.
Art Students League, New York
New School for Social Research, New York
New York University
Atelier 17 (William Hayter), Paris

### Solo Exhibitions
Retrospective, New Jersey State Museum, Trenton, 1991
Retrospective, Pratt Institute, New York, 1989
Montclair (New Jersey) Art Museum, 1987, 1974
Art Gallery, Montclair (New Jersey) State College, 1987
Millersville (Pennsylvania) University, 1986
Virginia Center for Creative Arts, Sweetbriar, 1986
Pastoral Gallery, Easthampton, New York, 1983
Roger Litz Gallery, New York, 1982
Camargo Foundation, Cassis, France, 1980
Gallery One, Montclair (New Jersey) State College, 1978
Discovery Art Galleries, Clifton, New Jersey, 1977, 1974
Cathedral Museum, Cathedral of St. John the Divine, New York, 1977
Graham Gallery, New York, 1977, 1972
Brooklyn Museum, New York, 1971
Benton and Bowles, New York, 1970
Chelsea Gallery, New York, 1969
Newport (Rhode Island) Art Association, 1965
Brooklyn Center, Long Island University, 1965

### Selected Collections
Andrew Dickson White Museum, Cornell University, Ithaca, New York
Arnot Art Museum, Elmira, New York
Brooklyn Museum, New York
Cathedral of St. John the Divine, New York
Israel Museum
Montclair (New Jersey) Art Museum
Morris Museum, Morristown, New Jersey
New Jersey State Museum, Trenton
New School for Social Research, New York
Newark (New Jersey) Museum
Newark (New Jersey) Public Library
University of Oregon, Eugene
Virginia Center for Creative Arts, Sweetbriar
Whitney Museum of American Art, New York
Zimmerli Art Museum, Rutgers, State University of New Jersey, New Brunswick

### Awards and Grants
Virginia Center for Creative Arts, Sweetbriar, artist's residency, 1992, 1991, 1990, 1989, 1987, 1986, 1985
University of Chicago, artist-in-residence, 1988
Blue Mountain Center, New York, artist's residency, 1988
Rutgers Center for Innovative Printmaking, fellowship/artist-in-residence, 1988
New Jersey State Council on the Arts, Distinguished Artist Award and grant
Leighton Artists Colony, Banff Center, Alberta, Canada, artist's residency, 1987, 1986
National Screening Committee, Fulbright Grants in Art, juror, 1986
Women's Research and Development Fund, City University of New York, grant, 1986
Residency fellowship, Virginia Center for Creative Arts, Sweetbriar, 1984, 1983
New Jersey State Council on the Arts, grant, 1983, 1978
Nominated for A.V.A. Award, 1983
Camargo Foundation, Cassis, France, residency fellowship, 1980
Burston Graphic Center, Jerusalem, Israel, visiting artist, 1980
Ossabaw Island Project, Georgia, residency fellowship, 1978
American Academy and Institute of Arts and Letters, Childe Hassam Purchase Award, 1977
Millay Colony, Austerlitz, New York, residency fellowship, 1976
American Institute of Graphic Arts, Book of the Year Award for The Enduring Beast, 1972
Creative Artists Public Service Program Grant, New York State Council on the Arts, 1971
MacDowell Colony, Peterborough, New Hampshire, residency fellowship, 1959
Fulbright Fellowship, Paris, 1953–55
Art Students League scholarship, New York, 1955
Rhode Island School of Design, Providence, Ives Prize for Painting, 1955

## Jack Boul

### Education
American Artists School, New York
Cornish School of Art, Seattle
American University, Washington, D.C.

### Teaching
Washington (D.C.) Studio School, 1984–present
American University, Washington, D.C., 1969–84
Montgomery College, Takoma Park and Rockville, Maryland, 1966–75
Smithsonian Associates, Washington, D.C., 1969–70
Chestnut Lodge, Rockville, Maryland, 1956–57

### Solo Exhibitions
Washington (D.C.) Studio Gallery, 1992, 1990, 1989
Circle Gallery, Washington, D.C., 1988
University of Maryland, College Park, 1986
Mint Museum, Charlotte, North Carolina, 1986
Watkins Gallery, American University, Washington, D.C., 1985, 1983, 1980, 1972, 1971, 1960
Baltimore Museum of Art, 1974
Jefferson Place Gallery, Washington, D.C., 1968, 1965
Franz Bader Gallery, Washington, D.C., 1957

## Morton C. Bradley, Jr.

*Education*
Harvard University
Fogg Art Museum

*Solo Exhibitions*
Art Museum, Indiana University, Bloomington,
1992
American Association for the Advancement of
Science, annual meeting, Boston, 1988
Lincoln (Massachusetts) Laboratory, 1985–86,
1982
Museum of Art, Smith College, Northampton,
Massachusetts, 1984
MIT Museum, Cambridge, Massachusetts, 1983
Sharon (New Hampshire) Art Center, 1983
Compton Gallery, Massachusetts Institute of
Technology, Cambridge, 1983
New Britain (Connecticut) Museum of American
Art, 1981

## Mala Breuer

*Solo Exhibitions*
Ruth Bachofner Gallery, Los Angeles, 1992
Laura Carpenter Fine Art, Santa Fe,
New Mexico, 1992
Graham Gallery, Albuquerque,
New Mexico, 1990, 1988
Craig Cornelius Gallery, New York, 1983
Hadler/Rodriguez Gallery, New York, 1983, 1981
SoHo Center for Visual Artists, New York, 1980
Source Gallery, San Francisco, 1976
Icehouse, San Francisco, 1975
Susan Rush Gallery, San Francisco, 1974
Zara Gallery, San Francisco, 1974
Labaudt Gallery, San Francisco, 1967, 1965

## Hans Burkhardt

*Education*
Grand Central School of Art, New York
(studied with Arshile Gorky), 1928–29
Cooper Union, New York, 1925–28

*Teaching*
California State University, Long Beach
University of Southern California, Los Angeles
University of California, Los Angeles

*Solo Exhibitions*
Graduate Theological Union, Berkeley,
California, 1993
Galerie Hesselbach, Berlin, Germany, traveled to
Jack Rutberg Fine Arts, Los Angeles, 1993
Jack Rutberg Fine Arts, Los Angeles, 1993, 1991,
1988, 1987, 1985, 1984, 1983, 1982
Cerro Coso Community College, Ridgecrest,
California, 1992
Portland Art Museum, 1990–91
Muhlenberg College, Allentown, Pennsylvania, 1990
Laguna Art Museum, Laguna Beach, California, 1990
Galway International Art Festival, Ireland, 1990

Sid Deutsch Gallery, New York, 1987
Cunningham Memorial Art Gallery, Bakersfield,
California, 1987
Oakland (California) Museum, 1987
Pacific Northwest College of Art, Portland, 1984
Robert Schoelkopf Gallery, New York, 1979
Palm Springs (California) Desert Museum, 1979, 1964
Santa Barbara (California) Museum of Art, 1977
Pasquale Iannetti Gallery, San Francisco, 1977
Oviatt Library, California State University,
Northridge, 1975
California State University, Northridge, 1973
Retrospective, Long Beach Museum of Art,
Michael Smith Gallery, Los Angeles, California, 1972
Fine Arts Gallery of San Diego, California, 1968
Laguna Beach (California) Art Association,
1966, 1963
Retrospective, San Diego (California)
Art Institute, 1966
San Fernando Valley (California) State College,
1965, 1963
Freie Schule, Basel, Switzerland, 1965
Ankrum Gallery, Los Angeles, 1963, 1961
Fresno (California) Art Center, 1962
Santa Monica (California) Municipal Art
Gallery, 1962
Retrospective, Santa Barbara (California) Museum
of Art; Palace of the Legion of Honor,
San Francisco; Los Angeles Municipal
Art Gallery; 1961–62
Pastel Exhibition, Ankrum Gallery,
Los Angeles, 1961
University of Southern California,
Los Angeles, 1960, 1953
Instituto Allende, San Miguel Allende,
Mexico, 1960, 1958, 1956
Long Beach (California) State College, 1959
Esther Robles Gallery, Los Angeles, 1959, 1957
Retrospective, Pasadena (California) Art
Museum, 1957
Mount Saint Mary's College, Los Angeles, 1956
Occidental College, Los Angeles, 1955
Falk-Raboff Gallery, Los Angeles, 1954
Paul Kantor Gallery, Los Angeles, 1952
Museo de Bellas Artes, Guadalajara, Mexico, 1951
Los Angeles Art Association, 1951
Fraymart Gallery, Los Angeles, 1951
University of Oregon, Eugene, 1947
Los Angeles County Museum, 1945
Circle Gallery, Los Angeles, 1940–45
Stendahl Gallery, Los Angeles, 1939

*Documentaries*
"Hans Burkhardt: The Artist's World," produced
by Gary and Sarah Legon, Estate Films, 1987
California State University, Northridge, 1977
University of California, Los Angeles, 1976
"Thirty-Year Retrospective," Los Angeles
Municipal Art Galleries, KHJ-TV, 1962
KHJ-TV, 1961

*Selected Collections*
Achenbach Foundation, Palace of the Legion of
Honor, San Francisco
Arkansas Art Center, Little Rock

British Museum, London
California State University, Northridge, Hans
Burkhardt Center for the Arts and Humanities
Calvin College, Grand Rapids, Michigan
Columbia (South Carolina) Museum of Art
Corcoran Gallery of Art, Washington, D.C.
Downey (California) Art Museum
Grunwald Center for the Graphic Arts, Los Angeles
Hirshhorn Museum and Sculpture Garden,
Smithsonian Institution, Washington, D.C.
Irish Museum of Modern Art, Dublin
Joslyn Art Museum, Omaha, Nebraska
Kunstmuseum Basel, Switzerland
La Jolla (California) Museum of Contemporary Art
Laguna Art Museum, Laguna Beach, California
Long Beach (California) Museum of Art
Los Angeles County Museum of Art
Lowe Art Museum, University of Miami, Coral
Gables, Florida
Moderna Museet, Stockholm, Sweden
Muhlenberg College, Allentown, Pennsylvania
Norton Simon Museum, Pasadena, California
Oakland (California) Museum
Palm Springs (California) Desert Museum
Portland (Maine) Museum of Art
Portland (Oregon) Museum of Art
San Diego (California) Museum of Art
Santa Barbara (California) Museum of Art
Skirball Museum, Los Angeles
Solomon R. Guggenheim Museum, New York
State of California
Tamarind Institute, University of New Mexico,
Albuquerque
Weatherspoon Art Gallery, University of North
Carolina, Greensboro
Worcester (Massachusetts) Art Museum
Yale University Art Gallery, New Haven,
Connecticut

## Awards and Grants
American Academy and Institute of Arts and
Letters, New York, Jimmy Ernst Award in Art for
Lifetime Achievement, 1992
LA Artcore, 4th Annual Award in Art, 1992
Citation from Mayor Tom Bradley, City of Los
Angeles, proclaiming Hans Burkhardt Week,
October 11–17, 1991
Academia Tomasso Campanella, Rome,
International Academy of Arts, Silver Medal, 1969
California Water Color Society, purchase award,
1963, 1960
California State Fair and Exposition, second prize,
1962; cash award, 1957; first prize, 1954
California All City Arts Festival, first purchase
award, 1961
Los Angeles All City Arts Festival, first purchase
award, 1960; purchase prize, 1957
Santa Barbara Museum of Art, Ala Story Purchase
Award, 1958
Los Angeles County Museum, Jr. Art Council Prize,
1957; second prize, 1954; purchase award, 1945
Chaffey Community Art Association, cash
award, 1955
Terry Art Institute, Miami, Florida, cash award, 1951

# Martin Canin

## Solo Exhibitions
Manhattanville College, Purchase, New York, 1984
Graham Gallery, New York, 1978, 1974,
1973, 1969, 1968
Darthea Speyer Gallery, Paris, 1973
Bear Lane Gallery, Oxford, England, 1970
Matsuzakaya Gallery, Tokyo, 1960

## Selected Collections
Art Gallery, Yale University, New Haven,
Connecticut
Boston Public Library
Graduate Center, City University of New York
Lincoln Hospital, Bronx, New York
Michener Collection, University Art Museum,
University of Texas, Austin
Museum of Fine Arts, Boston
Neuberger Museum, Purchase, New York
New Bellevue Hospital Center, New York
North Central Bronx Hospital, Bronx, New York
Philadelphia Museum of Art
Portland (Maine) Museum
Portland (Oregon) Museum of Art
Rensselaer Polytechnic Institute, Troy, New York
St. Lawrence College, Canton, New York
St. Petersburg (Florida) Museum
Woodhull Hospital, Brooklyn, New York

# Constance Teander Cohen

## Education
School of the Art Institute of Chicago (studied with
Boris Ainsfeld and Laura Van Papalendam)

## Solo Exhibitions
Three Illinois Center, Chicago, 1985
Jan Cicero Gallery, Chicago, 1984

## Awards
Illinois Arts Council, grant, 1985
Art Institute of Chicago, Logna Medal, 1985
Art Institute of Chicago, Armstrong Award, 1985

## Sherman Drexler

*Teaching*
Provincetown (Massachusetts) Art Association, summers 1986–87
City College, City University of New York, 1970–86
Parsons School of Design, New York, 1984
School of the Art Institute of Chicago, 1982
University of Pennsylvania, Philadelphia, 1980
Cooper Union, New York, 1974

*Solo Exhibitions*
P.S. 1, Long Island City, New York, 1984
Max Hutchinson Gallery, New York, 1982
Books and Company, New York, 1980
Aaron Berman Gallery, New York, 1977
Landmark Gallery, New York, 1976
New York University, 80 Washington Square East, 1975
Drew University, Madison, New Jersey, 1974
Skidmore College, Saratoga Springs, New York, 1970
Graham Gallery, New York, 1969
Sun Gallery, New York, 1962
Tirca Karlis Gallery, Provincetown, Massachusetts, 1961–63
Tibor de Nagy Gallery, New York, 1961–62
Rice Gallery, New York, 1960
Seven Arts Gallery, New York, 1958
Courtyard Gallery, Berkeley, California, 1956

*Selected Collections*
Bowdoin College, Brunswick, Maine
Corcoran Gallery of Art, Washington, D.C.
Dillard University, New Orleans
Hirshhorn Museum and Sculpture Garden, Smithsonian Institution, Washington, D.C.
University of California
University of Texas at Austin
Worcester (Massachusetts) Art Museum

*Awards and Grants*
John Simon Guggenheim Foundation
Longview Foundation
Walter K. Futman Foundation
Wadsworth Atheneum–American Federation of Arts

*Professional Activities*
School of the Art Institute of Chicago, commencement address, 1985

## Edward Dugmore

*Education*
University of Guadalajara, Mexico, 1951
California School of Fine Arts, San Francisco, 1948 (studied with Clyfford Still)
Kansas City (Missouri) Art Institute, summer 1941 (studied with Thomas Hart Benton)
Hartford (Connecticut) Art School, 1934

*Teaching*
Maryland Institute, College of Art, Baltimore, 1973–82
Pratt Institute, Brooklyn, New York, 1964–74
Drake University, Des Moines, Iowa, visiting artist, 1970
Montana Institute of Fine Arts, Great Falls, artist-in-residence, 1965
Southern Illinois University, Carbondale, visiting artist, 1961–62
Aspen (Colorado) School of Contemporary Art, visiting artist, 1961
St. Joseph's College, West Hartford, Connecticut, 1946–47

*Solo Exhibitions*
Manny Silverman Gallery, Los Angeles, 1991, 1992
Carlson Gallery, San Francisco, 1990
H. Marc Moyens, Alexandria, Virginia, 1975
Green Mountain Gallery, New York, 1973
Des Moines (Iowa) Art Center, 1972
M.I.A. Gallery, Great Falls, Montana, 1965
Howard Wise Gallery, New York, 1963, 1961, 1960
Holland-Goldowsky Gallery, Chicago, 1959
Stable Gallery, New York, 1956, 1954, 1953
Sheldon Street Studio, Hartford, Connecticut, 1953
Metart Gallery, San Francisco, 1950

*Selected Collections*
Albright-Knox Art Gallery, Buffalo, New York
Civic Museum and Gallery, Udine, Italy
Corcoran Gallery of Art, Washington, D.C.
Des Moines (Iowa) Art Center
Hirshhorn Museum and Sculpture Garden, Smithsonian Institution, Washington, D.C.
Housatonic Community College, Stratford, Connecticut
Kresge Art Center, Michigan State University, East Lansing
Southern Illinois University, Carbondale
University of Guadalajara, Mexico
Walker Art Center, Minneapolis
Weatherspoon Art Gallery, University of North Carolina, Greensboro

*Awards and Grants*
National Endowment for the Arts, grant, 1985, 1976
American Academy and Institute of Arts and Letters, award, 1980
John Simon Guggenheim Foundation, fellowship, 1966
Art Institute of Chicago, M. V. Kohnstamm award, 1962

*Professional Activities*
Co-organizer, Metart Gallery, San Francisco, an artists collaborative gallery, 1948

## Roberto Estopinan

*Solo Exhibitions*
Schweyer-Galdo Galleries, Birmingham, Michigan, 1983
Schweyer-Galdo Galleries, Morristown, New Jersey, 1982
Palazzo del Turismo, Montecatini, Italy, 1981
Brickell Gallery, Miami, Florida, 1975
Janus Gallery, Miami, Florida, 1970
McDonogh Gallery, Cleveland, Ohio, 1968
Hammond Gallery, Burlington, North Carolina, 1965
National Museum of Fine Arts, Havana, 1957

Lyceum Gallery, Havana, 1957, 1956,
1955, 1950, 1949
Centro Asturiano Salon, Havana, 1953
National Capitol, Havana, 1951

*Selected Collections*
Academia de Arte, Montecatini, Italy
Allen R. Hite Museum, Louisville, Kentucky
Art Museum, University of Oregon, Eugene
Brooklyn, Museum, New York
Cuban National Museum, Havana
Detroit Institute of Arts
Georgia Museum of Art, Athens
Institute of International Education, Paris
Instituto de Cultura Hispanica Museum, Madrid
Instituto Nacional de Bellas Artes, Mexico City
Jose Gomez-Sicre Foundation, Washington, D.C.
Lansing-Reilly Collection, University of Detroit
Maggio Miro Collection, Montecatini-Terme, Italy
Mead Art Museum, Amherst (Massachusetts) College
Morris Museum of Art, Morristown, New Jersey
Museum of Art, University of Iowa, Iowa City
Museum of Art, University of Wisconsin, Madison
Museum of Modern Art of Latin America,
Washington, D.C.
Museum of Modern Art, New York
Museum of the University of Caracas, Venezuela
Museum of the University of Puerto Rico
National Museum of Santo Domingo,
Dominican Republic
New Jersey State Museum, Trenton
Pan American Union, Washington, D.C.
Philadelphia Museum of Art
Rose Art Museum, Brandeis University,
Waltham, Massachusetts
Tate Gallery, London

# Claire Falkenstein

*Exhibitions*
Museum of Contemporary Art, Los Angeles, 1989
Knoxville (Tennessee) Museum of Art, 1989
Annual Landscape Architects Exhibition,
San Francisco, 1989
Jack Rutberg Fine Arts, Los Angeles,
1989, 1986, 1984
California State University, Fresno, 1988
Galerie Stadler, Paris, 1988, 1985, 1972, 1957, 1955
Cantini Museum, Marseilles, France, 1988
Art Gallery, Loyola Marymount College,
Los Angeles, 1988
Stanislaus (California) University Gallery, 1987
Solomon R. Guggenheim Museum,
New York, 1987, 1978
Anita Shapolsky Gallery, New York, 1986
Arbitrage Gallery, New York, 1985
National Museum of American Art, Smithsonian
Institution, Washington, D.C., 1985
University of California, Riverside, 1984
Tortue Gallery, Santa Monica, California, 1981, 1975
Smith Anderson, Palo Alto, California, 1981
Palm Springs (California) Desert Museum, 1980
Coos Art Museum, Coos Bay, Oregon, 1980
Seattle Art Museum, 1979
Stewart Neill Gallery, New York, 1978

Tate Gallery, London, 1978
Dorothy Rosenthal Gallery, Chicago, 1976
Smith Anderson Gallery, San Francisco, 1976
Los Angeles County Museum of Art, 1973
Brooklyn Museum, New York, 1970
Fresno (California) Art Center, 1969
Long Beach (California) Museum, 1968
Victoria and Albert Museum, London, 1968
Phoenix Museum of Art, 1967
Martha Jackson Gallery,
New York, 1965, 1963, 1960
Whitney Museum of American Art,
New York, 1964, 1960
Carnegie Institute, Pittsburgh,
Pennsylvania, 1964, 1958
Esther Robles Gallery, Los Angeles, 1963
San Francisco Museum of Art, 1963, 1948, 1940
Musée des Arts Decoratifs, Palais du Louvre,
Paris, 1962
Salon de Mai, Paris, 1961
Musée Rodin, Paris, 1961
Galerie Parnass, Wuppertal, Germany, 1960
Art Biennale of Paris, 1960
Art Nel Vitalita, Palazzo Grazzi, Venice, 1959
Osaka International, 1958
Rome–New York Art Foundation, Rome, 1958
Sala Gaspar, Barcelona, Spain, 1957
Galerie Rive Droit, Paris, 1956
Galeria Spazio, Rome, 1954
Museum of Modern Art, New York, 1954
Institute of Contemporary Art, London, 1953
Werkbund, Berlin, Germany, 1952
Metropolitan Museum of Art, New York, 1948
East-West Gallery, San Francisco, 1930–31

*Commissions*
California Art Council for the Department of
Motor Vehicles, Los Angeles, Forum, monumental
outdoor installation, tribute to A. Quincy Jones,
California State University, Dominguez Hills, 1987
Tide Pool Foundation, San Francisco, 1983
South Coast Plaza, Costa Mesa, California, 1982
Bing Theater, University of Southern California,
Los Angeles, 1976
San Diego Museum of Art, 1974
Sculpture Garden, University of California, Los
Angeles, 1970
St. Basil Church, Los Angeles, 1969
Three Fires, Fresno, California, 1966
California State University, Long Beach, 1965
Baron Alix de Rothschild, Normandy, France
Guggenheim Museum, Venice, Italy
Villa Princess Pignatelli, Rome, 1957

*Awards and Grants*
San Francisco State University,
Distinguished Artist Forum, 1988
Vesta Award, Woman of the Year in Art,
Los Angeles, 1985
Women's Caucus for Art, 1981
John Simon Guggenheim Memorial Foundation,
fellowship, 1978–79
Los Angeles Times, Woman of the Year for Art, 1969
California State University, Long Beach,
International Sculpture Symposium, 1965

## Sidney Gordin

*Education*
Cooper Union, New York, 1941

*Teaching*
University of California, Berkeley, 1958–86

*Solo Exhibitions*
Gallery Paule Anglim, San Francisco,
1991, 1988, 1984, 1981
Newspace, Los Angeles, 1985, 1979, 1977
Sid Deutsch Gallery, New York, 1982, 1980
Walnut Creek (California) Civic Arts Center, 1981
Zabriskie Gallery, New York, 1980
Center Gallery, U.C. Extension, San Francisco, 1974
Olive Hyde Art Center, Fremont, California, 1972
Quay Gallery, San Francisco, 1969
Berkeley (California) Art Center, 1967
St. Mary's College of California, Moraga, 1965
Dilexi Gallery, San Francisco, 1965, 1963, 1961, 1959
Kasha-Herman Gallery, Chicago, 1965, 1963
Bradford (Massachusetts) Junior College, 1964
Dilexi Gallery, Los Angeles, 1963
Junior Center of Art and Science,
Oakland, California, 1962
M. H. de Young Memorial Museum,
San Francisco, 1962
Grace Borgenicht, New York,
1961, 1958, 1955, 1953
Temple Israel, Tulsa, Oklahoma, 1959
Katonah (New York) Village Library Gallery, 1957
New School for Social Research, New York, 1957
Peter Cooper Gallery, New York, 1952
Bennington (Vermont) College, 1951

*Selected Collections*
Arizona State University, Tempe
Art Institute of Chicago
Brooklyn Museum, New York
Chrysler Museum, Norfolk, Virginia
Corcoran Gallery of Art, Washington, D.C.
Newark (New Jersey) Museum
Oakland (California) Museum
Security Pacific National Bank, Los Angeles
Southern Illinois University, Carbondale
Weatherspoon Art Gallery, University of North
Carolina, Greensboro
Whitney Museum of American Art, New York

## Frederick Hammersley

*Education*
Jepson Art School, Los Angeles, 1947–50
Ecole des Beaux-Arts, Paris, 1945
Chouinard Art School, Los Angeles,
1940–42, 1946–47
University of Idaho, Southern Branch,
Pocatello, 1936–38

*Teaching*
University of New Mexico, Albuquerque, 1968–71
Chouinard Art School, Los Angeles, 1964–68
Pasadena (California) Art Museum, 1956–61
Pomona College, Claremont, California, 1953–62

Jepson Art School, Los Angeles, 1948–51

*Solo Exhibitions*
Mulvane Art Museum, Washburn University,
Topeka, Kansas, 1993
Modernism, San Francisco, 1990, 1987
Graham Gallery, Albuquerque, New Mexico, 1989
New Mexico State Fair, Albuquerque, 1988
Lise Hoshour, Albuquerque, New Mexico,
1986, 1984
L. A. Louver Galleries, Venice, California,
1981, 1978
Middendorf/Lane Galleries,
Washington, D.C., 1977
University of New Mexico, Albuquerque,
1975, 1969
Hollis Galleries, San Francisco, 1966
Santa Barbara (California) Museum of Art, 1965
La Jolla (California) Art Museum, 1963
Heritage Gallery, Los Angeles, 1963, 1961
California Palace of the Legion of Honor, San
Francisco, 1962
Occidental College, Los Angeles, 1962
Pasadena (California) Art Museum, 1961

*Selected Collections*
Albuquerque (New Mexico) Museum of Art,
History, and Science
Butler Institute of American Art, Youngstown, Ohio
Corcoran Gallery of Art, Washington, D.C.
La Jolla (California) Museum of Art
Los Angeles County Museum of Art
Museum of Fine Arts, Santa Fe, New Mexico
Oakland (California) Museum
Petersburg Press, London
Roswell (New Mexico) Museum and Art Center
San Francisco Museum of Modern Art
Santa Barbara (California) Museum of Art
United States Navy
University Art Museum,
University of California, Berkeley
University of Nebraska, Lincoln
University of New Mexico, Albuquerque
Washington Post, Washington, D.C.

*Awards and Grants*
National Endowment for the Arts, grant,
1977, 1975
John Simon Guggenheim Foundation, fellowship, 1973

## Julius Hatofsky

*Education*
Hans Hoffman School of Art, 1952
Grande Chaumière, Paris, 1950–51
Art Students League, New York, 1946–50

*Teaching*
San Francisco Art Institute, 1962–present

*Solo Exhibitions*
San Francisco Museum of Modern Art Rental
Gallery, 1988
Gallery Paule Anglim, San Francisco, 1985, 1983
Smith-Anderson Gallery, San Francisco, 1975

Smith Andersen Gallery, Palo Alto, California, 1974
Emmanuel Walters Gallery, San Francisco
Art Institute, 1968
Spencer Museum of Art, University of
Kansas, Lawrence, 1967
Gallery of Art, Marylhurst (Oregon) College,
1966, 1965
Charles Egan Gallery, New York, 1963, 1961
Holland-Goldowsky Gallery, Chicago, 1959
Avant-Garde Gallery, New York, 1958

*Selected Collections*
Kalamazoo (Michigan) Institute of Arts
Neuberger Museum, State University of
New York, Purchase
Whitney Museum of American Art, New York

*Awards and Grants*
Francis J. Greenburger Foundation, 1987
National Endowment for the Arts, 1977, 1967

## Felrath Hines

*Education*
Pratt Institute, Brooklyn, New York, 1952–53
New York University, 1951
Nahum Tschacbosov, New York, 1947–48
Art Institute of Chicago, 1944–46

*Teaching*
Art Students League, New York, 1969–72
Pratt Institute, Brooklyn, New York, 1969–72

*Solo Exhibitions*
Franz Bader Gallery, Washington, D.C., 1992,
1989, 1986
Mitchell Art Gallery, St. John's College, Annapolis,
Maryland, 1989
Barbara Fiedler Gallery, Washington, D.C., 1979,
1977, 1976

*Selected Collections*
National Museum of American Art, Smithsonian
Institution, Washington, D.C.

*Professional Activities*
Hirshhorn Museum and Sculpture Garden,
Smithsonian Institution, Washington, D.C., chief
conservator, 1980–93
National Portrait Gallery, Smithsonian Institution,
Washington, D.C., chief conservator, 1972–80
Museum of Modern Art, New York, conservator,
1962–72
Fine Arts Conservation Labs, New York, supervi-
sory conservator, 1962–64

## Mel Katz

*Education*
Cooper Union, New York
Brooklyn Museum, New York

*Teaching*
Portland State University, 1966–present
University of Haifa, Israel, visiting artist, 1992, 1990

*Solo Exhibitions*
Laura Russo Gallery, Portland,
1993, 1991, 1989, 1987
Retrospective, Portland Art Museum, 1988
Lynn McAllister Gallery, Seattle, 1987
Fountain Gallery of Art, Portland, 1985, 1983,
1982, 1981, 1980, 1979, 1976, 1975,
1973, 1970, 1967
Foundation Gallery, New York, 1982
Linda Farris Gallery, Seattle, 1982, 1980, 1978,
1977, 1975
Gallery of Art, Marylhurst (Oregon) College, 1981
Museum of Art, Washington State University,
Pullman, 1979
Max Hutchinson Gallery, New York, 1978
Bolles Gallery, San Francisco, 1968
Portland State University, 1968
Gordon Woodside Gallery, San Francisco, 1966
Portland Art Museum, 1965
Amel Gallery, New York, 1963, 1961

*Selected Collections*
City of Seattle
Cougar Valley Elementary School, Silverdale,
Washington
Good Samaritan Hospital, Portland
Portland Art Museum
Powers Gallery of Contemporary Art, University of
Sydney, Australia
Seattle Art Museum

*Commissions*
The Quintet, Cascade Estates, Portland, 1991
Russell Development, 200 Market Street Building,
Portland, 1990

*Awards and Grants*
National Endowment for the Arts, fellowship, 1976
Western States Arts Foundation, fellowship, 1975
International Print Institute, Santa Cruz,
California, 1975

*Professional Activities*
Metropolitan Arts Commission, Selection
Committee, 1992
Seattle Art Museum, lecture, 1990
Cheney Cowles Museum, Spokane, Washington,
lecture, 1989
National Endowment for the Arts, Visual Arts
Panel, Washington, D.C., 1985, 1976
Center for the Visual Arts, Portland, co-founder
and first president, 1971–84
Rockefeller Foundation, Regional Artist Fellowship
Program, 1979
Seattle Repertory Theatre, Seattle Arts
Commisission, and NEA, juror, 1979
Individual Artists Grant-in-Aid, Rhode Island State
Arts Council, juror, 1979
New Artspace Conference, Los Angeles, panelist, 1978
*Bumbershoot,* Seattle, juror, 1978
Custom House, Portland, Art in Public Spaces,
NEA, juror, 1977
Metropolitan Arts Commission Advisory
Committee, 1976–77
*Helen Frankenthaler,* Portland Art Museum,

curator, 1972
*CRUSH,* Fountain Gallery of Art, Portland,
curator, 1970

## Vera Klement

*Education*
Cooper Union School of Art and Architecture,
1950

*Solo Exhibitions*
Roy Boyd Gallery, Chicago, 1993,
1987, 1985, 1983
Art Expo, Chicago, 1993
CDS Gallery, New York, 1984, 1981
Marianne Deson Gallery, Chicago, 1981, 1979
Goethe Institute, Chicago, 1981
Krannert Center for the Performing Arts,
University of Illinois, Champaign, 1978
Chicago Gallery, Chicago, 1976
Artemisia Gallery, Chicago, 1974
Bridge Gallery, New York, 1965
RoKo Gallery, New York, 1958

*Selected Collections*
David and Alfred Smart Gallery, University of
Chicago
Wright Museum, Beloit, Wisconsin
New School for Social Research, New York, NY

## Charles McGee

*Education*
Escuela Massana, Barcelona, Spain
School of Graphics, Barcelona, Spain
Society of Arts and Crafts, Detroit

*Teaching*
Eastern Michigan University, Ypsilanti

*Solo Exhibitions*
Arwin Galleries, Detroit
Corcoran Gallery, Muskegon, Michigan
Detroit Artist's Market
Detroit Focus Gallery
Eastern Michigan University, Ypsilanti
Gallery 7, Detroit
Howard University, Washington, D.C.
Midland (Michigan) Center for the Arts
Pontiac (Michigan) Creative Arts Center
Siena Heights College, Adrian, Michigan

*Selected Collections*
American Embassy, Peru
Atlanta (Georgia) University
Children's Museum of Detroit
Detroit Board of Education
Detroit Institute of Arts
Engineering Society of Detroit
Howard University, Washington, D.C.
School of Graphics, Barcelona, Spain
Willistead Art Gallery, Windsor, Canada

*Commissions*
Central Michigan University
Detroit People Mover project
Detroit Public Schools
Detroit Workshop of Fine Prints
East Lansing City Hall
Eastern Michigan University
Holtzman and Silverman, Detroit
Michigan Arthritis Foundation
Michigan Foundation for the Arts
Northern High School, Detroit
Urban Wall Mural Program, New Detroit, Inc.
Ypsilanti State Hospital

*Awards and Grants*
Artist of the Year Award
Atlanta Annual Art Show, honorable mention
Atlanta University, Georgia, first prize
Central Business District Association,
Detroit, first prize
Detroit Institute of Arts, Afro-American
Exhibition, second prize
Governor's Michigan Artist Award, Concerned
Citizens for the Arts in Michigan
Michigan Academy of Science, Arts, and Letters,
University of Michigan, Ann Arbor,
honorable mention
Michigan Council for the Arts, grant, 1988, 1985
Michigan State Fair, first prize, 1971, 1959
Michigan State Fair, Invitational Division,
special prize
Michigan State Fair, third prize for painting
Morgan Prize for Outstanding Painting

*Professional Activities*
Curator: Detroit Artist's Market; Pewabic Pottery,
Detroit; Eller Sign Company, Detroit; Pittman
Gallery, Detroit; Contemporary Art Institute of
Detroit; New Detroit, Inc.; Detroit Institute of Arts,
Rental Gallery
Consultant: Detroit Council for the Arts; Michigan
Council for the Arts; Blue Cross-Blue Shield of
Michigan; New Detroit General Hospital; Detroit
Institute of Arts
Artist-in-Residence: Children's Museum, Detroit;
Ferndale (Michigan) Public Schools; Delaware
University, Wilmington; Mercy College, Detroit;
Detroit Public Schools; Northern High School,
Detroit Public Schools
Anna Thompson Dodge Bequest Selection
Committee, Hart Plaza, Detroit
Center for Creative Studies, Detroit,
Board of Directors
Detroit Artist's Market, Board of Directors
Detroit Focus Gallery, Artist Selection Committee
Detroit Focus Gallery, Board of Directors
Director: Sill Gallery, Eastern Michigan University
Founder and director: Charles McGee
School of Art, Gallery 7
Michigan Commission on Art in Public Places
Michigan Council for the Arts Commission,
Detroit

## Carl Morris

*Education*
Art Institute of Chicago
Akademie der Bildenden Künste, Vienna
Institute for International Education, Paris

*Teaching*
Port Townsend (Washington) Summer School of
Arts, 1975

*Solo Exhibitions*
Retrospective, Portland Art Museum, 1993
Laura Russo Gallery, Portland,
1992, 1990, 1988, 1986
Foster/White Gallery, Seattle, 1988
Fountain Gallery of Art, Portland, 1985, 1983,
1982, 1979, 1961
Gordon Woodside Gallery, Seattle, 1984, 1979
Retrospective, American Federation of Arts,
New York (traveled), 1960–62
Portland Art Museum, 1952
Kraushaar Galleries, New York, since 1950
Triangle Gallery, San Francisco, since 1948
California Palace of the Legion of Honor,
San Francisco, 1947

*Selected Collections*
Albright-Knox Art Gallery, Buffalo, New York
Allentown (Pennsylvania) Art Museum
Art Gallery of Toronto
Art Institute of Chicago
Chrysler Museum, Norfork, Virginia
Colorado Springs (Colorado) Fine Arts Center
Columbus (Ohio) Museum of Art
Corcoran Gallery of Art, Washington, D.C.
Dayton (Ohio) Art Institute
Denver Art Museum
Henderson Museum, University of Colorado, Boulder
Hirshhorn Museum and Sculpture Garden,
Smithsonian Institution, Washington, D.C.
Krannert Art Museum, University of Illinois, Champaign
Kresge Art Center, Michigan State University,
East Lansing
Memorial Art Gallery,
University of Rochester, New York
Metropolitan Museum of Art, New York
Minnesota Museum of Art, St. Paul
Munson-Williams-Proctor Institute,
Utica, New York
Museo de Arte Moderno, São Paulo, Brazil
Museum of Fine Arts, Houston
Museum of Modern Art, New York
Nelson-Atkins Museum of Art, Kansas City, Missouri
New Jersey State Museum, Jean Outland Chrysler
Collection, Trenton
Oregon Health Sciences University, Portland
Portland Art Museum
Reed College, Kenin Collection, Portland
San Francisco Museum of Modern Art
Santa Barbara (California) Museum of Art
Seattle Art Museum
Smithsonian Institution, Washington, D.C.
Solomon R. Guggenheim Museum, New York
Stanford University Art Gallery, Palo Alto,

California
University of Oregon, Eugene
University of Texas at Austin, Michener Collection
Wadsworth Atheneum, Hartford, Connecticut
Walker Art Center, Minneapolis
Wichita (Kansas) Art Museum, Roland P. Murdock
Collection

*Commissions*
Oregon Symphony poster design, 1976
Hall of Religious History, Oregon Centennial
Exposition, 9 murals (now in Museum of Art,
University of Oregon, Eugene), 1959

*Awards and Grants*
Lewis and Clark College, Portland, Aubrey R.
Watzek award, 1985
Oregon Arts Commission, Governor's Award for
the Arts, 1985
National Drawing Show, purchase award, 1975
Tamarind Lithography Workshop, fellowship, 1962
Ford Foundation, purchase award, 1960
University of Illinois, purchase award, 1957
Stanford University Art Gallery, purchase
award, 1950
National Institute of Arts and Letters, purchase
award, 1950
San Francisco Museum of Art, Phelan award, 1950
San Francisco Museum of Art, Emmanuel Walter
purchase prize, 1948
Seattle Art Museum, Margaret E. Fuller award,1946
San Francisco Museum of Art, Anne Bremmer
Memorial Prize, 1946
Denver Art Museum, purchase award, 1946

## Florence Pierce

*Education*
Emil Bisttram School of Art, Taos,
New Mexico, 1936–39
Studio School, Duncan Phillips Collection,
Washington, D.C., 1935–36

*Solo Exhibitions*
Graham Gallery, Albuquerque, New Mexico,
1991, 1987
Lew Allen Butler, Santa Fe, New Mexico, 1988
Jonson Gallery, University of New Mexico,
Albuquerque, 1985, 1974
Meridian Gallery, Albuquerque, New Mexico,
1983

*Documentary*
"The Art of Growing Older," KNME-TV, Colores,
1990

*Selected Collections*
Albuquerque (New Mexico) Museum of Art,
History, and Science
Rockefeller University, New York
Sasebo Museum, Japan
University of New Mexico, Albuquerque

## Michele Russo

### Solo Exhibitions
Laura Russo Gallery, Portland, 1992, 1991, 1990, 1988, 1987
Retrospective, Portland Art Museum, 1988, 1966
Fountain Gallery of Art, Portland, 1985, 1984, 1983, 1982, 1980, 1978, 1977, 1975, 1971, 1968, 1963
Wentz Gallery, Pacific Northwest College of Art, Portland, 1985
Seattle Art Museum, 1984
Fountain Fine Arts, Seattle, 1982
Northlight Editions, Portland, 1982
Center for the Visual Arts, Portland, 1978
Reed College, Portland, 1959, 1952, 1951

### Selected Collections
Dayton (Ohio) Art Institute
Emanuel Hospital, Portland
Hilton Hotel, Portland
Museum of Art, University of Oregon, Eugene
Oregon Art Institute, Portland
Oregon Health Sciences University, Portland
Portland Art Museum
Reed College, Portland
Seattle Art Museum
State of Oregon, State Office Building, Portland
University of Oregon, Eugene, Science Building

## Jon Serl

### Solo Exhibitions
Jamison/Thomas Gallery, Portland, 1993, 1991, 1989, 1988, 1987
Oneiros Gallery, San Diego, California, 1991, 1989, 1988
Mia Gallery, Seattle, 1991, 1989
Cavin-Morris, New York, 1991, 1987, 1986
Gasperi Gallery, New Orleans, 1989
Rainbow Man Gallery, Santa Fe, New Mexico, 1989
Primitivo, San Francisco, 1988
Art Galleries, Ramapo College, Mahwah, New Jersey, 1986
Ethnographic Arts, New York, 1985
Orange County Center for Contemporary Art, Santa Ana, California, 1984
Newport Harbor Art Museum, Newport Beach, California, 1982

### Selected Collections
Laguna Art Museum, Laguna Beach, California
Museum of American Folk Art, New York
National Museum of American Art, Smithsonian Institution, Washington, D.C.

## Oli Sihvonen

### Education
Black Mountain (North Carolina) College, 1946–48
Art Students League, New York, 1938–41
Norwich (Connecticut) Art School, Norwich Free Academy, 1933–38

### Teaching
Louisiana State University, Baton Rouge, 1976
University of Denver, 1965
University of New Mexico, Albuquerque, 1964
Hunter College, New York, 1954–56
Georgetown Day School, Washington, D.C., 1950–52

### Solo Exhibitions
Craig Cornelius Gallery, New York, 1983
Hoshour Gallery, Albuquerque, New Mexico, 1983, 1978
Roswell (New Mexico) Museum and Art Center, 1977
Art Gallery, Rice University, Houston, Texas, 1967
Burpee Art Museum, Rockford, Illinois, 1965
Stable Gallery, New York, 1963

### Selected Collections
Addison Gallery of American Art, Phillips Academy, Andover, Massachusetts
Albuquerque (New Mexico) Museum of Art, History, and Science
Art Institute of Chicago
Burpee Museum, Rockford, Illinois
Citibank, New York
Corcoran Gallery of Art, Washington, D.C.
Dallas Museum of Art
Museum of Fine Arts, Santa Fe, New Mexico
Museum of Modern Art, New York
New York State Art Collection, Albany
Northwestern University, Evanston, Illinois
Rockefeller University, New York
Rose Art Museum, Brandeis University, Waltham, Massachusetts
Roswell (New Mexico) Museum and Art Center
University Art Museum, University of New Mexico, Albuquerque
University of Michigan, Ann Arbor
Whitney Museum of American Art, New York
Worcester (Massachusetts) Art Museum

### Commissions
Citibank (First National City Bank), New York, 1973
Core and Research Library, Northwestern University, Evanston, Illinois, 1970
New York State Agency Building (South Mall), Albany, 1969
Midland Federal Savings Bank, Denver, 1966

### Awards and Grants
Pollock-Krasner Foundation, 1988
Yaddo Art Colony, fellowship, 1985, 1980
Adolph and Esther Gottlieb Foundation, 1985
National Endowment for the Arts, grant, 1977, 1967

## Sal Sirugo

### Solo Exhibitions
Landmark Gallery, New York, 1981, 1978, 1976
Great Jones Gallery, New York, 1966
K Gallery, Woodstock, New York, 1963
Tanager Gallery, New York, 1961
Camino Gallery, New York, 1959

*Selected Collections*
Boston Mutual Life Insurance Company, Canton, Massachusetts
Ciba-Geigy Corporation, Ardsley, New York
Dillard University, New Orleans
Grey Art Gallery and Study Center, New York University
Lannan Foundation, Los Angeles
Pace University, New York
Southern Illinois University, Carbondale
Syracuse (New York) University
University of Montevallo, Alabama
Vassar College Art Gallery, Poughkeepsie, New York
Zimmerli Art Museum, Rutgers University, New Brunswick, New Jersey

*Awards and Grants*
Adolph and Esther Gottlieb Foundation, award, 1984, 1982
Creative Artists Public Service (CAPS), fellowship, 1980
Longview Foundation, purchase award, 1962
Woodstock Foundation, award, 1952
Emily Lowe award, 1951

## David Slivka

*Education*
Art Institute of Chicago
California School of Fine Arts, San Francisco

*Teaching*
Pennsylvania Academy of the Fine Arts, Philadelphia, 1972–88

*Solo Exhibitions*
Benton Gallery, Southampton, New York, 1987
Noyes Museum, Oceanville, New Jersey, 1984
Elaine Benson Gallery, Bridgehampton, New York, 1979
University of Pennsylvania, Philadelphia, 1975–76
Hammarskjold Plaza Sculpture Garden, New York, 1975
Grace Plaza, New York, 1975
Everson Museum of Art, Syracuse, New York, 1974
University Museum, Southern Illinois University, Carbondale, 1968
Douglass College, Rutgers University, New Brunswick, New Jersey, 1963
Graham Gallery, New York, 1962
Pasadena (California) Museum of Art, 1958
Oakland (California) Museum, 1958

*Selected Collections*
Archer M. Huntington Art Gallery, University of Texas at Austin
Baltimore Museum of Art
Brooklyn Museum, New York
Everson Museum of Art, Syracuse, New York
Hirshhorn Museum and Sculpture Garden, Smithsonian Institution, Washington, D.C.
Kennedy International Arrivals Building, New York
Massachusetts Institute of Technology, Cambridge
National Museum of Wales, Swansea
Noyes Museum, Oceanville, New Jersey
Rutgers University, Camden, New Jersey

Rutgers University, New Brunswick, New Jersey
Southern Illinois University, Carbondale
University of Pennsylvania, Philadelphia
Walker Art Center, Minneapolis
Wellington-Ivest Collection, Boston
World Trade Center, New York

*Awards and Grants*
Pollock-Krasner Foundation, grant, 1985–86
Adolph and Esther Gottlieb Foundation, award, 1979
Louis Comfort Tiffany Foundation, award, 1977
Mark Rothko Foundation, grant, 1975
Brandeis University Creative Arts Award for American Sculpture, 1962
Longview Foundation, award, 1962, 1961, 1960

## Stella Waitzkin

*Education*
Alfred University
New York University
Columbia University

*Solo Exhibitions*
Galerie Caroline Corre, Paris, 1987
Creiger Sesen Gallery, Boston, 1984
Everson Museum of Art, Syracuse, New York, 1983
E. P. Gurewitsch, New York, 1977
James Yu Gallery, New York, 1977, 1975, 1974
Donnell Library, New York, 1976
Lowenstein Library, Fordham University, New York, 1975
Yale University Art Gallery, Calhoun College, New Haven, Connecticut, 1974

*Selected Collections*
Bectin Dickenson
Dow Jones
Everson Museum of Art, Syracuse, New York
Israel Museum, Tel Aviv
Jewish Museum, New York
New York Public Library
Patrick Lannon Foundation
Philip Morris, New York
Renwick Gallery, National Museum of American Art, Smithsonian Institution, Washington, D.C.
Virginia Museum of Fine Arts, Richmond
Walker Art Center, Minneapolis

*Awards and Grants*
Louis Comfort Tiffany Foundation, grant
MacDowell fellowship
Yaddo Foundation

## Robert Wilbert

*Education*
University of Illinois, M.F.A., 1954, B.F.A., 1951
University of Denver, 1950
Art Institute of Chicago

*Teaching*
Wayne State University, Detroit, 1956–present
Flint Institute of Arts and Flint Junior College, 1954–56

### Solo Exhibitions

Donald Morris Gallery, Birmingham, Michigan, 1992, 1989, 1986, 1984, 1980, 1977
Roger Ramsay Gallery, Chicago, 1990, 1986
John C. Stoller and Co., Minneapolis, 1987
Droll-Kolbert Gallery, New York, 1979
J. B. Speed Art Museum, Louisville, Kentucky, 1975
Donald Morris Gallery, Detroit, 1973, 1972, 1967, 1964
Wayne State University, Detroit, 1973, 1967
Part Gallery, Detroit, 1962
University of Illinois Student Union, 1960
Rackham Memorial, Detroit, 1958
Saginaw (Michigan) Art Museum, 1958

### Selected Collections

Detroit Institute of Arts
Kalamazoo (Michigan) Institute of Arts
Kresge Art Center, Michigan State University, East Lansing
Saginaw (Michigan) Art Museum
South Bend (Indiana) Art Center
Wayne State University, Detroit
Western Michigan University, Kalamazoo

### Commission

Stamp commemorating the sesquicentennial of Michigan statehood, United States Postal Service, 1987

### Awards and Grants

Michigan Foundation for the Arts, award, 1981
National Endowment for the Arts, 1977
Detroit Institute of Arts, Michigan Artists Exhibition, award, 1969, 1968, 1966
Michigan State Fair, award, 1967
South Bend (Indiana) Art Center, Michigan Regional Exhibition award, 1966, 1962, 1960
Scarab Club, Detroit, Michigan Watercolor Exhibition, first prize, 1960
Michigan Watercolor Society, award, 1959, 1958, 1957

## Jack Zajac

### Solo Exhibitions

El Paso (Texas) Museum of Art, 1984
Stephen Wirtz Gallery, San Francisco, 1984
Forum Gallery, New York, 1983, 1978, 1974, 1971
Mekler Gallery, Los Angeles, 1983
Retrospective, Fresno (California) Arts Center, 1981
Cedar Street Gallery, Santa Cruz, California, 1980
California State University, Los Angeles, 1978
Jodi Scully Gallery, Los Angeles, 1977, 1975, 1973
James Willis Gallery, San Francisco, 1977, 1974
Retrospective, Palm Springs (California) Desert Museum, 1977
Fortress of Albornoz, Orvieto, Italy, 1976
Galleria Maitani, Orvieto, Italy, 1976
Galleria la Margherita, Rome, 1976, 1972
Retrospective, Santa Barbara (California) Museum of Art, 1975, 1953
Galleria l'Obelisco, Rome, 1973
Fairweather Hardin Gallery, Chicago, 1970

Retrospective, Jaffee-Friede Gallery, Dartmouth College, Hanover, New Hampshire, 1970
Felix Landau Gallery, Los Angeles, 1969, 1967, 1964, 1962, 1960, 1958, 1956, 1954, 1953, 1951
California Institute of Technology, 1969
Retrospective, Galleries of Temple University, Tyler School of Art, Rome, 1968
Alpha Gallery, Boston, 1968
Landau Alan Gallery, New York, 1968, 1966
Gallery Marcus, Laguna Beach, California, 1966
Newport Pavilion Gallery, Balboa Park, California, 1965
Art Gallery, Mills College, Oakland, California, 1963
California Palace of the Legion of Honor, San Francisco, 1963
Galleria Pogliani, Rome, 1963
John Bolles Gallery, San Francisco, 1961
Downtown Gallery, New York, 1960
Devorah Sherman Gallery, Chicago, 1960
Roland, Browse and del Banco Gallery, London, 1960
Galeria Il Segno, Rome, 1957
John Young Gallery, Honolulu, 1956
Art Gallery, Scripps College, Claremont, California, 1955
Schneider Gallery, Rome, 1955
Pasadena (California) Art Museum, 1951

### Selected Collections

Arizona State University, Tempe
Butler Museum of American Art, Youngstown, Ohio
Center in Beverly Hills, California
Civic Center Plaza, City of Huntington Beach, California
Civic Center, City of Inglewood, California
Colorado Springs (Colorado) Fine Arts Center
Columbus (Ohio) Museum of Art
Cowell College, University of California, Santa Cruz
Dartmouth College, Hanover, New Hampshire
Fine Arts Gallery of San Diego, California
Frederick S. Wight Gallery and Sculpture Garden, University of California, Los Angeles
Fresno (California) Art Center
Hirshhorn Museum and Sculpture Garden, Smithsonian Institution, Washington, D.C.
Honolulu Academy of Art
Israel Museum, Jerusalem
Los Angeles County Museum of Art
Lowe Art Center, Syracuse University, New York
Marion Koogler MacNay Museum, San Antonio, Texas
Milwaukee Art Center
Museum of Modern Art, New York
Nelson-Atkins Museum of Art, Kansas City, Missouri
Newport Harbor Art Museum, Newport Beach, California
Oakland (California) Museum
Palm Springs (California) Desert Museum
Pasadena (California) Art Museum
Pennsylvania Academy of the Fine Arts, Philadelphia
Plaza Mall, Mission Viejo, California
Plaza Mall, San Jose, California
San Francisco International Airport
Santa Barbara (California) Museum of Art
Seattle Art Museum

# checklist of the exhibition

**1** Ernest Acker-Gherardino
*Isadora,* 1993
found twisted iron grate
26 x 46 x 12 inches (66.0 x 116.8 x 30.5 cm)
Collection of the artist
[not illustrated]

**2** Ernest Acker-Gherardino
*Cloak of Homelessness,* 1990
found crushed metal
44 x 29 x 20 inches (111.8 x 73.7 x 59.8 cm)
Collection of the artist
[fig. 1]

**3** Guy Anderson
*Three Men over a White Sea,* 1989
oil on reinforced paper
26 x 98 inches (66.0 x 248.9 cm)
Galleria dei Gratia, La Conner, WA
[not illustrated]

**4** Guy Anderson
The Seeding, 1986
oil on reinforced paper
98 x 74 inches (248.9 x 188.0 cm)
Galleria dei Gratia, La Conner, WA
[fig. 2]

**5** Guy Anderson
*Dreamer over a Blue Sea,* 1984
oil on reinforced paper
33 x 98 inches (83.8 x 248.9 cm)
Galleria dei Gratia, La Conner, WA
[not illustrated]

**6** Robert Barnes
*Pandora, Psyche, Minerva,* 1992
oil on canvas
87 1/2 x 75 inches (222.3 x 190.5 cm)
Struve Gallery, Chicago
[not illustrated]

**7** Robert Barnes
*Ludlow Silkie,* 1987
oil on canvas
86 x 86 inches (218.4 x 218.4 cm)
Struve Gallery, Chicago
[fig. 3]

**8** Don Baum
*Arf,* 1992–93
oil on canvasboard (found)
24 x 20 x 26 inches (61.0 x 50.8 x 66.0 cm)
Betsy Rosenfield Gallery, Chicago
[not illustrated]

**9** Don Baum
*Cygnus,* 1992
oil on canvasboard and wooden
cutting board
16 x 22 x 11 inches (40.6 x 55.9 x 27.9 cm)
Betsy Rosenfield Gallery, Chicago
[not illustrated]

**10** Don Baum
*Odysseus,* 1992
oil on canvasboard and wooden
cutting board
20 x 17 1/2 x 9 inches (50.8 x 44.5 x 22.9 cm)
Betsy Rosenfield Gallery, Chicago
[fig. 4]

**11** Miriam Beerman
Duende, 1993
oil on canvas
64 x 67 inches (162.6 x 170.2 cm)
Collection of the artist
[not illustrated]

**12** Miriam Beerman
*December (In Memory),* 1992
oil on linen
74 x 79 inches (188.0 x 200.7 cm)
Collection of the artist
[fig. 5]

**13** Jack Boul
*Wooden Gate,* 1993
oil on wood
5 1/2 x 7 1/2 inches (14.0 x 19.1 cm)
Collection of the artist
[not illustrated]

**14** Jack Boul
*Three Cows,* 1993
oil on museum board
9 x 11 3/4 inches (22.9 x 29.8 cm)
Collection of R. Christian Berg, Royal
Oak, Maryland
[not illustrated]

**15** Jack Boul
*Figure Reading,* 1993
oil on gesso panel
7 x 9 1/2 inches (17.8 x 24.1 cm)
Collection of Jack Barrett and Lauren
Saunders, Los Angeles
[not illustrated]

**16** Jack Boul
*Cows and Barn,* 1993
oil on wood
6 1/2 x 9 inches (16.5 x 22.9 cm)
Collection of R. Christian Berg, Royal
Oak, Maryland
[not illustrated]

**17** Jack Boul
*Clouds,* 1993
oil on wood
4 3/4 x 8 inches (12.1 x 20.3 cm)
Collection of Donald and Fan S. Ogilvy,
Washington, D.C.
[not illustrated]

**18** Jack Boul
*Seascape,* 1992
oil on gesso panel
5 x 9 inches (12.7 x 22.9 cm)
Private collection, Washington, D.C.
[not illustrated]

**19** Jack Boul
*Upstate,* 1992
oil on wood
4 3/4 x 7 3/4 inches (12.1 x 19.7 cm)
Collection of the artist
[not illustrated]

**20** Jack Boul
*Cows in a Gulley,* 1992
oil on canvas
9 x 11 inches (22.9 x 27.9 cm)
Collection of E. Van Houten,
Alexandria, Virginia
[fig. 6]

**21** Morton C. Bradley, Jr.
*Chrysalis,* 1989
polychromed wood
diameter: 41 inches (104.1 cm)
Collection of the artist
[not illustrated]

**22** Morton C. Bradley, Jr.
*Festival,* 1988
steel rod
diameter: 46 1/2 inches (118.1 cm)
Collection of the artist
[fig. 7]

**23** Morton C. Bradley, Jr.
*Labyrinth,* 1988
square brass tubing
32 x 32 x 45 inches (81.3 x 81.3 x 114.3 cm)
Collection of the artist
[not illustrated]

**24** Mala Breuer
*Untitled,* 1993
oil and wax on canvas
60 x 60 inches (152.4 x 152.4 cm)
Collection of the artist
[not illustrated]

**25** Mala Breuer
*Untitled,* 1992
oil and wax on canvas
72 x 72 inches (182.9 x 182.9 cm)
Collection of the artist
[fig. 8]

**26** Mala Breuer
*Untitled,* 1992
oil and wax on canvas
72 x 72 inches (182.9 x 182.9 cm)
Collection of the artist
[not illustrated]

**27** Hans Burkhardt
*Black Rain,* 1993
oil and mixed media on canvas
66 x 96 inches (167.6 x 243.8 cm)
Jack Rutberg Fine Arts, Los Angeles
[fig. 9]

**28** Hans Burkhardt
*County Museum,* 1993
oil and mixed media on canvas
66 x 96 inches (167.6 x 243.8 cm)
Jack Rutberg Fine Arts, Los Angeles
[not illustrated]

**29** Hans Burkhardt
*Requiem,* 1993
oil and mixed media on canvas
42 x 32 inches (106.9 x 81.3 cm)
Collection of Eugene Rogolsky,
Los Angeles
[not illustrated]

**30** Martin Canin
*Untitled,* 1993
oil on linen
50 1/2 x 70 inches (128.3 x 177.8 cm)
Collection of the artist
[not illustrated]

**31** Martin Canin
*Untitled,* 1993
oil on linen
54 1/2 x 93 inches (138.4 x 236.2 cm)
Collection of the artist
[fig. 10]

**32** Martin Canin
*Untitled,* 1993
oil on linen
78 x 89 1/2 inches (198.1 x 227.3 cm)
Collection of the artist
[not illustrated]

**33** Constance Teander Cohen
*Scaffold,* 1985
oil on linen
48 x 53 inches (121.9 x 134.6 cm)
Jan Cicero Gallery, Chicago
[not illustrated]

**34** Constance Teander Cohen
*Island, Phases of the Moon,* 1985
oil on canvas
66 x 78 inches (167.6 x 198.1 cm)
Jan Cicero Gallery, Chicago
[not illustrated]

**35** Constance Teander Cohen
*Swimmers,* 1982
oil on canvas
32 x 52 inches (81.3 x 132.1 cm)
Jan Cicero Gallery, Chicago
[fig. 11]

**36** Constance Teander Cohen
*Rowing in Eden,* 1982
oil on canvas
52 x 32 inches (132.1 x 81.3 cm)
Jan Cicero Gallery, Chicago
[not illustrated]

**37** Sherman Drexler
65 pieces dating from 1986 to 1994
acrylic on various media, including marble,
brick, stone, and wood Varying in height
from 2 1/2 to 14 inches (6.4 to 35.6 cm)
Collection of the artist
[fig. 12]

**38** Edward Dugmore
*Untitled 131B-90,* 1993
oil on canvas
70 x 48 inches (177.8 x 121.9 cm)
Manny Silverman Gallery, Los Angeles
[not illustrated]

**39** Edward Dugmore
*Opus 131B,* 1990
oil on canvas
68 x 48 inches (172.7 x 121.9 cm)
Manny Silverman Gallery, Los Angeles
[not illustrated]

**40** Edward Dugmore
*Guad Quartet 132,* 1984
oil on canvas
84 x 65 inches (213.4 x 165.1 cm)
Manny Silverman Gallery, Los Angeles
[fig. 13]

**41** Roberto Estopinan
*Two Torsos,* 1992
graphite on paper
44 x 30 inches (111.8 x 76.2 cm)
Collection of the artist
[not illustrated]

**42** Roberto Estopinan
*Camille Claudel Series:
Torso #1,* 1992
pastel and graphite on paper
28 x 20 inches (71.1 x 50.8 cm)
Collection of the artist
[fig. 14]

**43** Roberto Estopinan
*Camille Claudel Series: Torso #2,* 1992
pastel and graphite on paper
28 x 20 inches (71.1 x 50.8 cm)
Collection of the artist
[not illustrated]

**44** Roberto Estopinan
*Untitled,* 1988
graphite on paper
44 x 30 inches (111.8 x 76.2 cm)
Collection of the artist
[not illustrated]

**45** Claire Falkenstein
*Migration,* 1992
acrylic on canvas
87 x 75 inches (221.0 x 190.5 cm)
Collection of the artist
[not illustrated]

**46** Claire Falkenstein
*Performance,* 1992
acrylic on canvas
30 x 40 inches (76.2 x 101.6 cm)
Collection of the artist
[not illustrated]

**47** Claire Falkenstein
*Tower of Nymphs,* 1991
acrylic on canvas
78 x 54 inches (198.1 x 137.2 cm)
Collection of the artist
[fig. 15]

**48** Sidney Gordin
*#2.89,* 1989
acrylic on birch plywood
48 x 60 inches (121.9 x 152.4 cm)
Gallery Paule Anglim, San Francisco
[fig. 16]

**49** Sidney Gordin
*#5.88,* 1988
acrylic on birch plywood
48 x 60 inches (121.9 x 152.4 cm)
Gallery Paule Anglim, San Francisco
[not illustrated]

**50** Frederick Hammersley
*Field Ration,* 1992
oil on cotton mounted on wood
9 1/2 x 12 1/2 inches (24.1 x 31.8 cm)
Collection of the artist
[not illustrated]

**51** Frederick Hammersley
*Late Afternoon,* 1992
oil on linen mounted on wood
9 x 12 inches (22.9 x 30.5 cm)
Collection of the artist
[not illustrated]

**52** Frederick Hammersley
*Twist of Lemon,* 1992
oil on linen mounted on wood
5 5/8 x 5 5/8 inches (14.3 x 14.3 cm)
Collection of the artist
[not illustrated]

**53** Frederick Hammersley
*Payday,* 1992
oil on linen mounted on wood
9 3/4 x 7 3/4 inches (24.8 x 19.7 cm)
Collection of the artist
[not illustrated]

**54** Frederick Hammersley
*Group Effort,* 1992
oil on paper mounted on linen and wood
9 1/2 x 11 1/2 inches (24.1 x 29.2 cm)
Collection of the artist
[not illustrated]

**55** Frederick Hammersley
*Private Income,* 1991
oil on linen mounted on wood
12 x 9 inches (30.5 x 22.9 cm)
Collection of the artist
[not illustrated]

**56** Frederick Hammersley
*Dark Horse,* 1991
oil on linen mounted on wood
11 1/8 x 11 1/4 inches (28.3 x 28.6 cm)
Collection of the artist
[not illustrated]

**57** Frederick Hammersley
*Group Insurance,* 1991
oil on linen mounted on wood
14 x 11 3/4 inches (35.6 x 29.8 cm)
Collection of the artist
[not illustrated]

**58** Frederick Hammersley
*Dry Heat,* 1991
oil on linen mounted on wood
12 x 10 inches (30.5 x 25.4 cm)
Collection of the artist
[not illustrated]

**59** Frederick Hammersley
*City Limits,* 1991
oil on linen mounted on Masonite
12 x 15 inches (30.5 x 38.1 cm)
Collection of the artist
[not illustrated]

**60** Frederick Hammersley
*Go Between,* 1990
oil on cotton mounted on wood
9 1/2 x 7 inches (24.1 x 17.8 cm)
Collection of the artist
[not illustrated]

**61** Frederick Hammersley
*Zen Scent,* 1990
oil on linen mounted on wood
12 x 9 inches (30.5 x 22.9 cm)
Collection of the artist
[not illustrated]

**62** Frederick Hammersley
*Picnic,* 1990
oil on linen mounted on wood
11 x 9 1/2 inches (27.9 x 24.1 cm)
Collection of the artist
[not illustrated]

**63** Frederick Hammersley
*Final Word,* 1988
oil on linen mounted on Masonite
12 x 9 inches (30.5 x 22.9 cm)
Collection of the artist
[fig. 17]

**64** Frederick Hammersley
*Money from Home,* 1986
oil on paper mounted on linen and wood
7 3/4 x 10 1/2 inches (19.7 x 26.7 cm)
Collection of the artist
[not illustrated]

**65** Frederick Hammersley
*Band Concert,* 1986
oil on paper mounted on linen and wood
8 x 10 1/8 inches (20.3 x 25.7 cm)
Collection of the artist
[not illustrated]

**66** Julius Hatofsky
*Untitled Dream Fragment,* 1991
oil on canvas
80 x 68 inches (203.2 x 172.7 cm)
Collection of the artist
[fig. 18]

**67** Julius Hatofsky
*Untitled Dream Fragment,* 1991
oil on canvas
84 x 70 inches (213.4 x 177.8 cm)
Collection of the artist
[not illustrated]

**68** Julius Hatofsky
*Untitled,* 1984
oil on canvas
66 x 72 inches (167.6 x 182.9 cm)
Collection of the artist
[not illustrated]

**69** Felrath Hines
*Midnight Garden,* 1991
oil on linen
52 x 58 inches (132.1 x 147.3 cm)
Collection of Dorothy Fischer,
Silver Spring, Maryland
[fig. 19]

**70** Felrath Hines
*Lovers Knot,* 1990
oil on linen
58 x 52 inches (147.3 x 132.1 cm)
Collection of Dorothy Fischer, Silver
Spring, Maryland
[not illustrated]

**71** Felrath Hines
*Elevation*, 1986
oil on linen
40 x 48 inches (101.6 x 121.9 cm)
Collection Dorothy Fischer, Silver
Spring, Maryland
[not illustrated]

**72** Mel Katz
*Confetti Stripes and Aluminum Too*, 1991
plastic laminate and vinyl
96 x 46 x 31 1/2 inches (243.8 x 116.8 x
80.0 cm)
Laura Russo Gallery, Portland
[fig. 20]

**73** Mel Katz
*Granite'Mica*, 1986
plastic laminate
88 x 30 x 9 inches (223.5 x 76.2 x 22.9 cm)
Laura Russo Gallery, Portland
[not illustrated]

**74** Vera Klement
*Embrace*, 1993
oil on canvas
78 x 60 inches (198.1 x 152.4 cm)
Roy Boyd Gallery, Chicago
[fig. 21]

**75** Vera Klement
*27 Tears*, 1991
acrylic and oil collage on canvas
84 x 72 inches (213.4 x 182.9 cm)
Roy Boyd Gallery, Chicago
[not illustrated]

**76** Charles McGee
*Noah's Ark Series: Ecosystem*, 1994
polychromed aluminum
62 x 106 x 18 inches (157.5 x 269.2 x
45.7 cm)
Collection of the artist
[created specifically for the exhibition;
not illustrated]

**77** Carl Morris
*Calligraphy Series #792*, 1986
acrylic on canvas
48 x 60 inches (121.9 x 152.4 cm)
David Curt Morris
[not illustrated]

**78** Carl Morris
*#688—Yellow Sky*, 1990
acrylic on canvas
85 x 73 inches (215.9 x 185.4 cm)
David Curt Morris
[fig. 23]

**79** Carl Morris
*Calligraphy Series #711*, 1990
acrylic on canvas
56 x 60 inches (142.2 x 152.4 cm)
David Curt Morris
[not illustrated]

**80** Florence Pierce
*Fan #2*, 1988
polyester resin on mirrored Plexiglas
laminated to plywood
48 x 72 x 2 inches (121.9 x 182.9 x 5.1 cm)
Collection of the artist
[fig. 24]

**81** Florence Pierce
*Prayer Sticks*, 1986
polyester resin on mirrored Plexiglas
laminated to plywood
72 x 24 x 2 inches (182.9 x 61.0 x 5.1 cm)
Collection of the artist
[not illustrated]

**82** Florence Pierce
*Folded Circle*, 1985
polyester resin on mirrored Plexiglas
laminated to plywood
83 x 51 x 2 inches (210.8 x 129.5 x 5.1 cm)
Collection of Raymond Jonson
Gallery of the University of New
Mexico, Albuquerque
[not illustrated]

**83** Michele Russo
*Sacco and Vanzetti*, 1994
acrylic on canvas
45 x 60 inches (114.3 x 152.4 cm)
Laura Russo Gallery, Portland
[not illustrated]

**84** Michele Russo
*The Juggler,* 1993
acrylic on canvas
70 x 60 inches (177.8 x 152.4 cm)
Arlene and Harold Schnitzer, Portland, OR
[fig. 25]

**85** Michele Russo
*Hop, Skip, and Jump,* 1992
acrylic on canvas
70 x 55 inches (177.8 x 139.7 cm)
Laura Russo Gallery, Portland
[not illustrated]

**86** Jon Serl
*Indian Fisherman,* 1990
oil on board
45 x 32 inches (114.3 x 81.3 cm)
Cavin–Morris Gallery New York
[fig. 26]

**87** Jon Serl
*Heigh Ho to Circumcision,* 1990
oil on board
40 x 60 inches (101.6 x 152.4 cm)
Basel Dalloul , Washington, DC
[not illustrated]

**88** Jon Serl
*Unbelievable Opposition,* 1989
oil on board
48 x 48 inches (121.9 x 121.9 cm)
Collection of Amr Shaker
[not illustrated]

**89** Oli Sihvonen
*Addendum,* 1990
oil on canvas
96 x 56 inches (243.8 x 142.2 cm)
Estate of Oli Sihvonen
[fig. 27]

**90** Oli Sihvonen
*Mobius Mode,* 1989
oil and acrylic on canvas
96 x 68 inches (243.8 x 172.7 cm)
Estate of Oli Sihvonen
[illustrated on cover]

**91** Sal Sirugo
*M-306,* 1992
ink on paper
3 3/16 x 4 3/8 inches (8.3 x 11.4 cm)
Collection of the artist
[not illustrated]

**92** Sal Sirugo
*M-272,* 1992
ink on paper
1 9/16 x 2 3/16 inches (4.1 x 5.7 cm)
Collection of the artist
[not illustrated]

**93** Sal Sirugo
*M-381,* 1992
ink on paper
3 1/2 x 4 7/16 inches (8.9 x 11.4 cm)
Collection of the artist
[not illustrated]

**94** Sal Sirugo
*M-383,* 1992
ink on paper
3 1/2 x 4 3/8 inches (8.9 x 11.1 cm)
Collection of the artist
[not illustrated]

**95** Sal Sirugo
*M-217,* 1991
ink on paper
3 3/16 x 3 7/16 inches (8.3 x 8.9 cm)
Collection of the artist
[fig. 28]

**96** Sal Sirugo
*M-145,* 1991
ink on paper
1 13/16 x 2 11/16 inches (4.8 x 7.0 cm)
Collection of the artist
[not illustrated]

**97** David Slivka
*Mangrove,* 1994
stained woods and rope
height: 89 inches (226.1 cm); diameter:
72 inches (182.9 cm)
Collection of the artist
[fig. 29]

**98** Stella Waitzkin
*Details of a Lost Library,* 1950–93
cast polyester resin and mixed media
ca. 7 x 12 feet (2.1 x 3.7 m)
Collection of the artist
[fig. 30]

**99** Robert Wilbert
*Self-Portrait with Mannequins,* 1994
oil on canvas
48 x 60 inches (121.9 x 152.4 cm)
Donald Morris Gallery Inc,
Birmingham, Michigan
[not illustrated]

**100** Robert Wilbert
*Still Life with Toy Piano,* 1994
oil on canvas
30 x 40 inches (76.2 x 101.6 cm)
Donald Morris Gallery Inc,
Birmingham, Michigan
[not illustrated]

**101** Robert Wilbert
*Gerry with a Chicory Bouquet,* 1993
oil on canvas
50 x 40 inches (127.0 x 101.6 cm)
Donald Morris Gallery Inc,
Birmingham, Michigan
[fig. 31]

**102** Jack Zajac
*Santa Cruz Series: Falling Water XIX,* 1991
cast bronze
96 inches (243.8 cm) high
Stephen Wirtz Gallery, San Francisco
[fig. 32]

**103** Jack Zajac
*Santa Cruz Series: Falling Water XVII,* 1991
cast bronze
96 inches (243.8 cm) high
Stephen Wirtz Gallery, San Francisco
[not illustrated]

**104** Jack Zajac
*Santa Cruz Series: Falling Water XIII,* 1987
cast bronze
108 inches (274.3 cm) high
Stephen Wirtz Gallery, San Francisco
[fig. 32]

**105** Jack Zajac
*Santa Cruz Series: Falling Water I,* 1984
cast bronze
75 inches (190.5 cm) high
Stephen Wirtz Gallery, San Francisco
[not illustrated]

## photography credits

Black-and-white photographs
are by Larry Fink.

Damian Andrus, pp. 51, 65, 71,
and cover
Bill Bachhuber, p. 63
Dirk Bakker, p. 79
David Browne, p. 67
Rod del Pozo, p. 21
Dan Dragon, p. 27
Tony Grant, p. 81
Mary Ann Gurley, p. 29
Jamie Hart, p. 33

Stewart Harvey, p. 57
Peter Jacobs and David Plaake, p. 43
Elliot Klein, p. 37
Robert Mates, p. 41
Norman McGrath, p. 77
Bill McNeece, p. 61
William Nettles, p. 35
Kevin Noble, p. 75
John Urban, p. 31
Tom Van Eynde, p. 25
Page Wilson, p. 69
Joe Ziolkowski, p. 39
Earl Zukboff, p. 55

# index of artists